SHROPSHIRE
from dawn to dusk

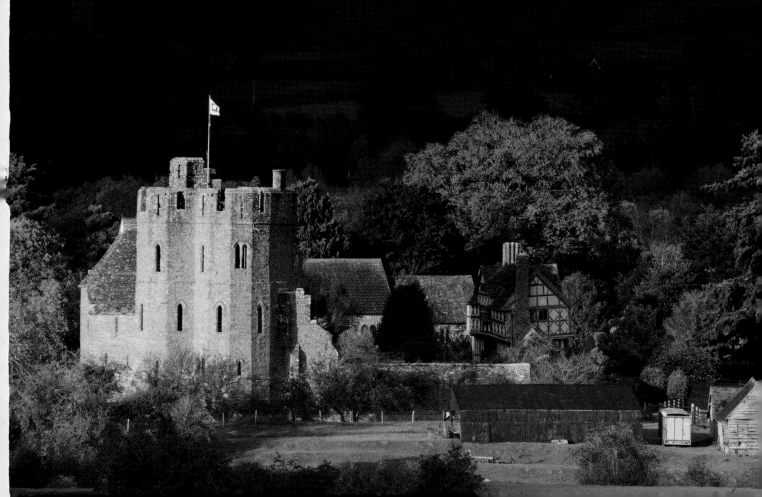

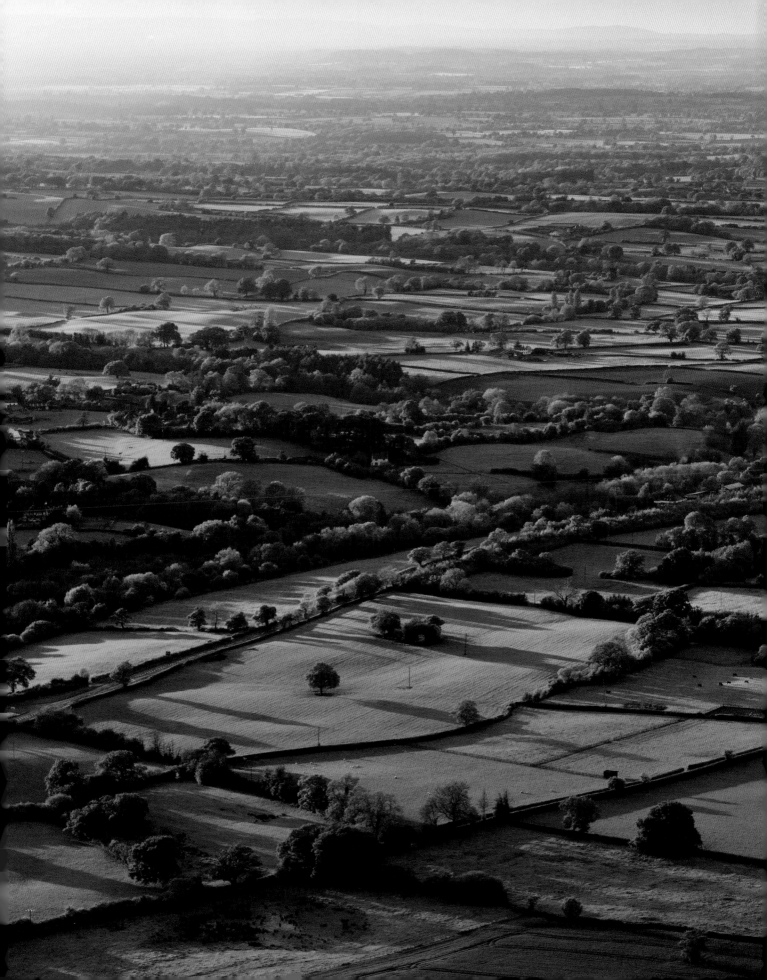

SHROPSHIRE
from dawn to dusk

PHOTOGRAPHS BY JOHN AND MIKE HAYWARD

MERLIN UNWIN BOOKS

First published in Great Britain by Merlin Unwin Books Ltd 2020

Photographs © John and Mike Hayward 2020
Text © Lynne Hayward 2020

Merlin Unwin Books Ltd
Palmers House
7 Corve Street
Ludlow
Shropshire SY8 1DB
UK

www.merlinunwin.co.uk

ISBN 978-1-913159-16-0

Typeset in 12 point Minion Pro by Merlin Unwin Books
Printed and bound by Leo Paper Products

Half-title page:
A rainbow appears over Stokesay Castle after a rain storm.

Previous double page:
The view from the summit of Caer Caradoc, near Church Stretton.

Under jacket image:
Swans at sunrise on the Severn with the Wrekin in the background, seen from Cressage Bridge.

Introduction

Light and dark, sunshine and shadow, morning and night – a photographer faces up to these challenges every single day. Step outside into the Shropshire landscape and a different view will always present itself, depending upon where – and when – you are. Add in the changing seasons and everything becomes much more complicated, although no less inspirational.

Mike and John never become bored with photographing our beautiful county, although their frustrations are evident when the weather and consequent poor light levels keep them indoors.

Our first reaction on being asked to produce a follow-up to the success of our earlier book, *A Year in Shropshire*, was to ask ourselves if there was anything new to photograph or to write about.

The answer in a heartbeat, of course, was 'yes'. The changing faces of Shropshire are an ever-present delight, and there is always something new to discover in this wonderful county that we are happy to call home.

So here is a fresh look at the glorious hills and countryside of Shropshire, the towns and villages and the people and customs that make this place so very special.

We hope you enjoy this latest celebration of Shropshire and, like us, glory in the county's variety and diversity. Once again, we hope that we have done Shropshire proud.

Lynne Hayward
Shifnal 2020

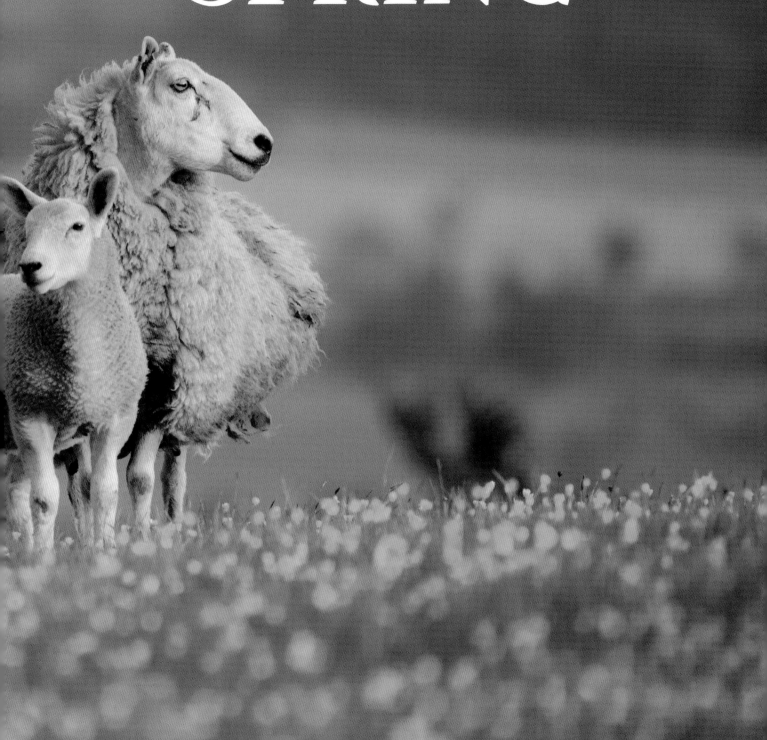

SPRING

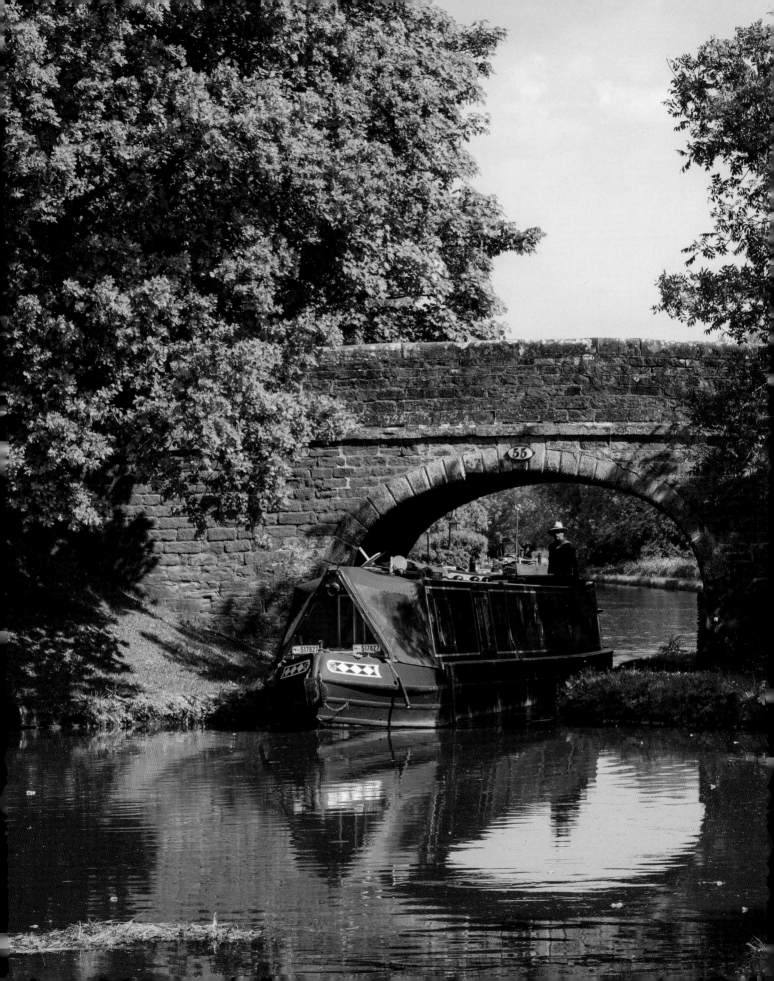

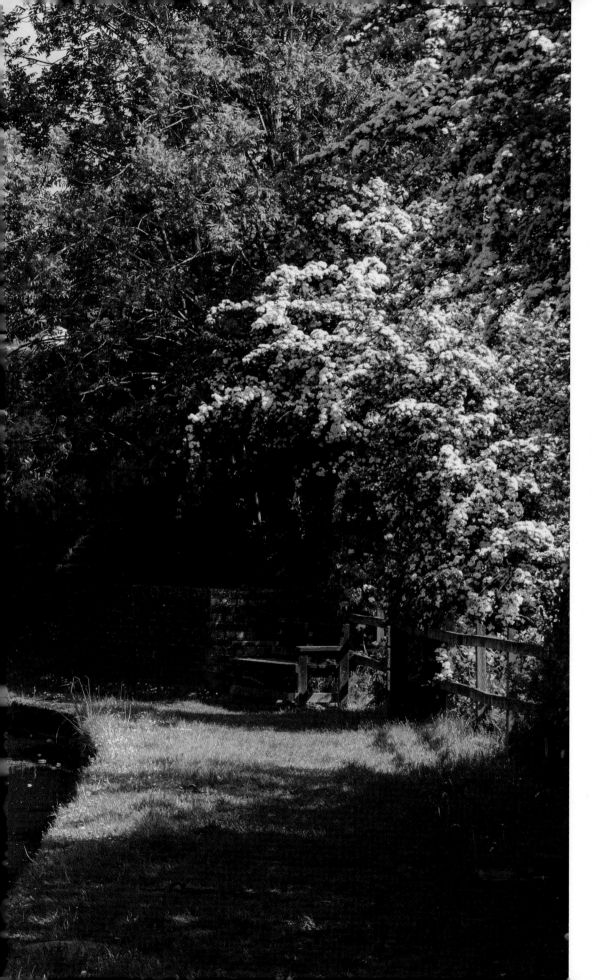

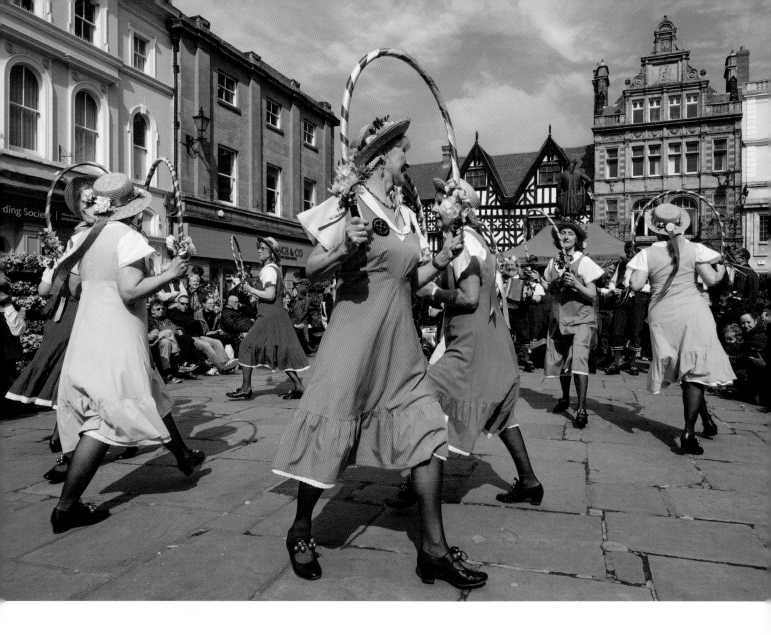

Above
SHREWSBURY. A bright splash of colour as Shrewsbury Lasses – one of the three Shrewsbury Morris teams – perform in the Square at the Big Busk.

Above, right
SHREWSBURY. Science fiction and fantasy meet the 19th century as enthusiasts gather at St Mary's Church for the Steampunk Spectacular.

Right
LUDLOW. Reverend Kelvin Price, Rector of St Laurence's, leads a special church service celebrated among the dodgem cars – one of the highlights of the annual May Fair.

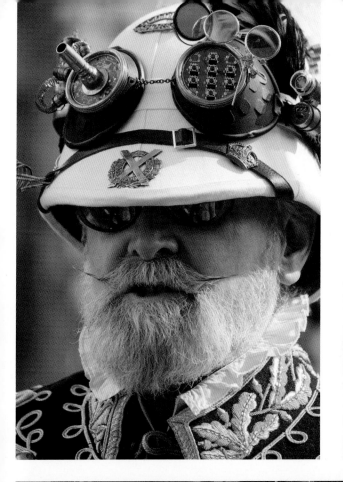
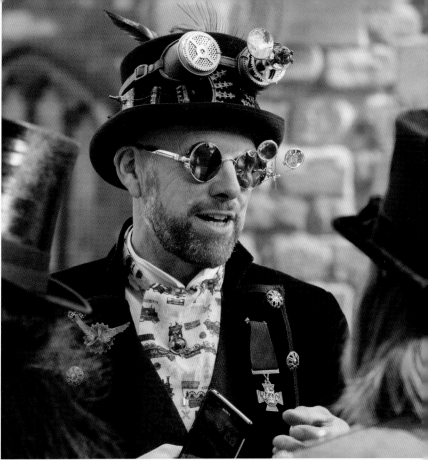
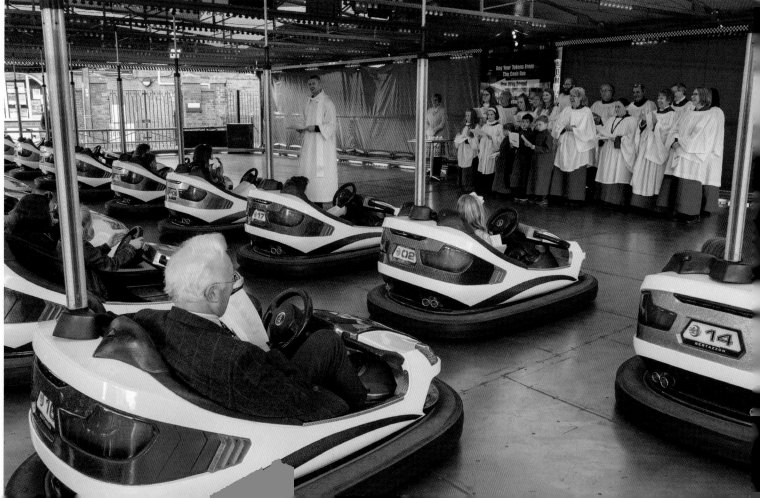

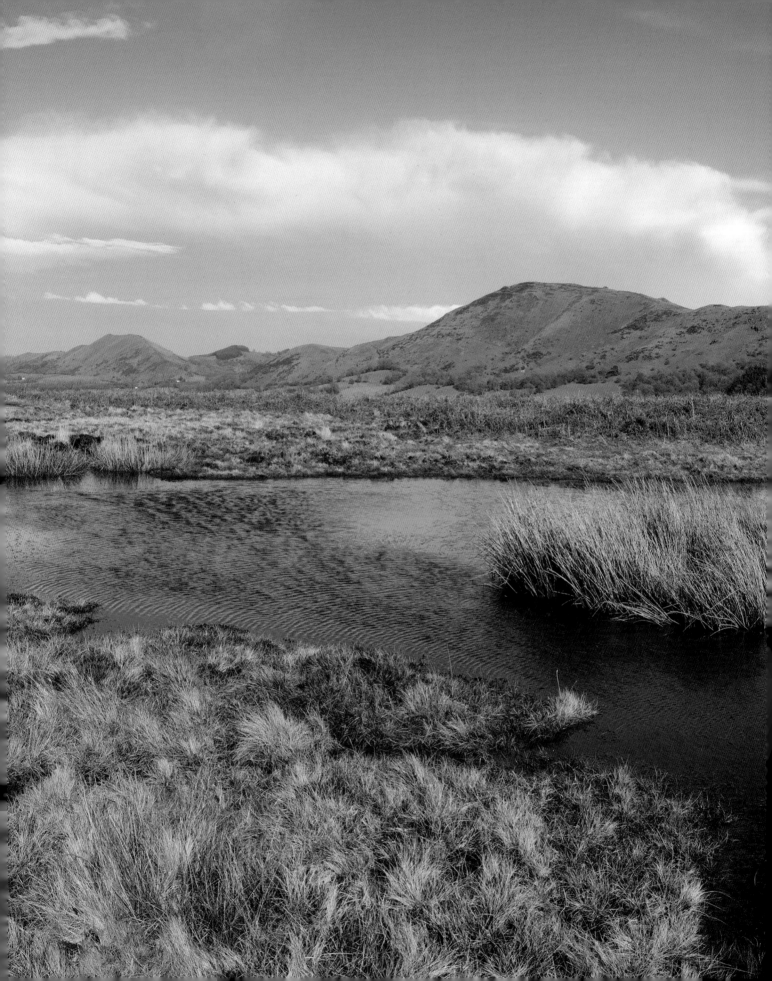

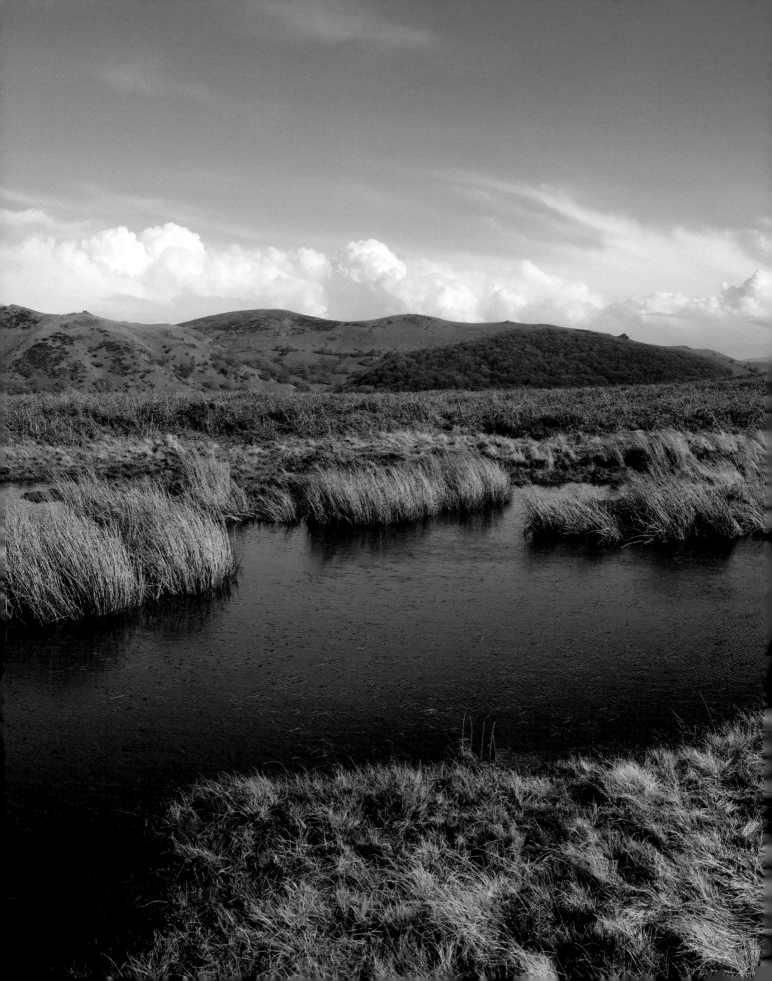

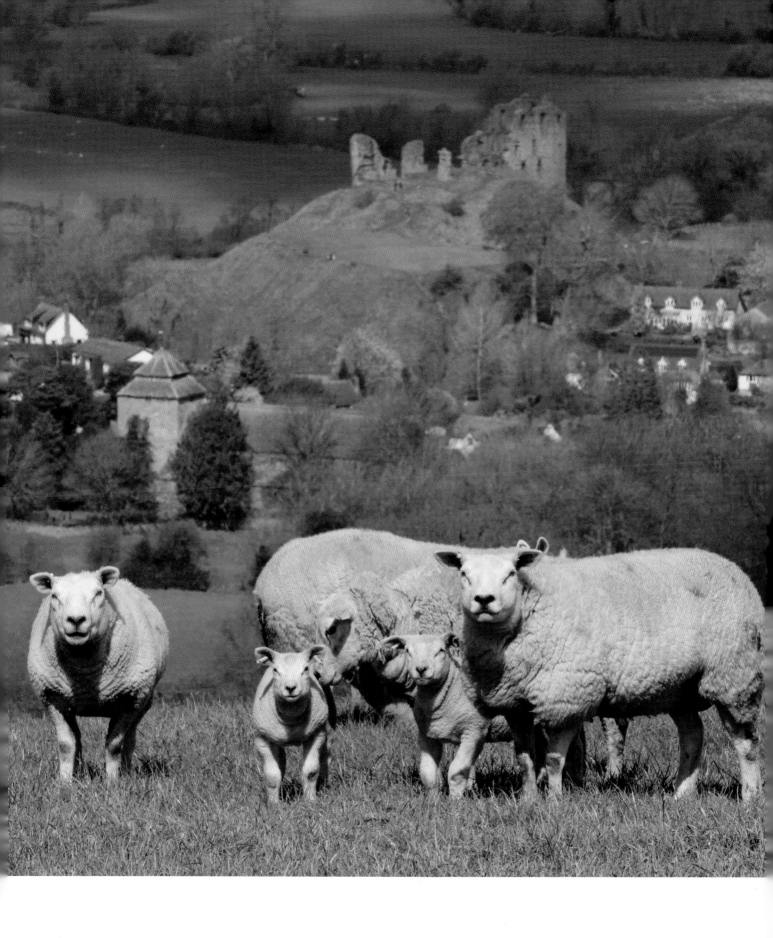

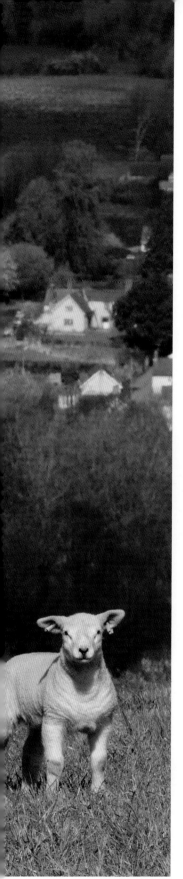

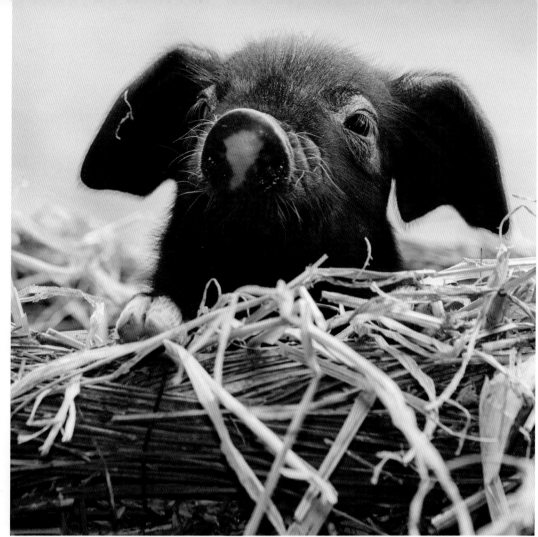

Previous page
THE LONG MYND. A breeze ripples across the surface of a pool on Nover's Hill. In the background are the Lawley, Caer Caradoc, Hope Bowdler Hill and Helmeth Hill.

Left
CLUN. Sheep graze in a field overlooking the town and its magnificent ruined castle.

Above
ACTON SCOTT. A four-day-old Large Black piglet greets the world just south of Church Stretton.

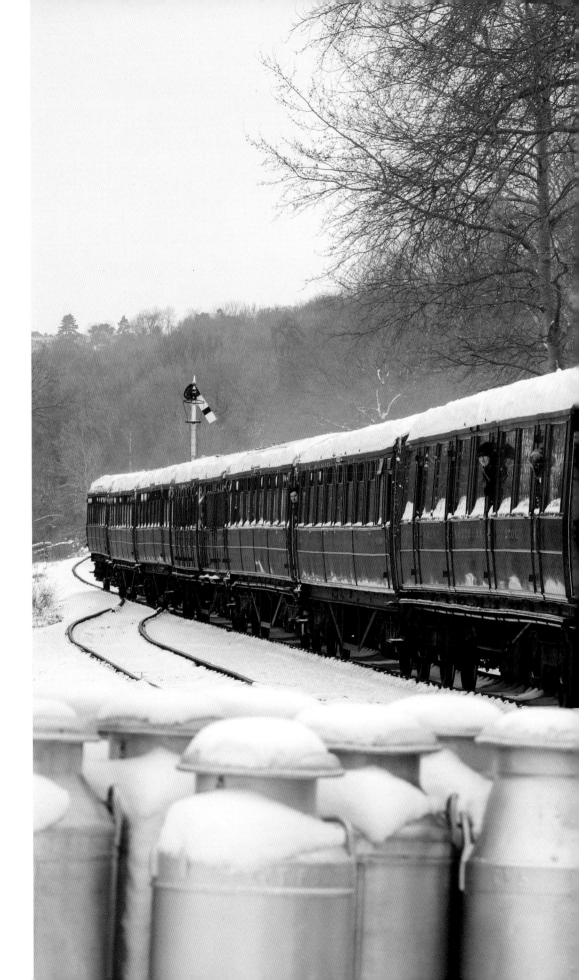

HAMPTON LOADE

An unseasonal covering of snow on the Severn Valley Railway heritage line. Here, LNER steam locomotive 8572 pulls into the station on the final day of the Spring Steam Gala.

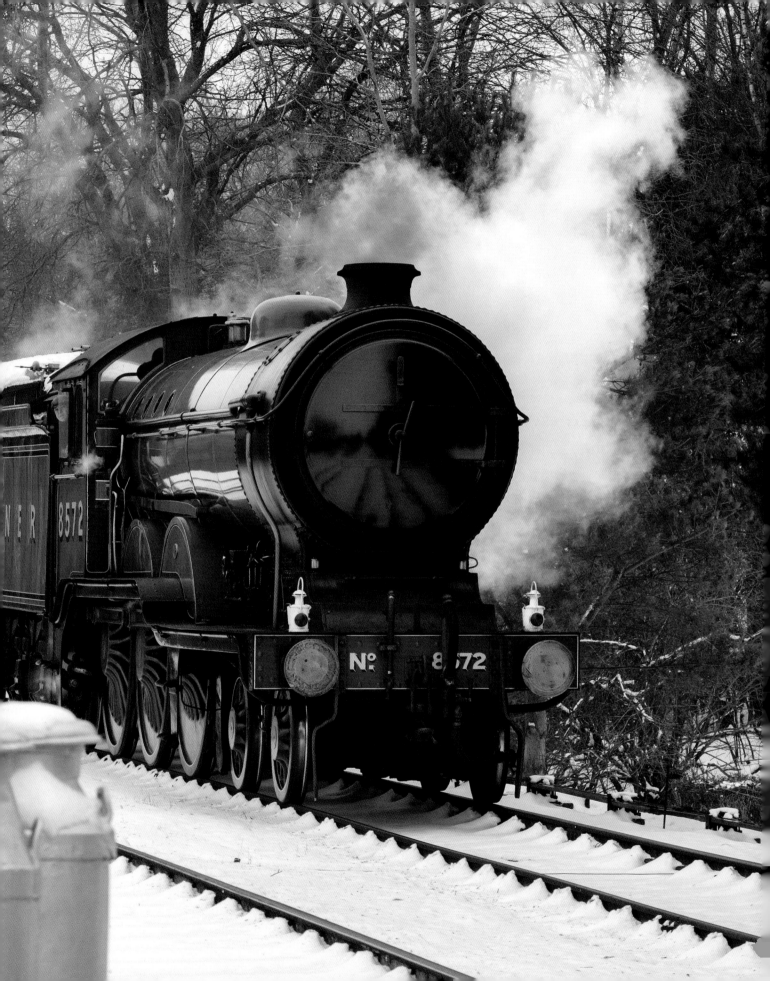

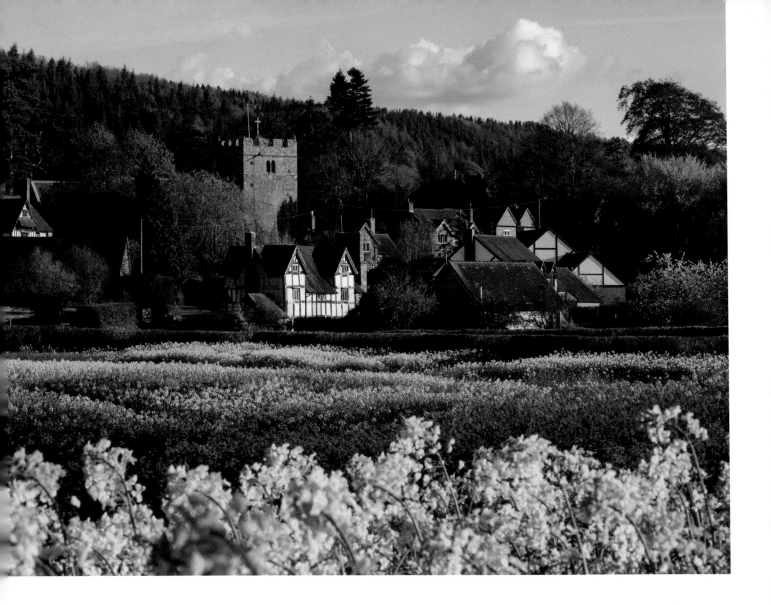

Above
RUSHBURY. Evening sun and shadow in tranquil Ape Dale. The 12th century tower of St Peter's Church stands proud above the village, which lies at the foot of Wenlock Edge.

Right, top
LITTLE STRETTON. All Saints, which lies beneath the Long Mynd, must be one of the most picturesque churches in Shropshire. It was built in 1903, so is not as old as it looks.

Right, bottom
HOPE BAGOT. A froth of cow parsley beneath the slopes of Titterstone Clee. More than 65 species of wildflowers have been identified in the churchyard of St John the Baptist, which is maintained to encourage diversity.

Following page
ALL STRETTON. The village nestles beneath Batch Valley and the Long Mynd, whose folds and contours are emphasised in the late evening light.

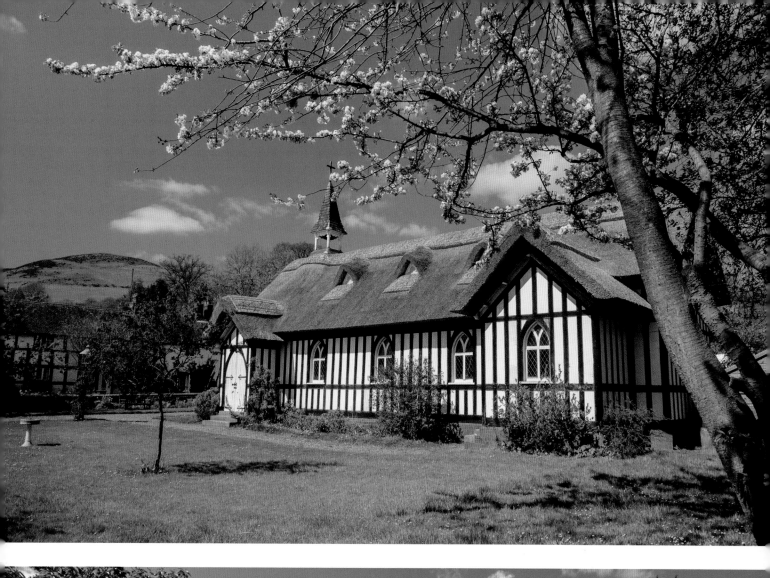
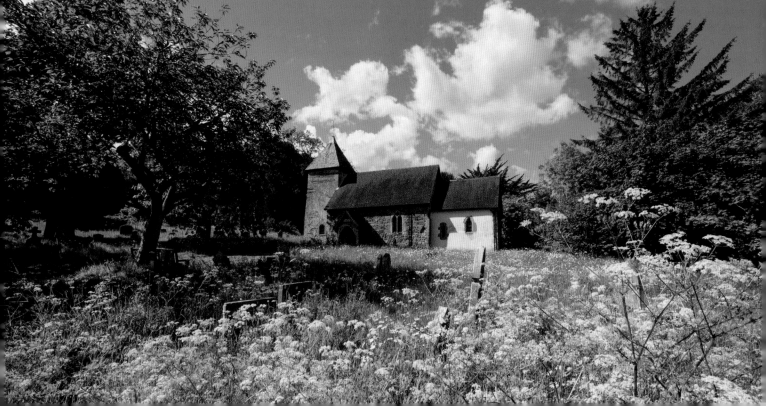

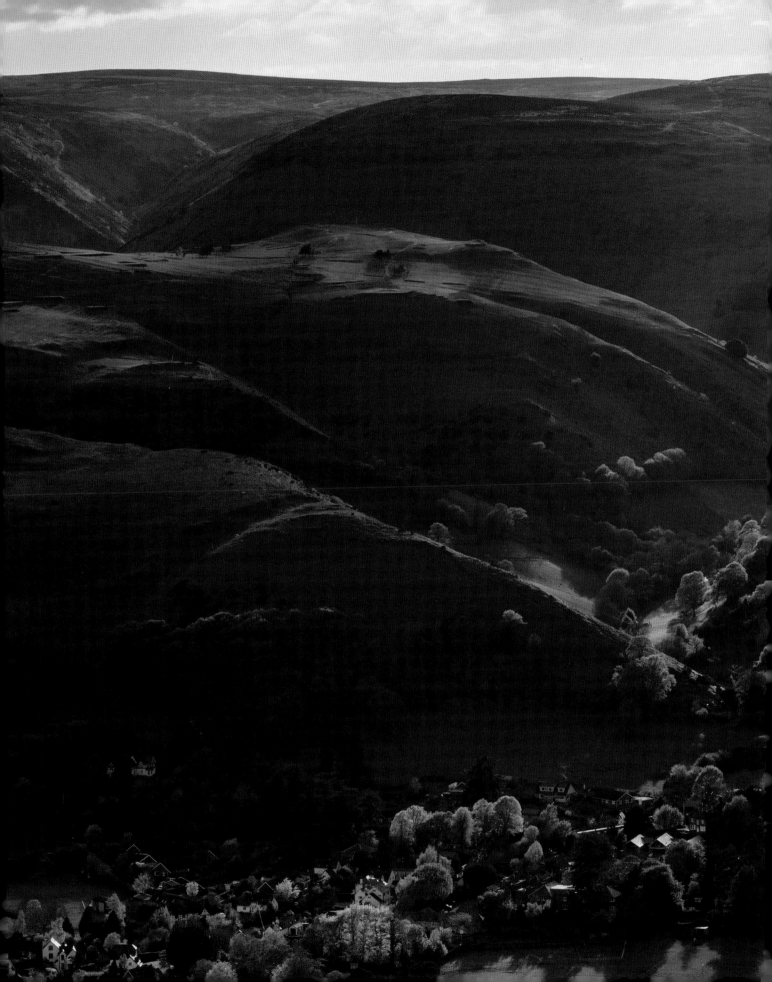

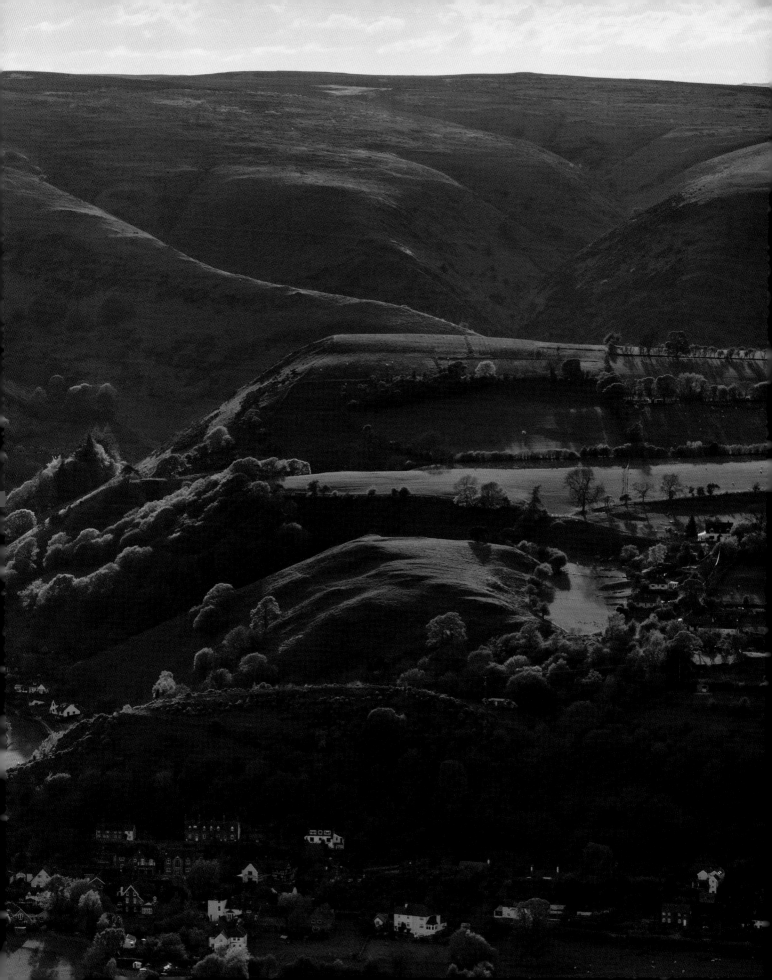

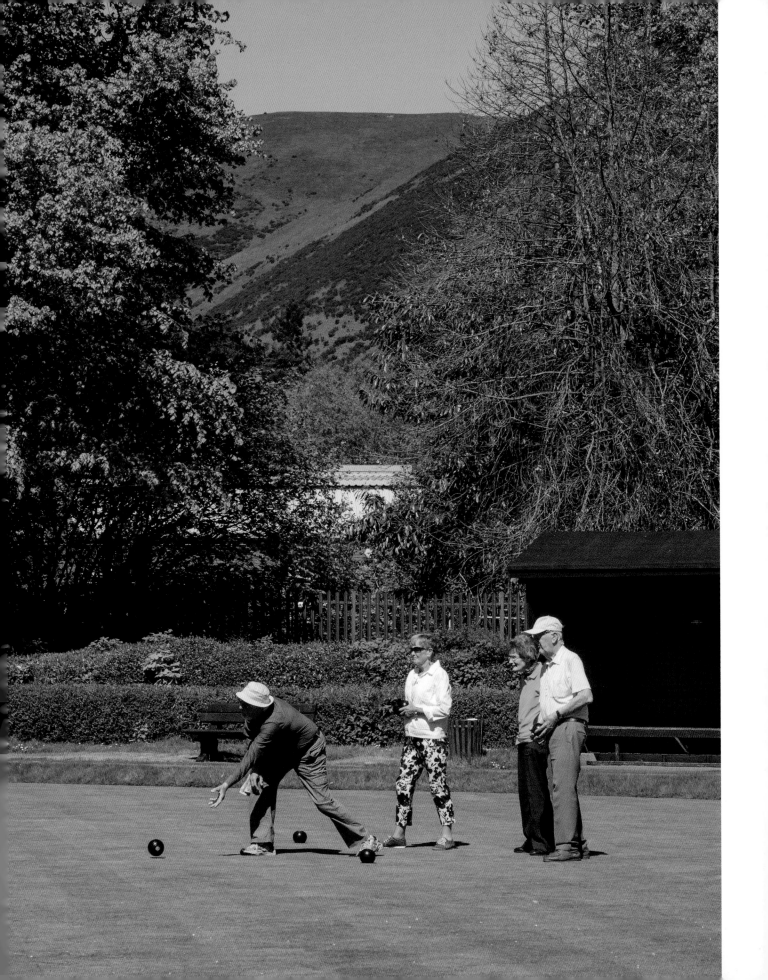

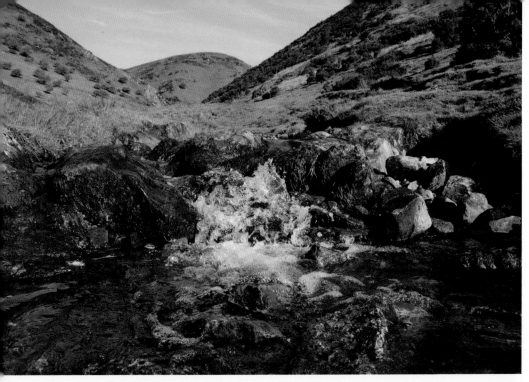

Far left
CHURCH STRETTON
A game of bowls is played out beneath the Long Mynd.

Left
CARDING MILL VALLEY
Water tumbles through this beautiful valley whose name is a reminder of the area's former wool industry.

Below
HELMETH HILL. A sunlit path through bluebells in woodland near Church Stretton.

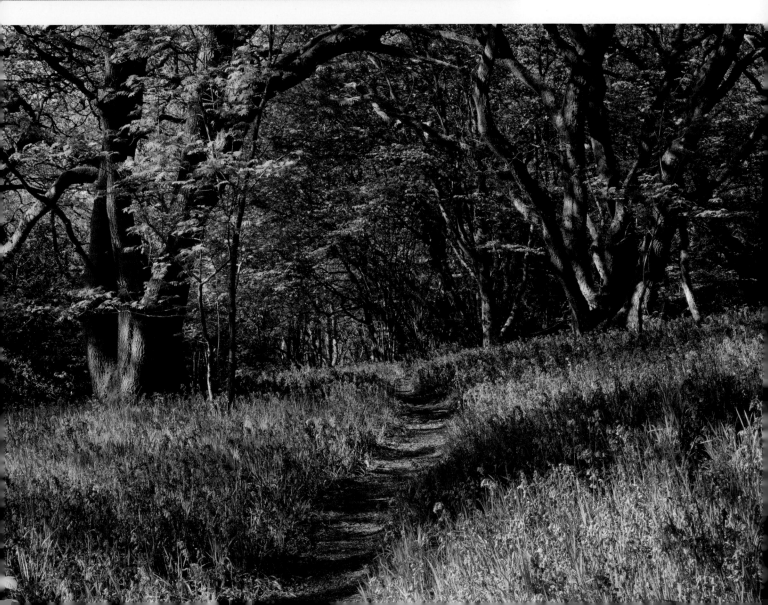

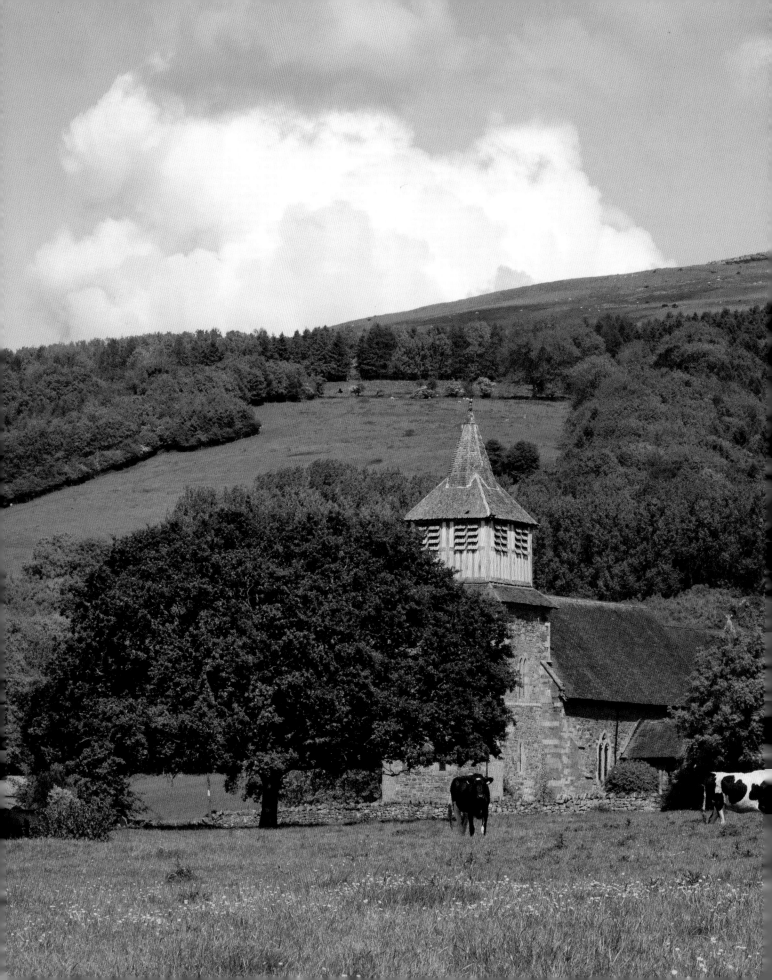

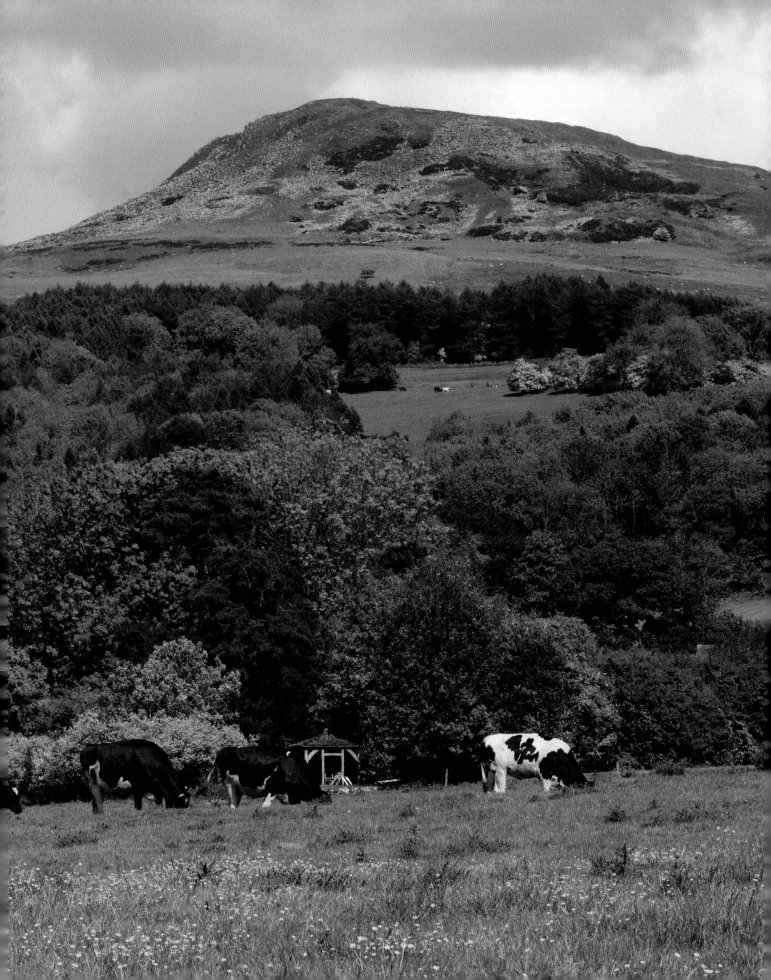

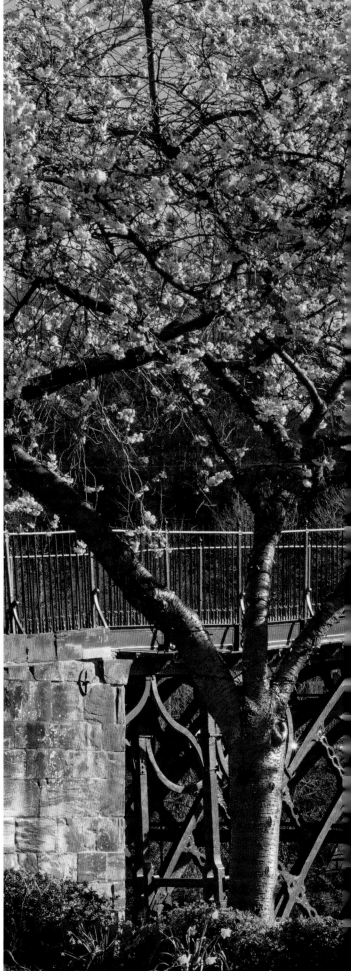

Previous page
BITTERLEY. St Mary's Church in a buttercup meadow beneath Titterstone Clee.

Above top
MUCH WENLOCK. Ashfield Hall was once an inn, reputedly visited by Charles I.

Above
BRIDGNORTH. St Mary's Church seen from Castle Gardens.

Right
IRONBRIDGE. Spring blossom near the Iron Bridge, repainted here in its original red-brown colour.

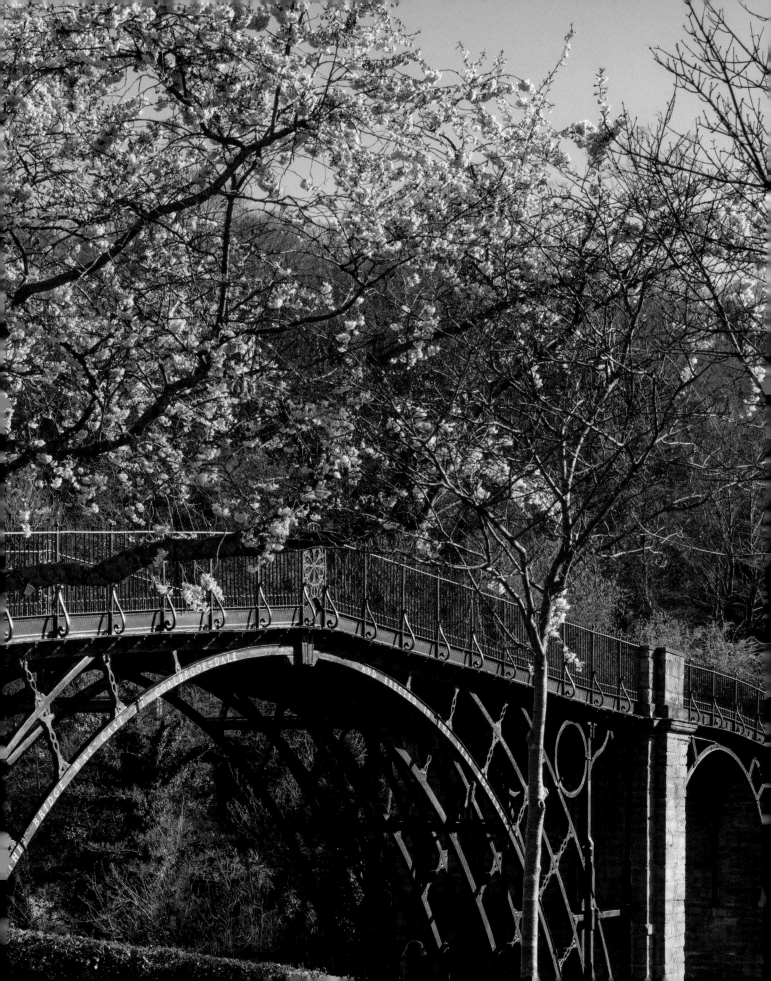

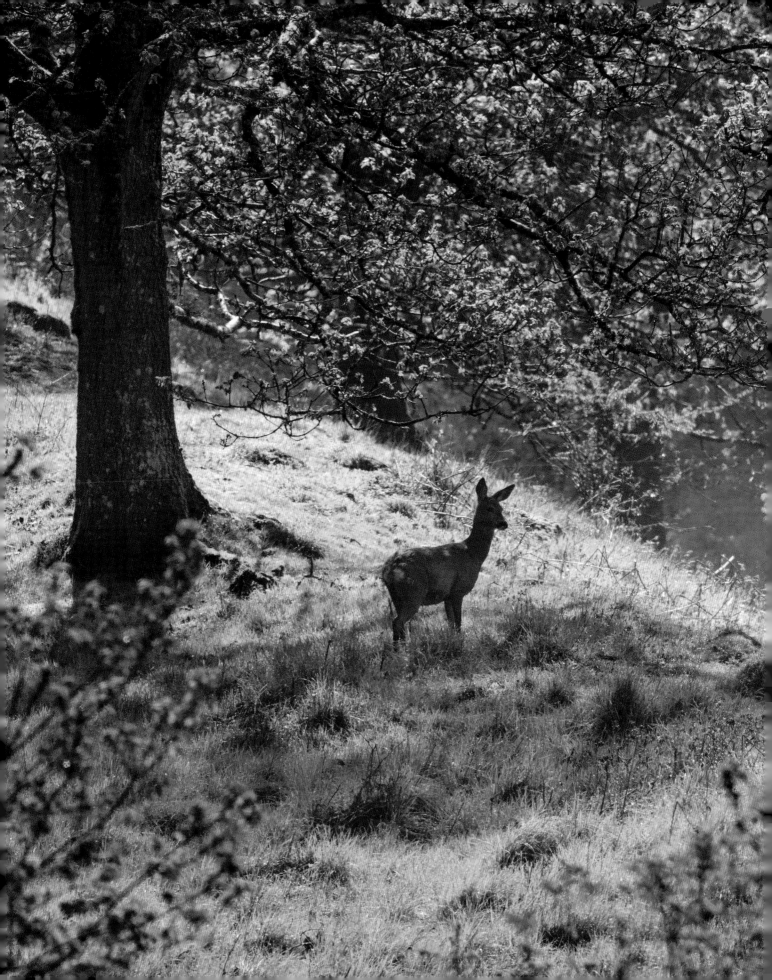

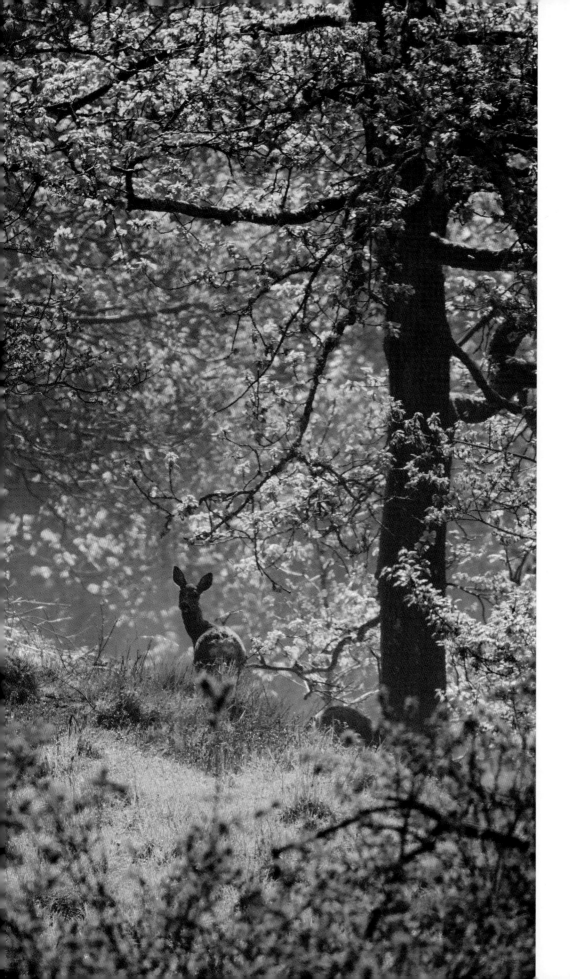

BURROW HILL

Dappled morning sunlight picks out two roe deer amid a drift of bluebells growing in this peaceful place, which overlooks the village of Hopesay, near Craven Arms.

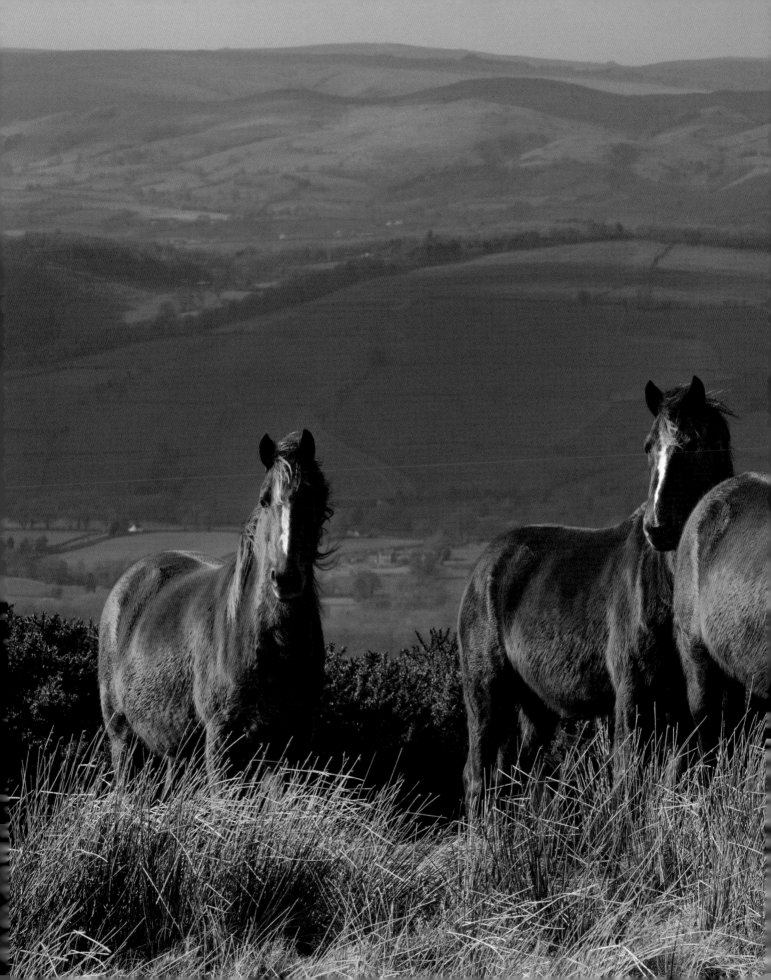

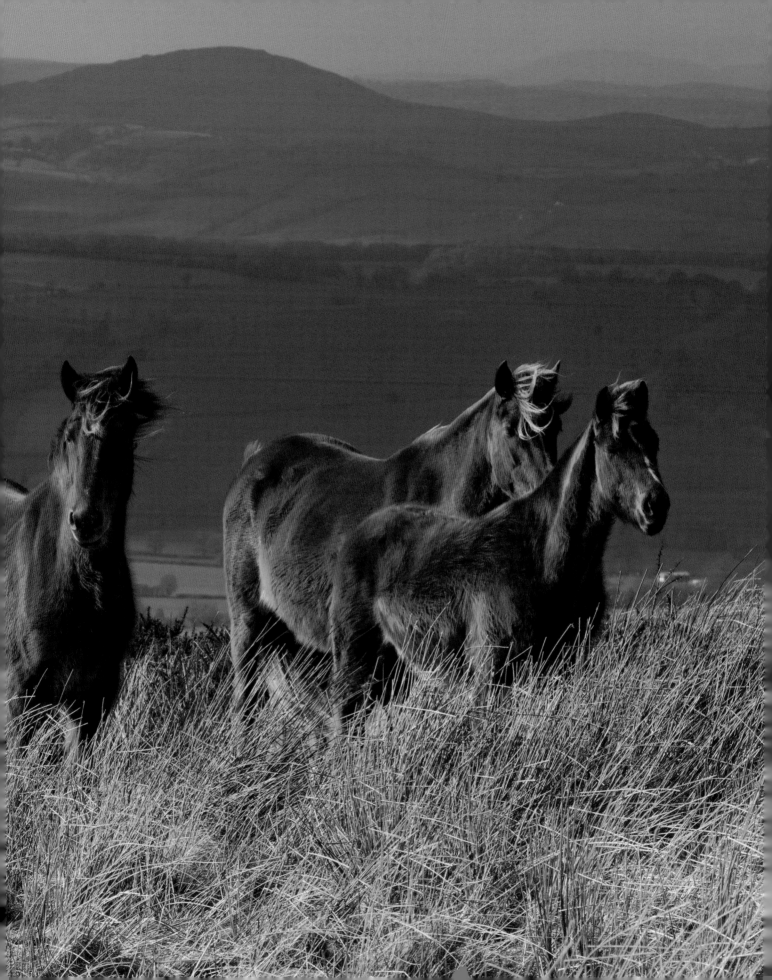

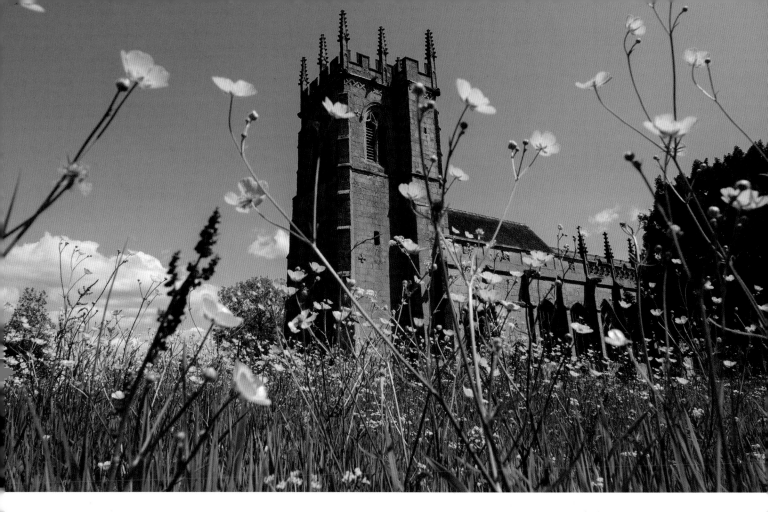
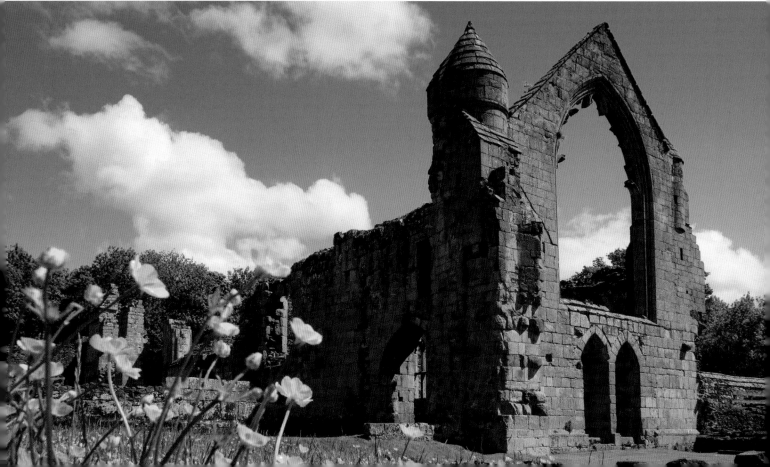

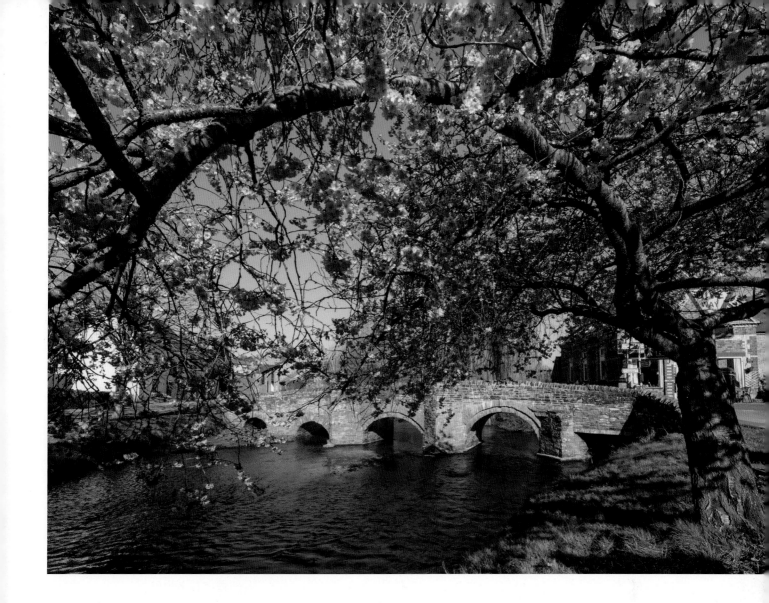

Previous page
BROWN CLEE. Wild ponies near the summit, with Corvedale and the Stretton Hills
in the distance.

Left, top
BATTLEFIELD. St Mary's Church was built on the orders of Henry IV in memory of up to
1,600 men who died at the Battle of Shrewsbury in 1403.

Left, bottom
HAUGHMOND. The extensive remains of this Augustinian abbey lie just a few miles
from Shrewsbury.

Above
CLUN. Dazzling pink cherry blossom near the medieval packhorse bridge, which divides the
town in two.

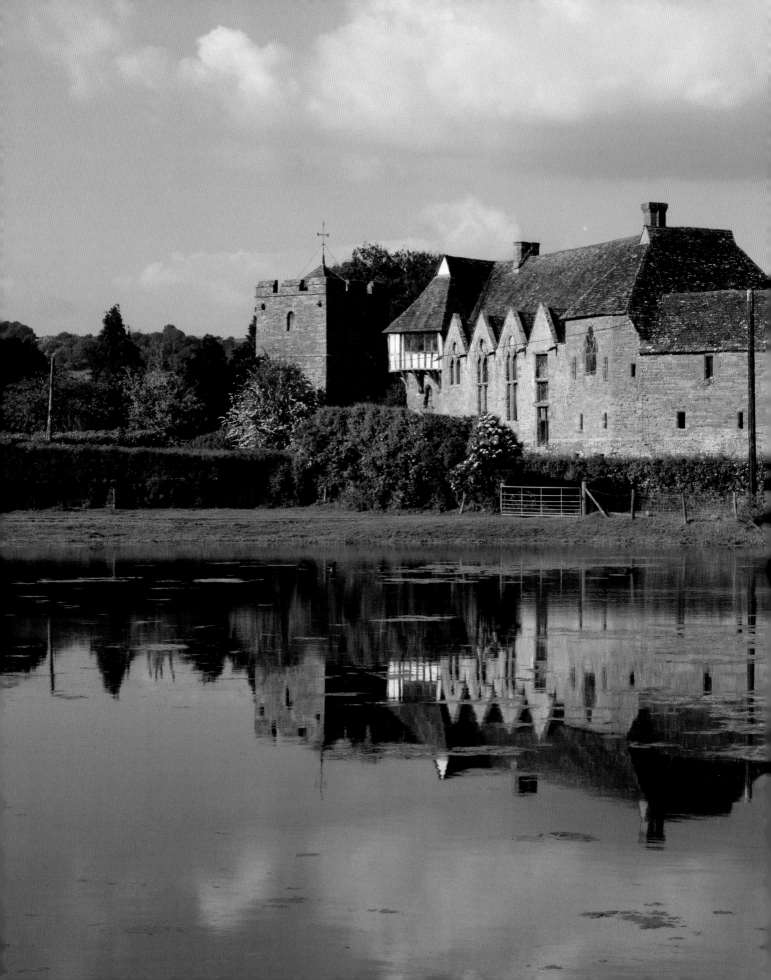

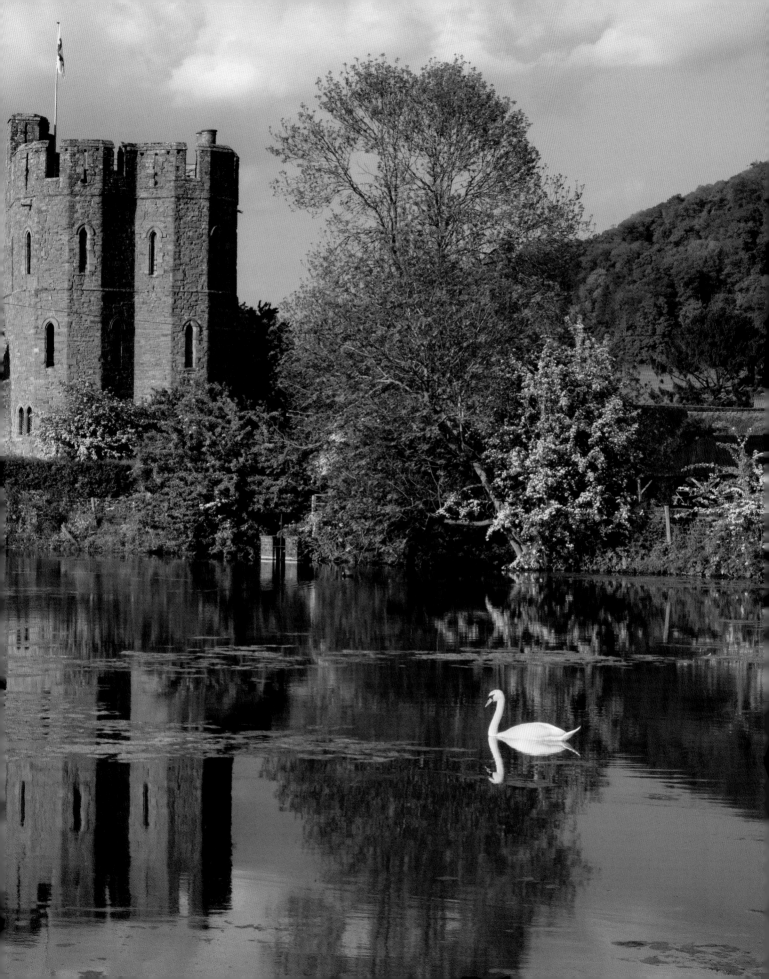

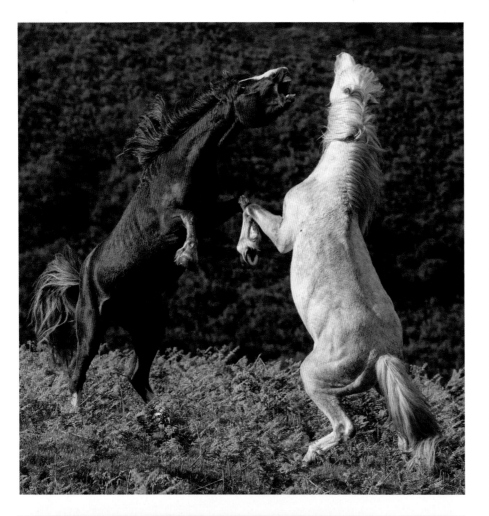

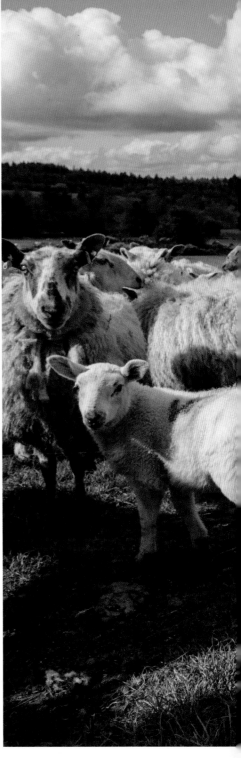

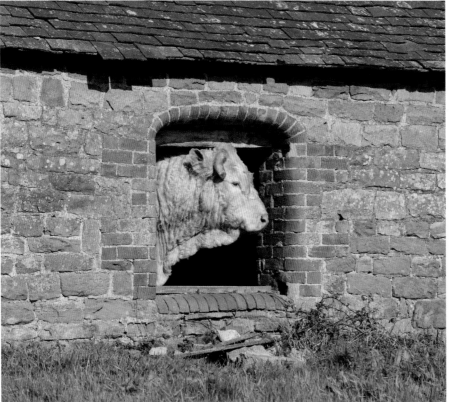

Previous page
STOKESAY CASTLE

A majestic swan on the pool in front of the best-preserved fortified medieval manor house in England.

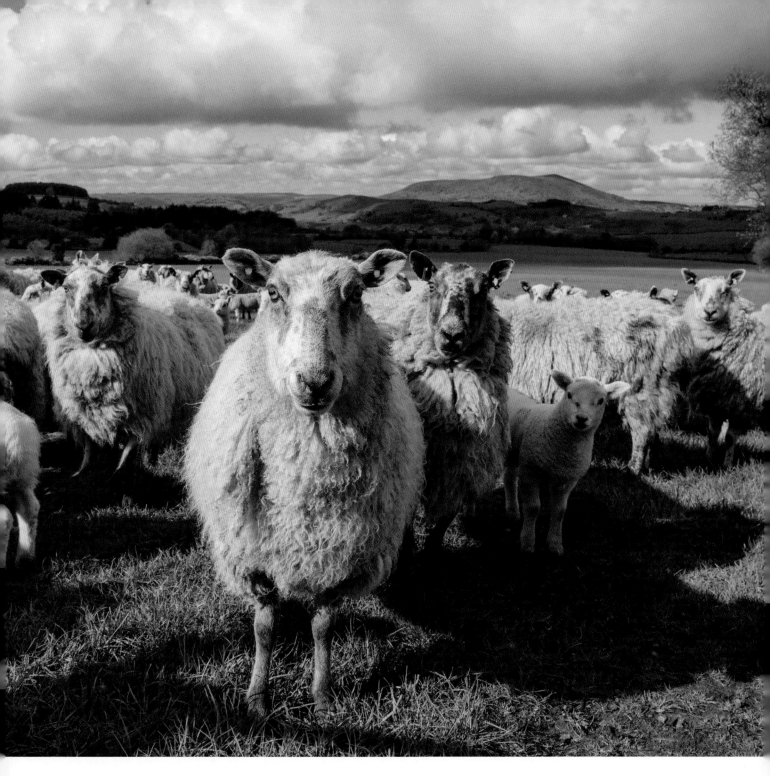

Left, top
THE LONG MYND. Wild ponies fight for supremacy near the Burway.

Left, bottom
HOLDGATE. A barn with a view.

Above
THE STIPERSTONES. Feeding time near The Bog, with Corndon Hill seen on the horizon.

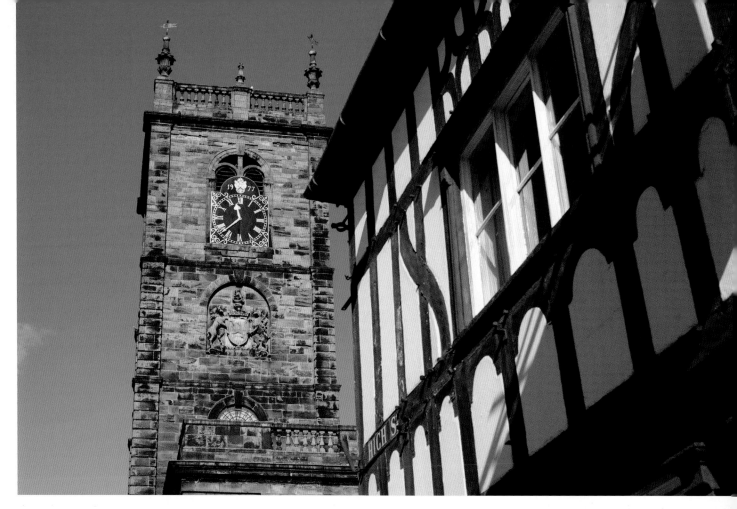

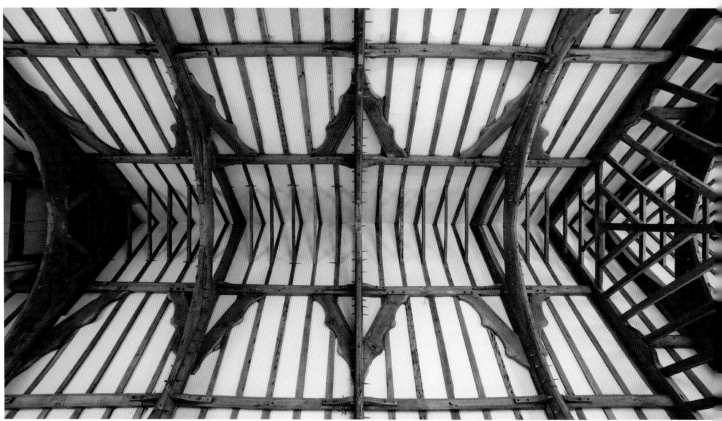

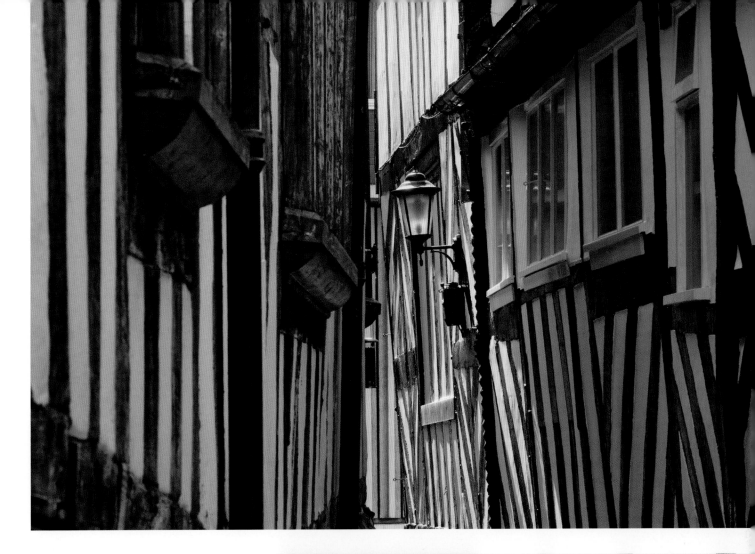

Top, left
WHITCHURCH. A contrast in styles – the sandstone tower of St Alkmund's Church overlooks a half-timbered building.

Bottom, left
SMETHCOTT (SMETHCOTE). The magnificent nave roof in the Church of St Michael and All Angels.

Above and right
SHREWSBURY. Half-timbered buildings in Grope Lane and Mardol.

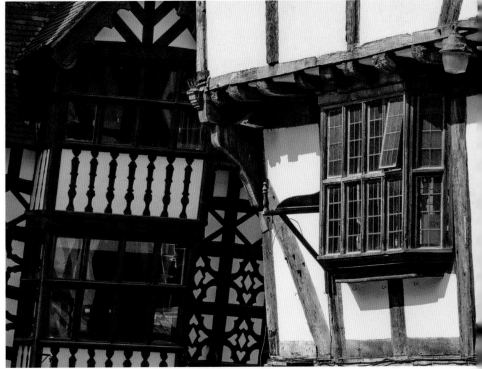

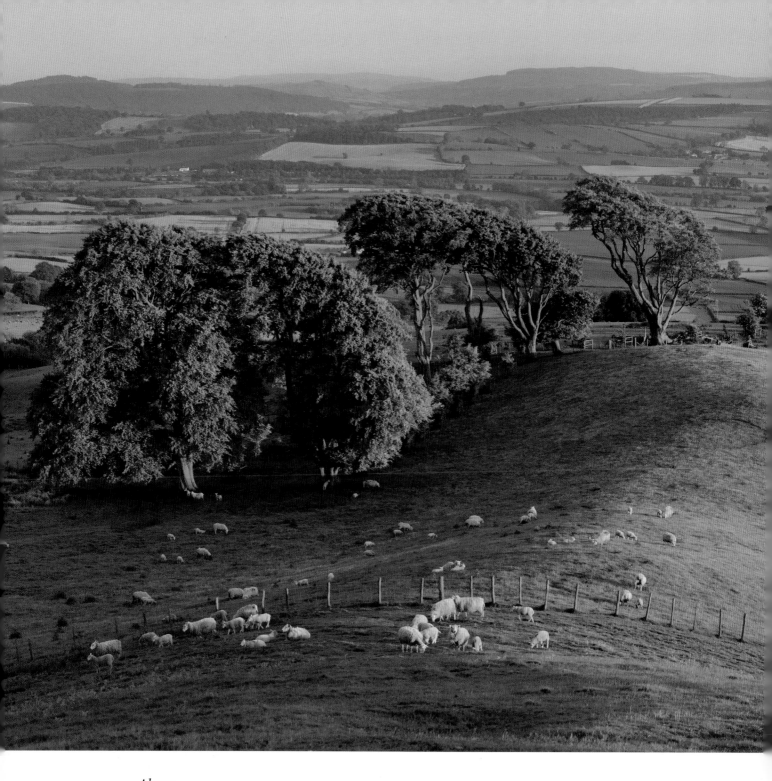

Above
LINLEY HILL. An avenue of mature beech trees stretches along this ridge near Norbury. The trees were planted around 1740 by local MP Robert More, who was a noted amateur botanist. New beeches are being planted as the original ones are nearing the end of their lives.

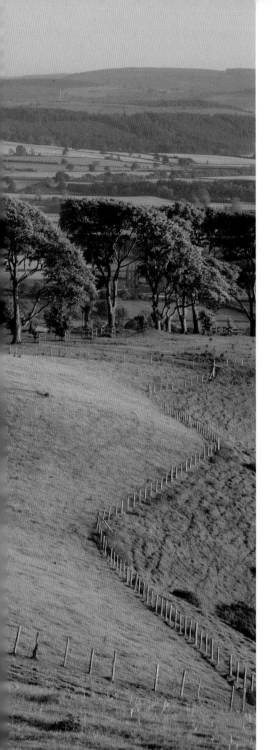

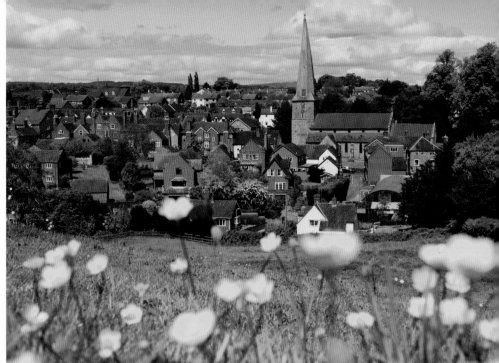

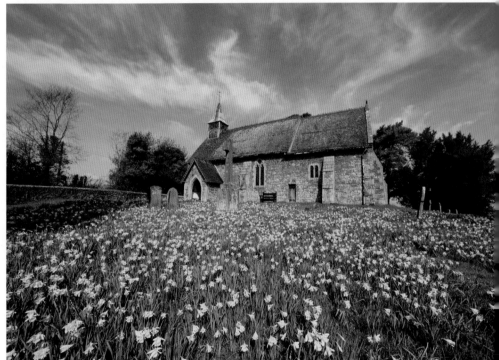

Top right
CLEOBURY MORTIMER. A landmark of this small market town is St Mary's Church
and its crooked spire, which can be dated back to the 13th century.

Bottom right
SMETHCOTT (SMETHCOTE). A sea of daffodils surrounds the Church of St Michael
and All Angels, which has stood on this site since at least the 12th century. It was rebuilt
in 1850 but retains some Norman features.

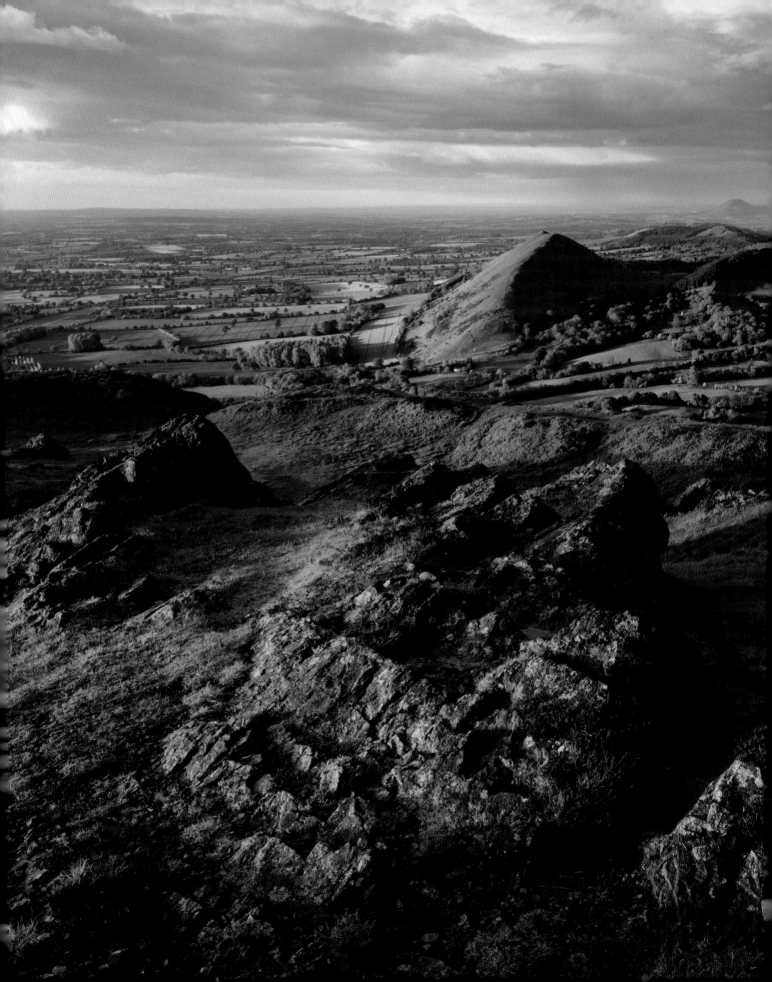

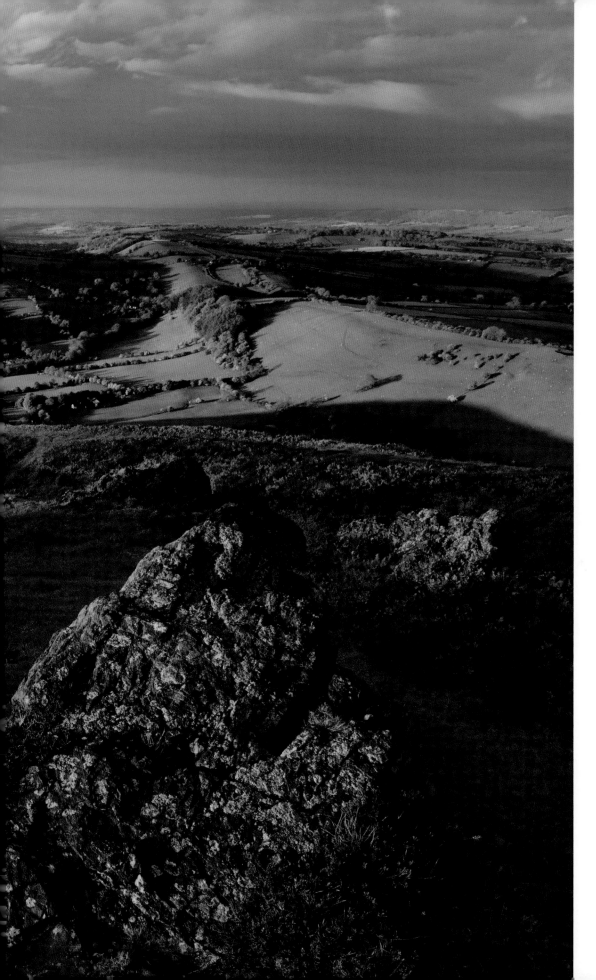

CAER CARADOC

Sunset seen from the Iron Age hill fort on the summit, where it is said that Caractacus may have staged his last stand against the Roman invasion. Immediately beyond the ramparts is the Lawley, with the Wrekin standing out on the horizon.

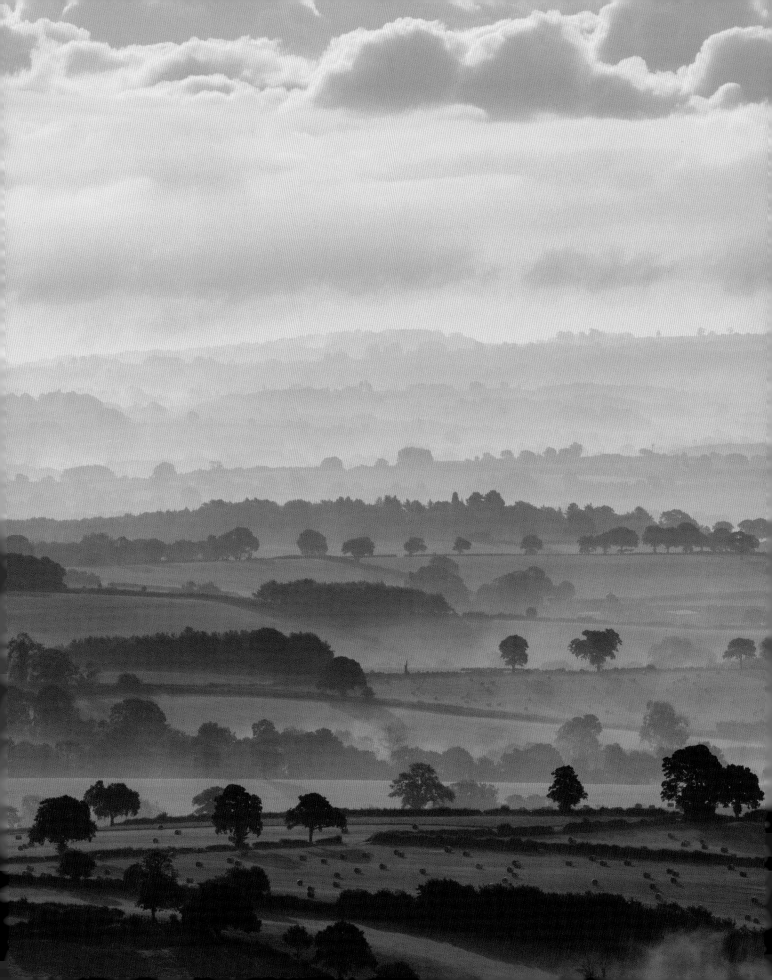

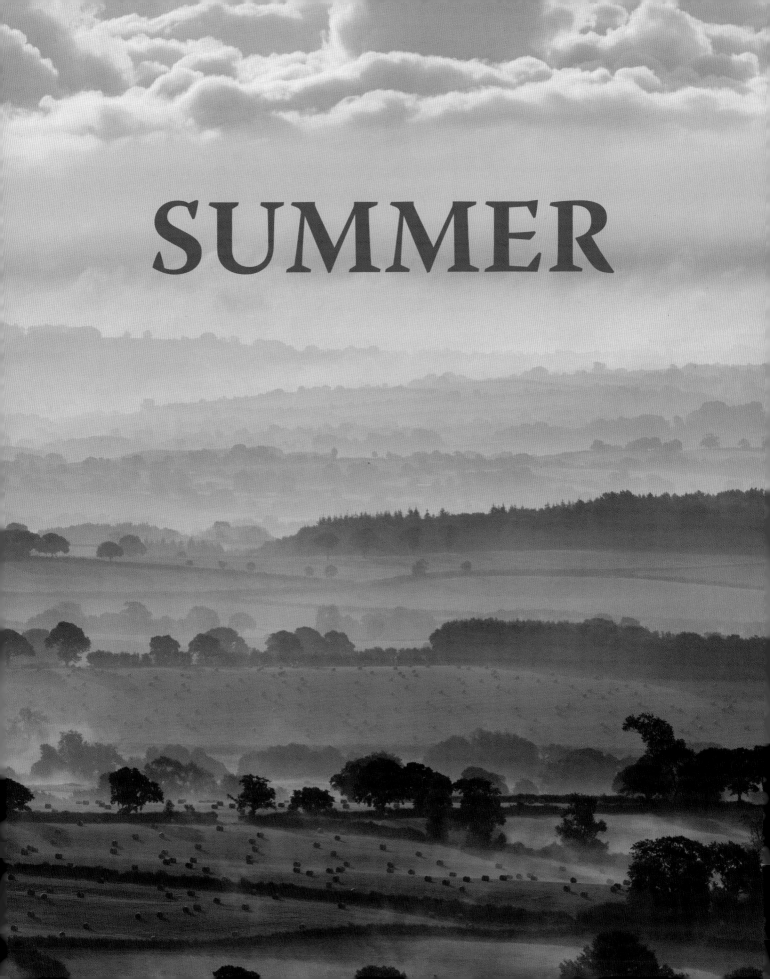

SUMMER

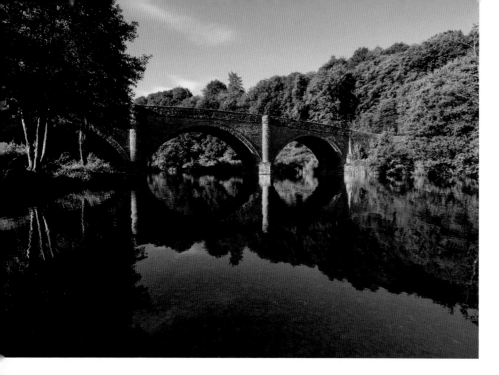

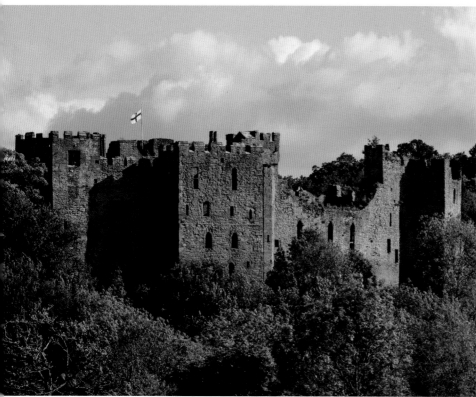

Previous page
BROWN CLEE. Early morning sunshine and shadows near Cleobury North, seen from the lower slopes of the hill.

Above left, top and bottom
LUDLOW. The arches of Dinham Bridge reflected in the River Teme; and the northern side of majestic Ludlow Castle, seen from Coronation Avenue.

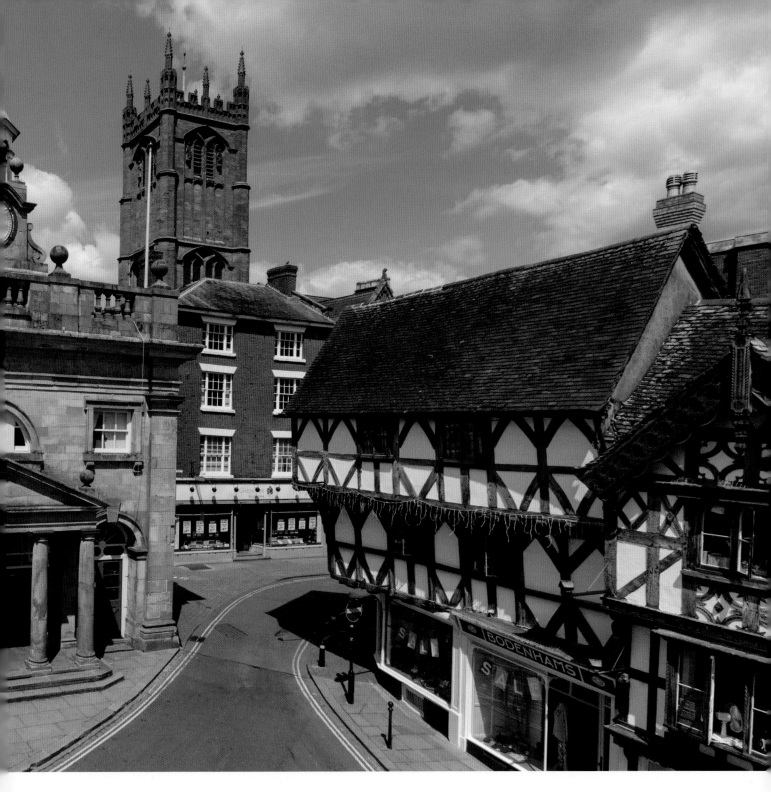

Above

LUDLOW

At the heart of the town is the Buttercross, built as a market hall in 1746 on the site of the High Cross. The ground floor was originally a butter market and is still used by market traders, while the upper floor houses Ludlow Museum.

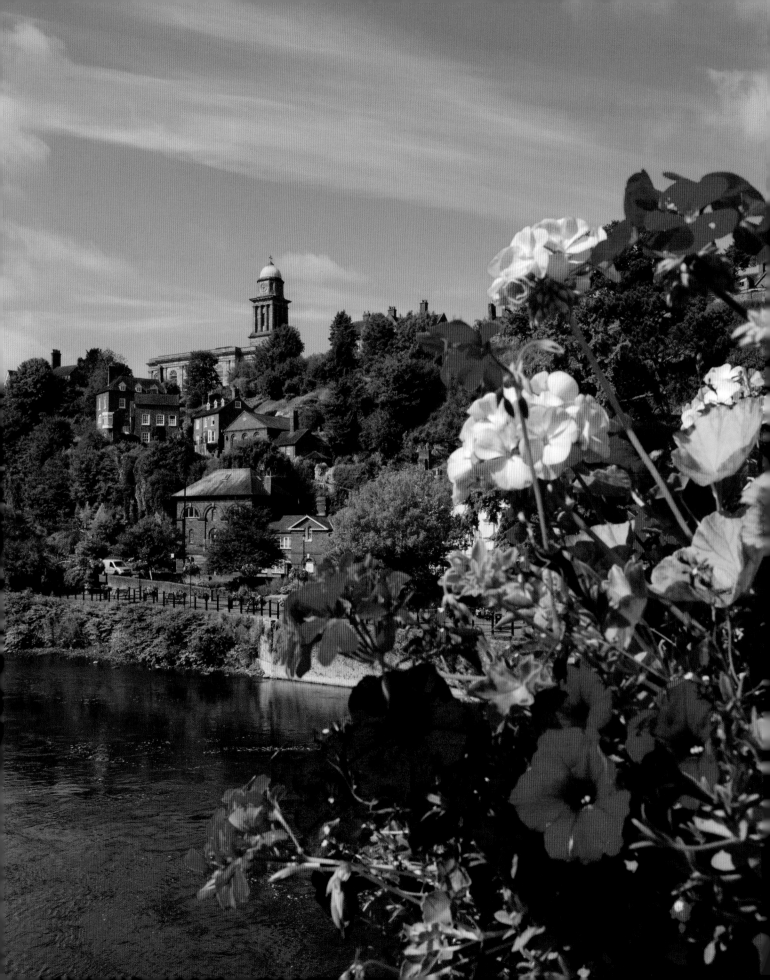

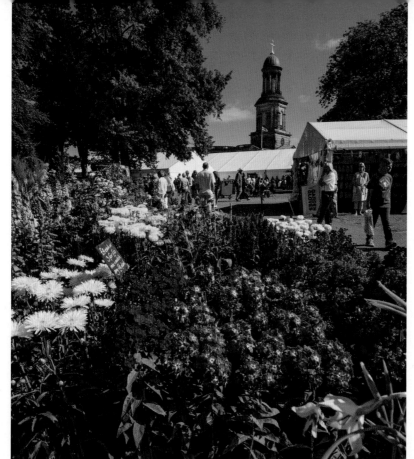

Far left
BRIDGNORTH

Beautiful St Mary's Church, designed by Thomas Telford, dominates the skyline of this busy market town.

Near left
SHREWSBURY

Bright floral displays at the Flower Show, with St Chad's Church seen in the background.

Below
CLAVERLEY

Flowers surround the 14th century stone cross near the entrance to All Saints' Church.

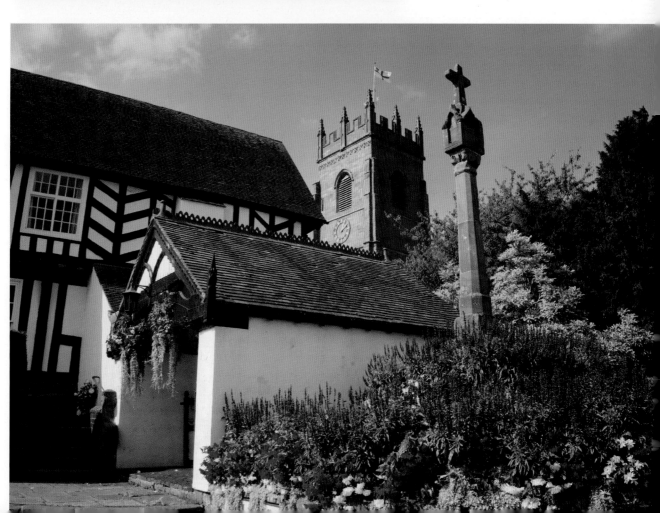

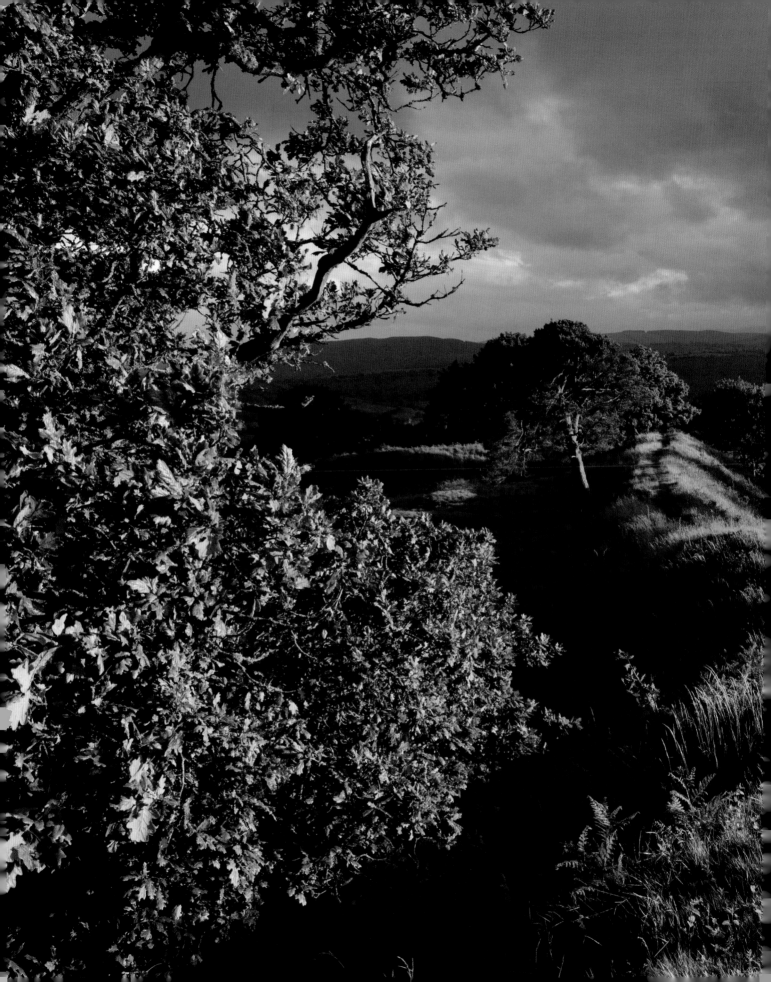

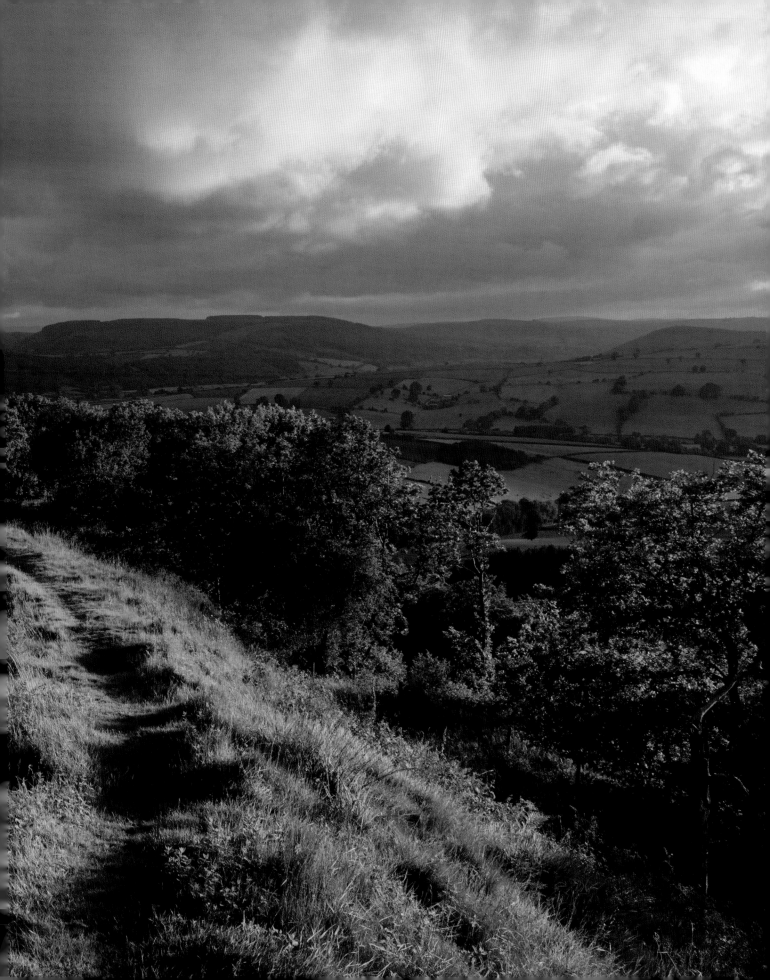

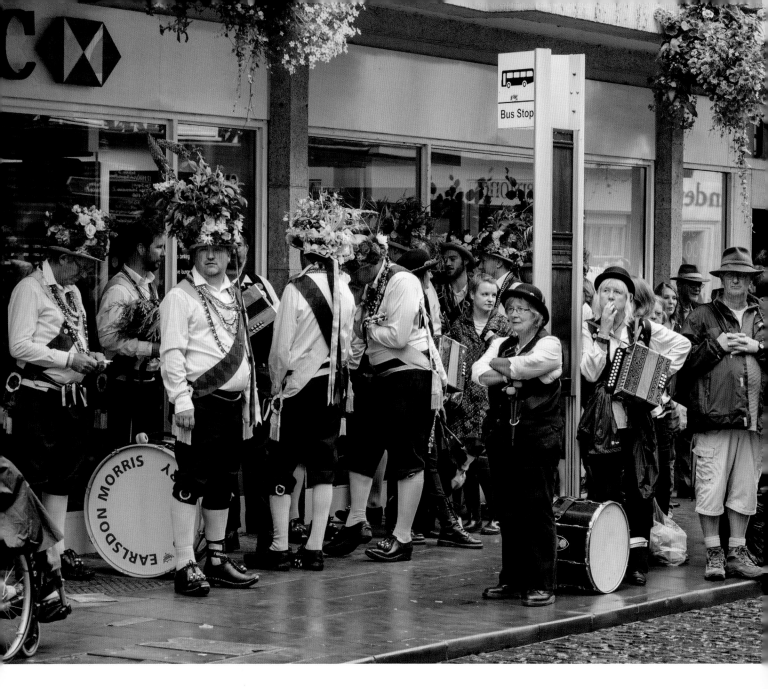

Previous page
BURROW HILL. Evening light picks out a path along the ramparts of the Iron Age hill fort on the summit.

Above and right
SHREWSBURY. A bus queue with a difference in High Street; and time for a nap in the castle grounds.

Right, bottom
SHREWSBURY. Shropshire Bedlams and Martha Rhoden's Tuppenny Dish join the morris dance procession at the annual folk festival.

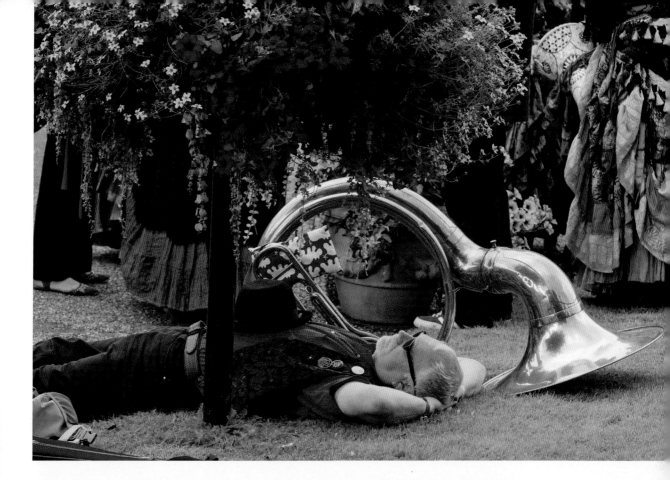
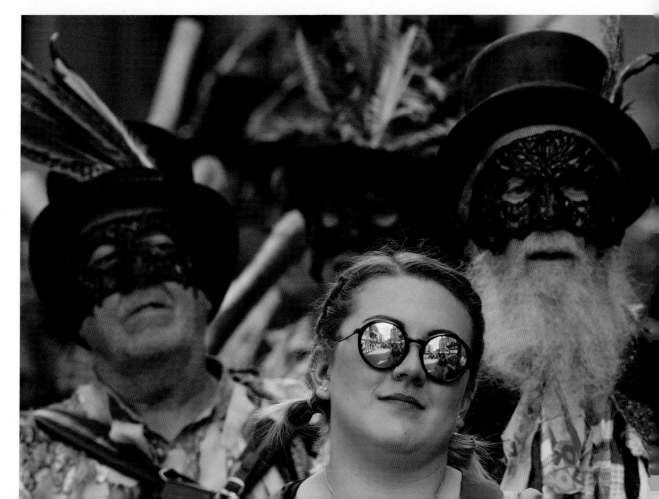

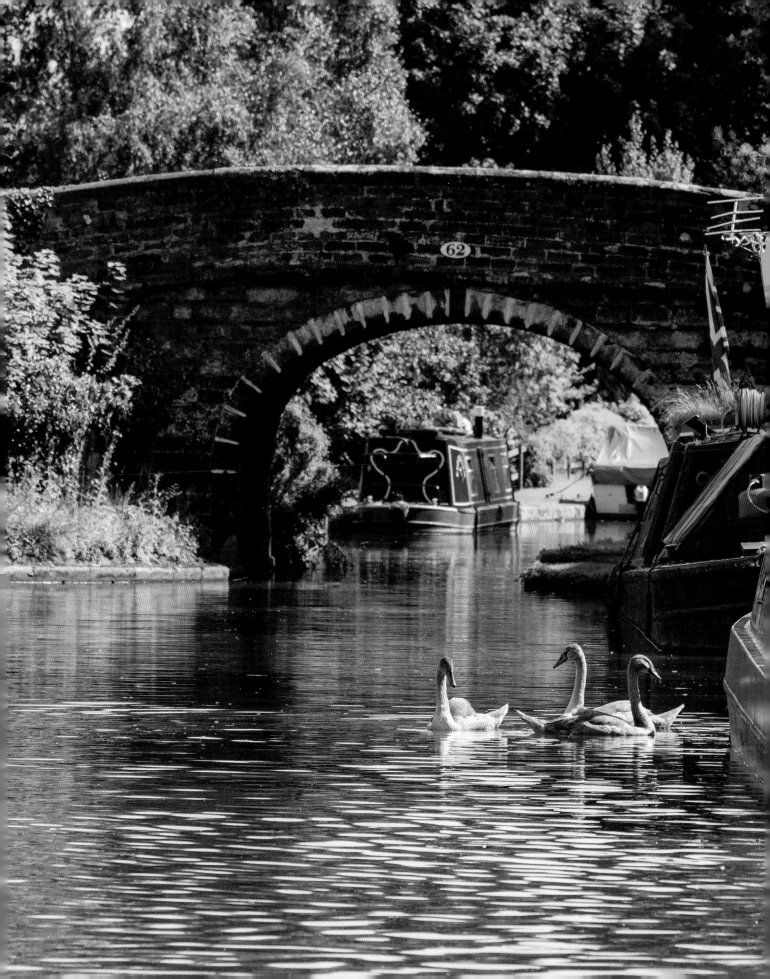

MARKET DRAYTON

A tranquil scene on the Shropshire Union Canal at Talbot Wharf. The 'Shroppie', as it is affectionately known, links the canal system of the West Midlands with the River Mersey and the Manchester Ship Canal at Ellesmere Port.

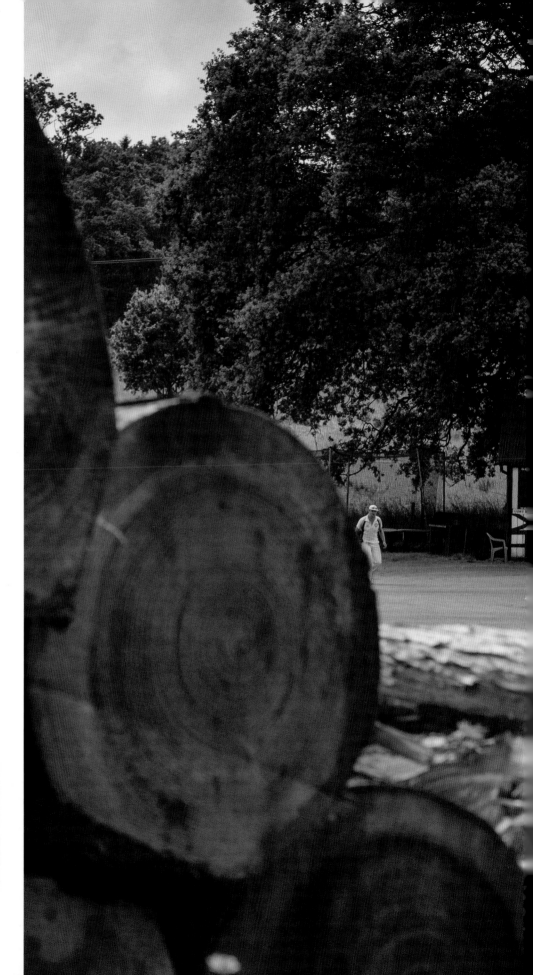

BURWARTON

A cricket match in progress beneath Brown Clee.

Below
GRINSHILL

Fielders look for a lost ball.

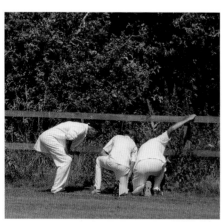

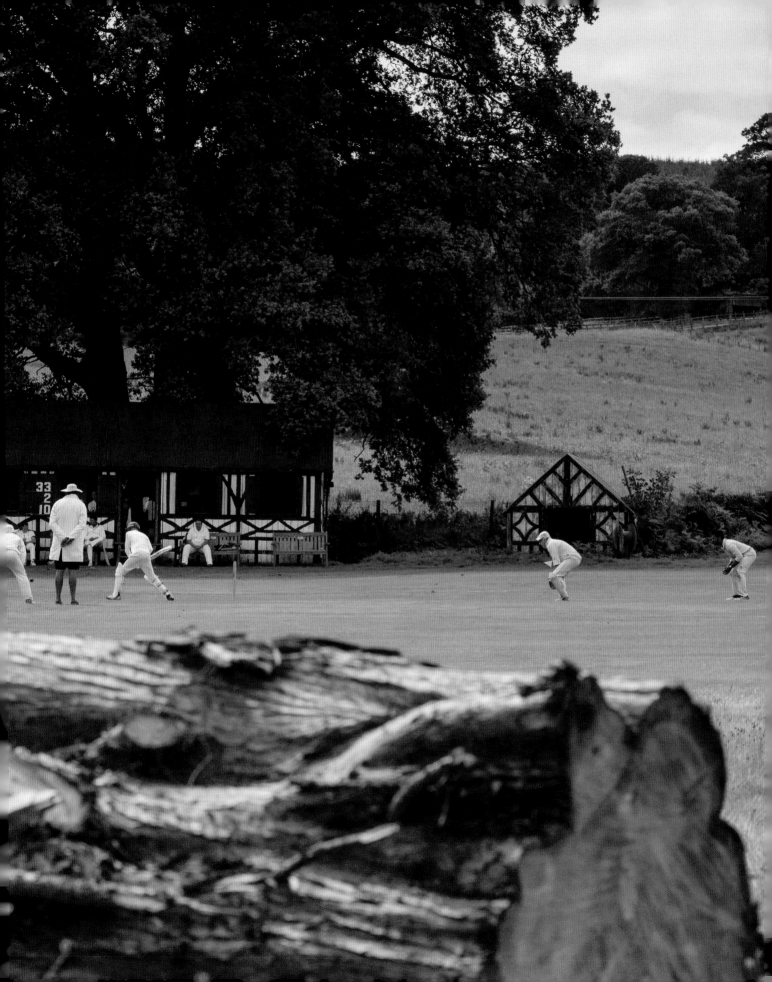

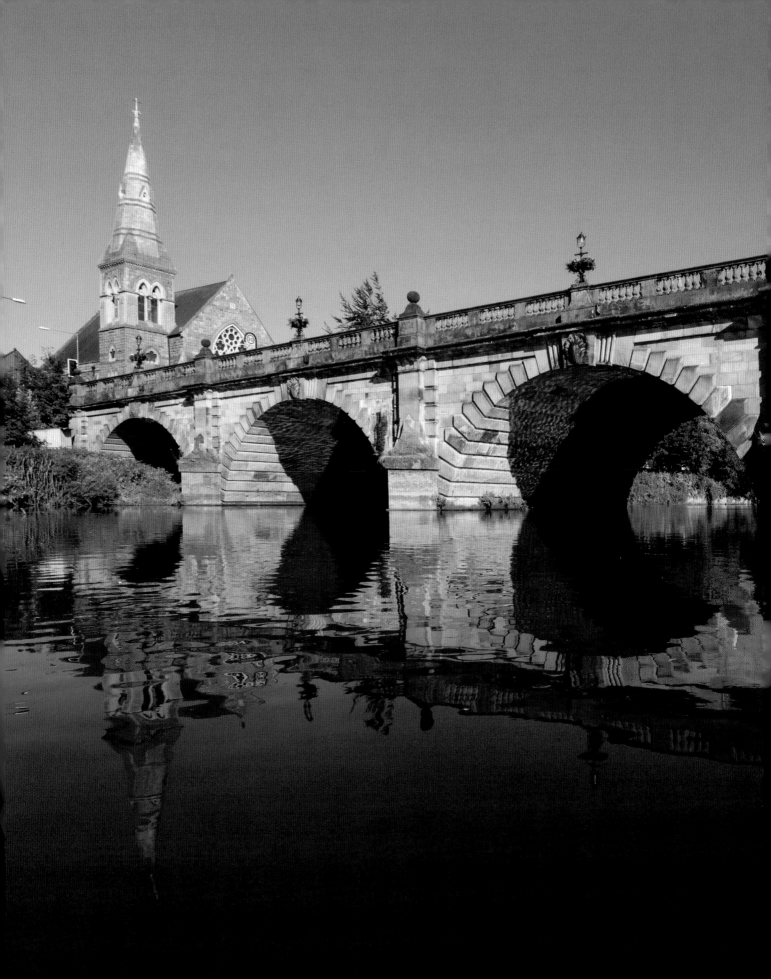

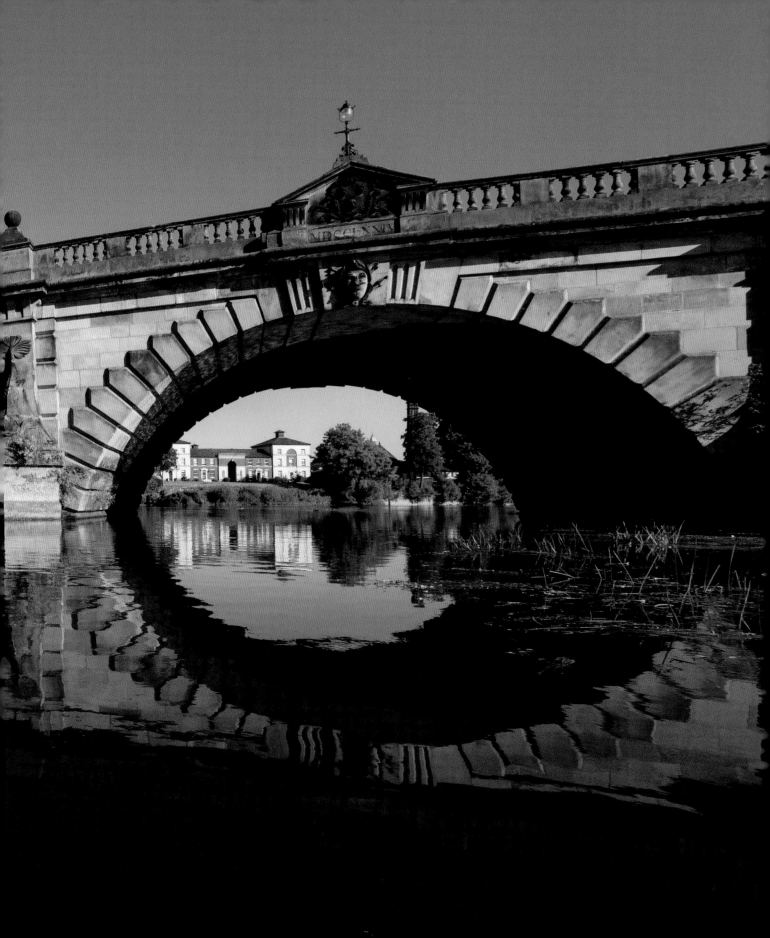

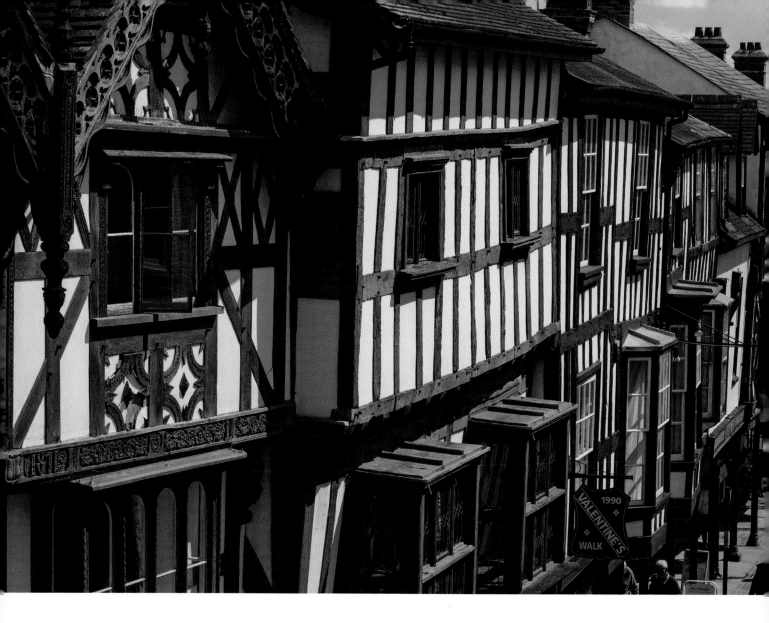

Previous page
SHREWSBURY. The arches of English Bridge reflected in the River Severn.

Above and top right
LUDLOW. A contrast in styles – half-timbered medieval buildings; and Georgian facades – all in Broad Street.

Right
CRAVEN ARMS. A full-size replica of the mammoth skeleton found at Condover in 1986 is housed at the Shropshire Hills Discovery Centre.

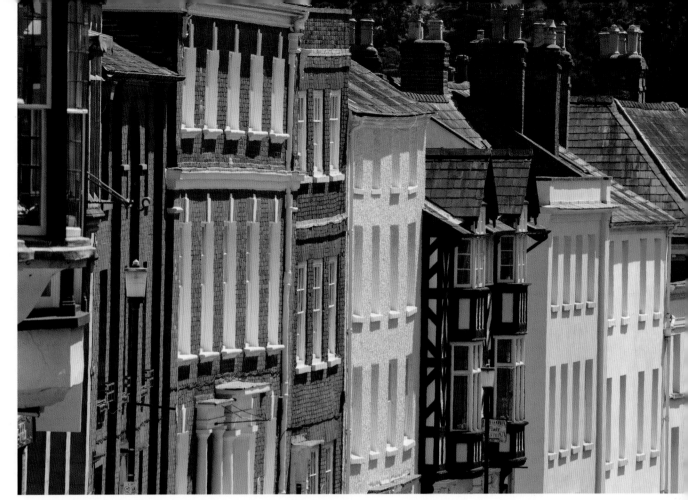
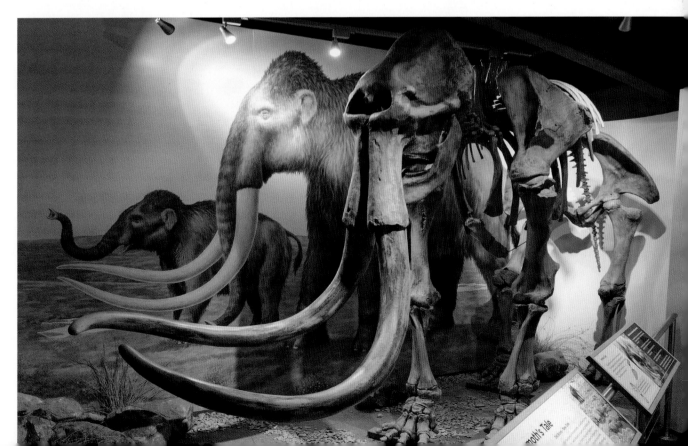

ACTON SCOTT

A step back in time during haymaking at the Acton Scott Historic Working Farm near Church Stretton. Horse and waggoner work in perfect harmony against the beautiful backdrop of Acton Scott Hall, an Elizabethan mansion of 1580.

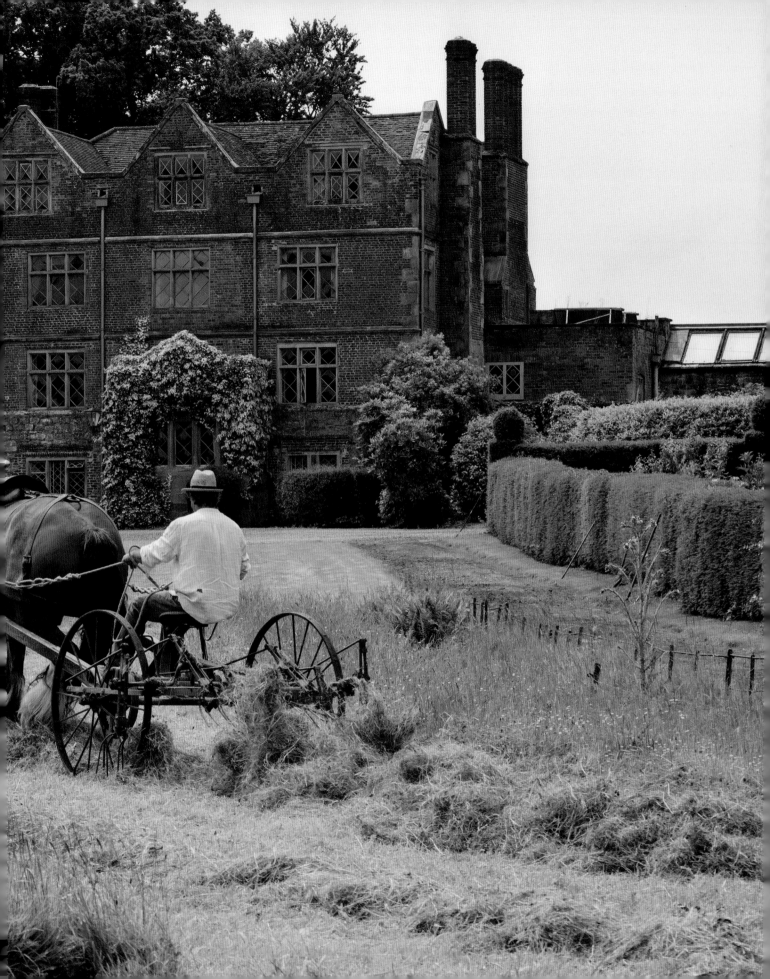

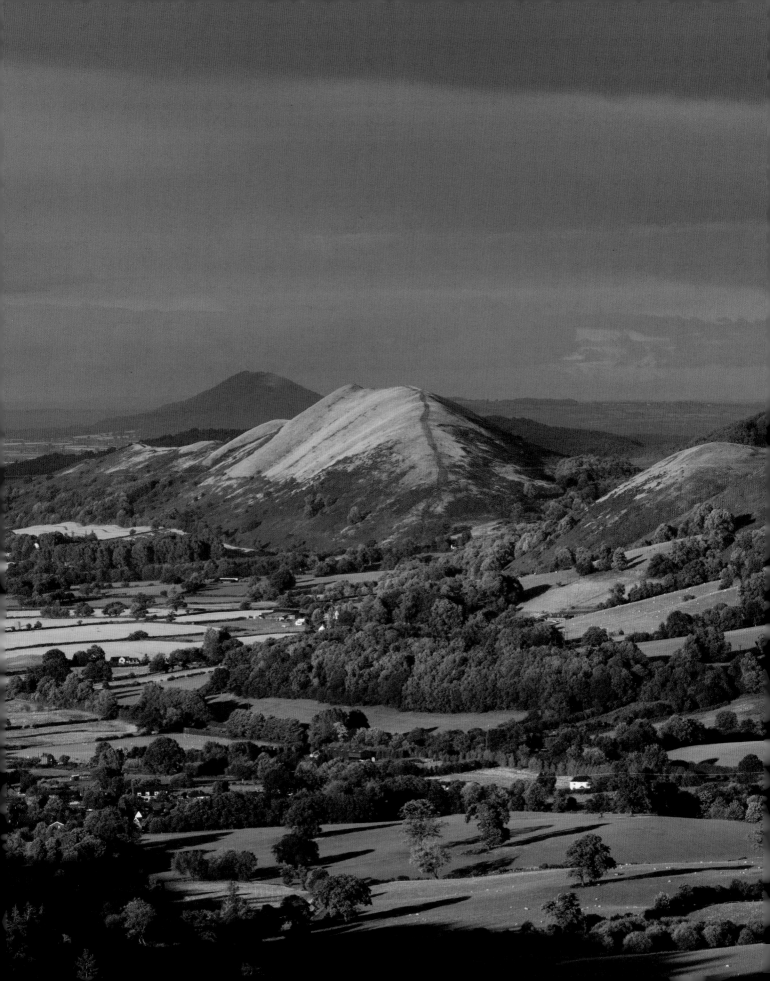

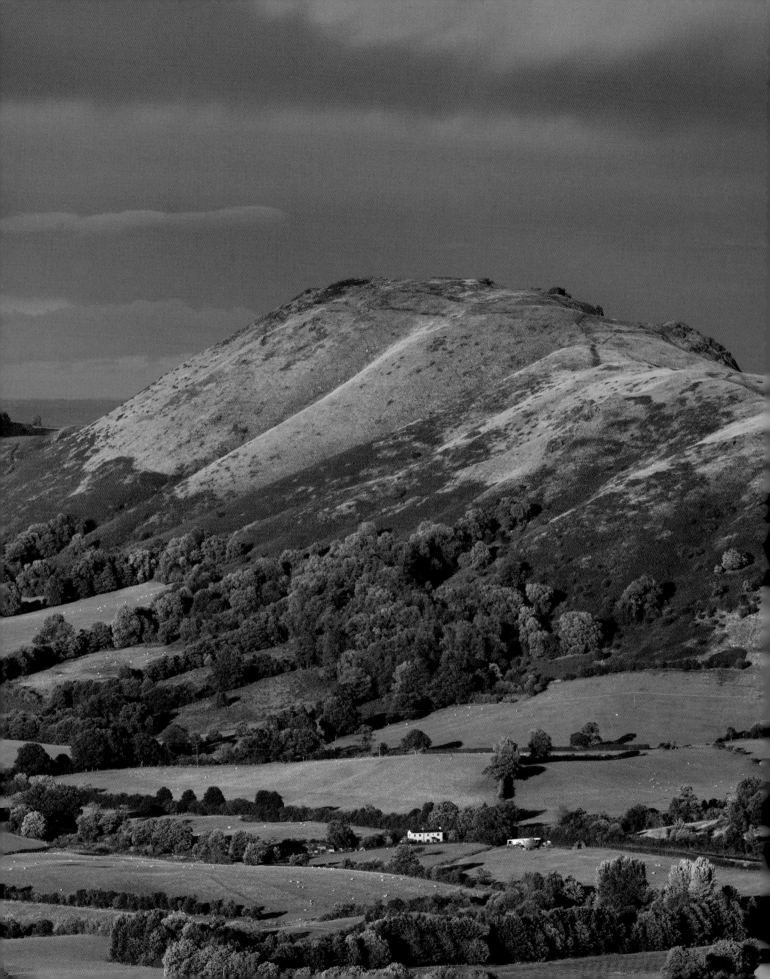

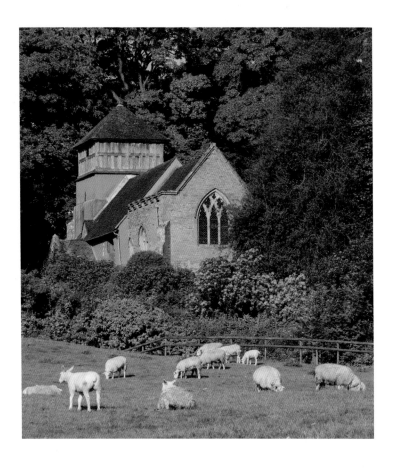

Previous page
THE STRETTON HILLS. Sunshine and dark skies
follow a sudden downpour over Caer Caradoc and
the Lawley.

Above
SHIPTON. The four innocent victims of a family scandal
are commemorated in St James' Church, where they
were all baptised. Katherine More's young children were
banished to America on board the *Mayflower* in 1620 but
only one of them survived.

Right
SHIPTON. Rhododendrons frame beautiful Shipton
Hall in this small village near Much Wenlock.
The hall was built around 1587 to replace a much older
house that was destroyed by fire.

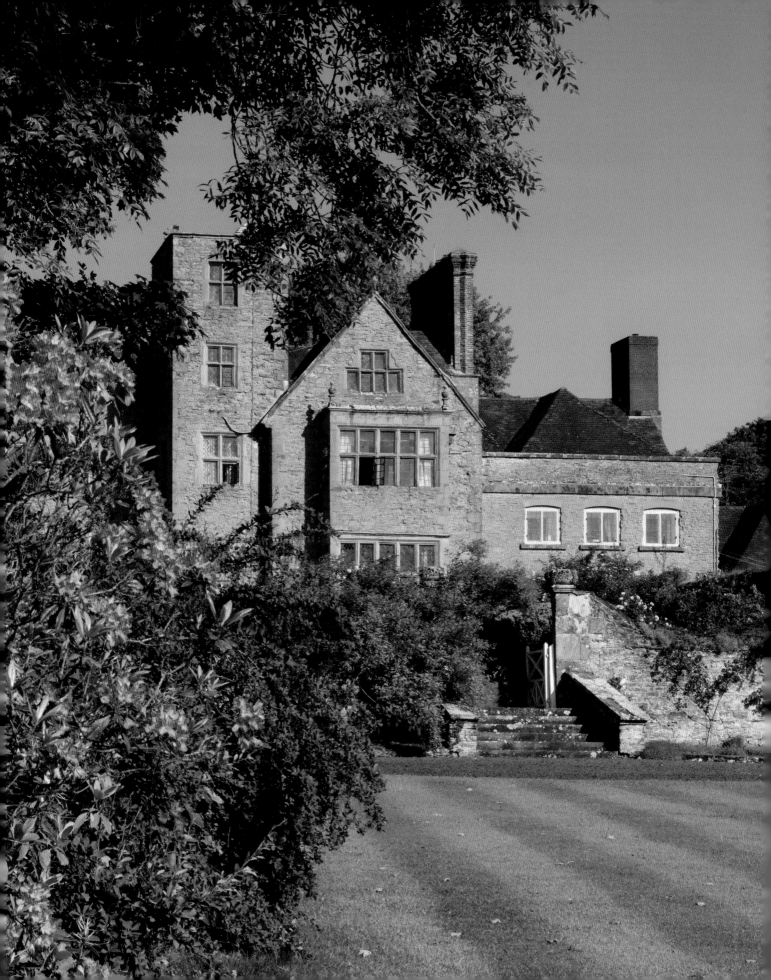

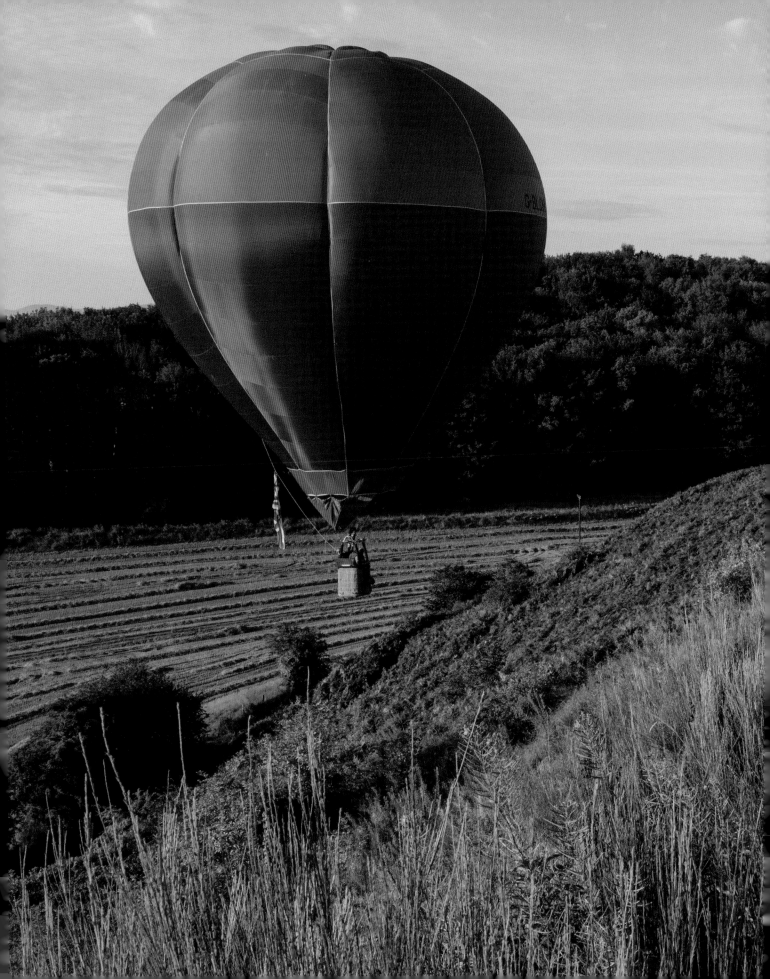

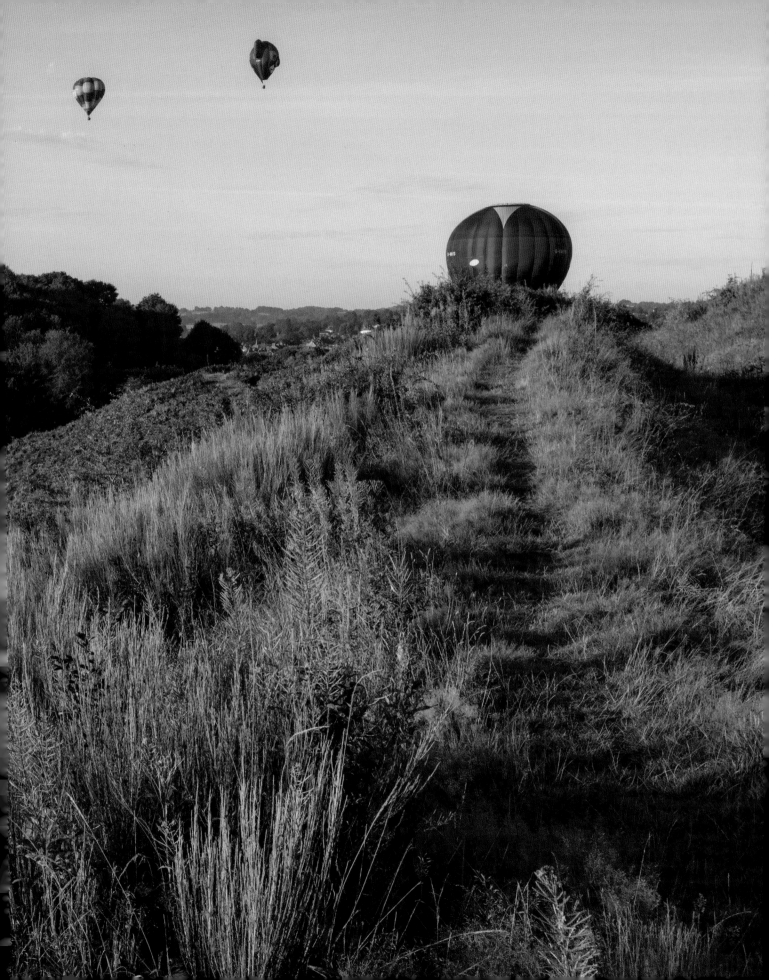

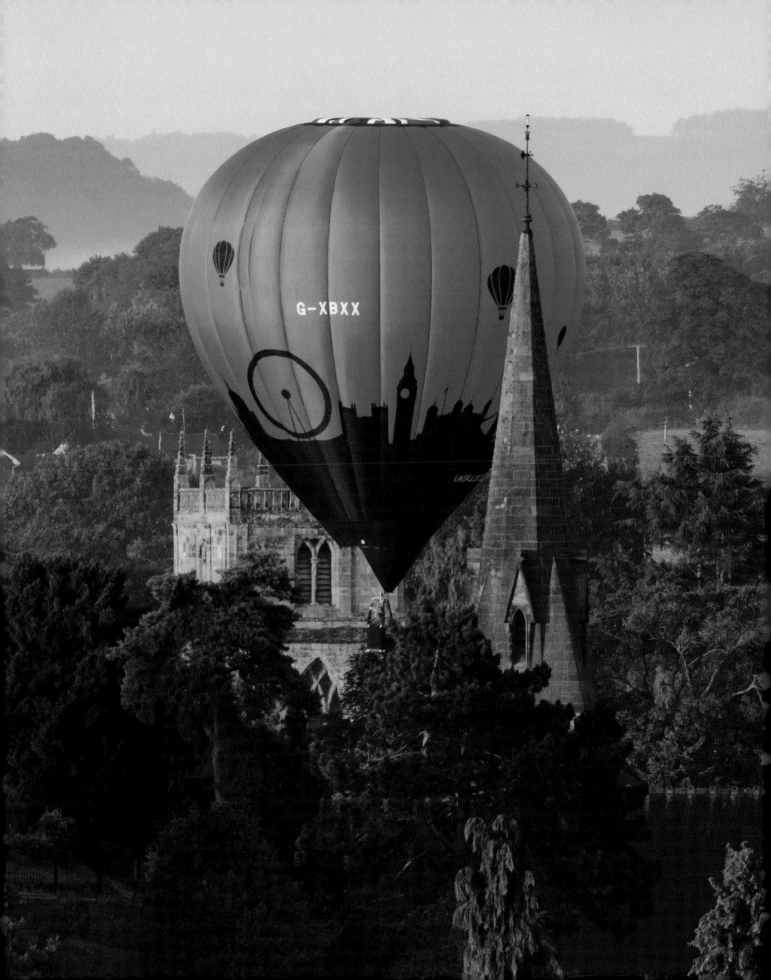

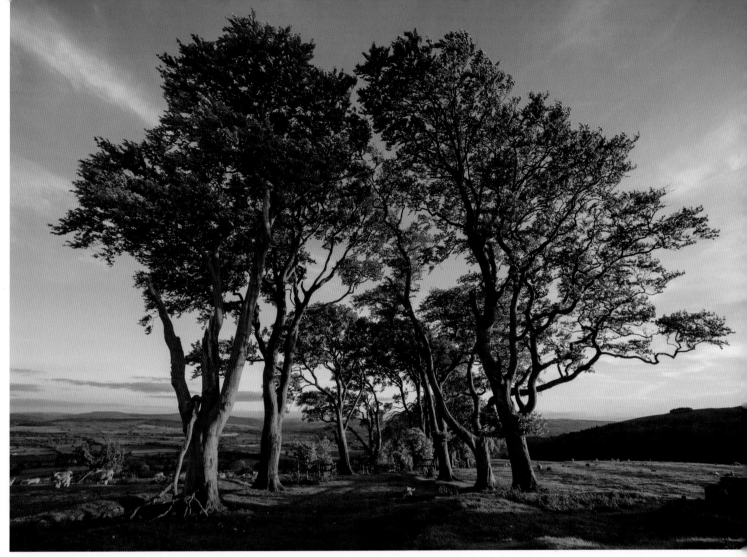

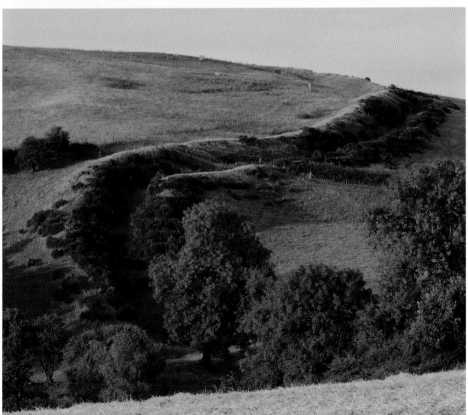

Previous page and far left
OSWESTRY. Hot air balloons hover over Old Oswestry hill fort and move majestically between St Oswald's Church and Christ Church.

Above
LINLEY HILL. Golden light at sunset picks out the beech trees near the summit.

Left
NEWCASTLE ON CLUN. Offa's Dyke snakes its way across the landscape. This earthwork was constructed in the 8th century on the orders of Offa, king of Mercia, and roughly follows England's border with Wales.

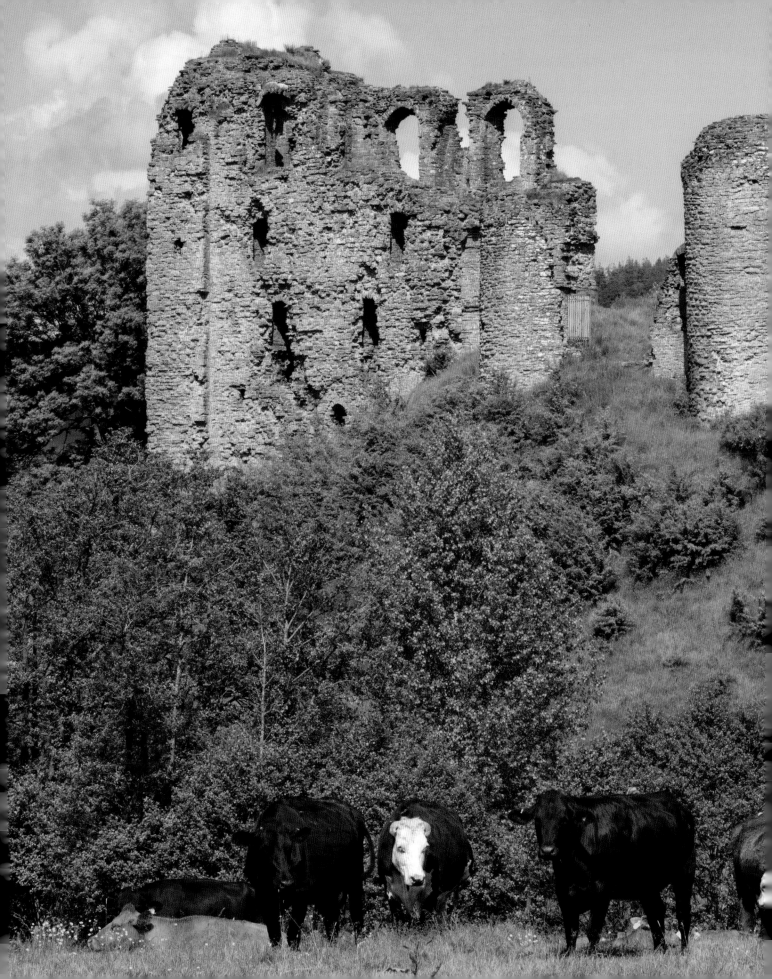

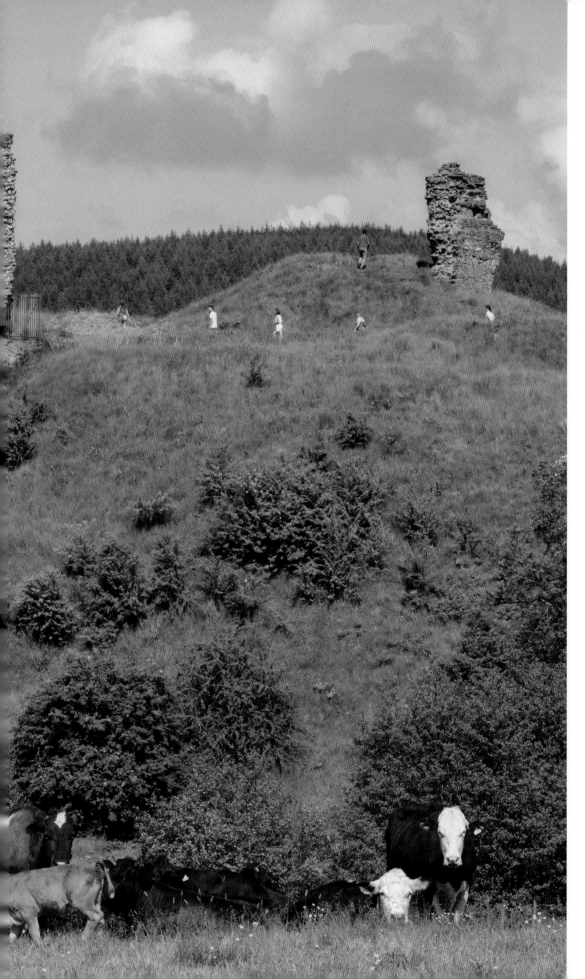

CLUN

The castle was founded shortly after the Norman Conquest and sits high on a rocky mound above the town. This romantic ruin is thought to have inspired the fortress known as Garde Douloureuse in Sir Walter Scott's novel *The Betrothed*, which he wrote while staying in Clun.

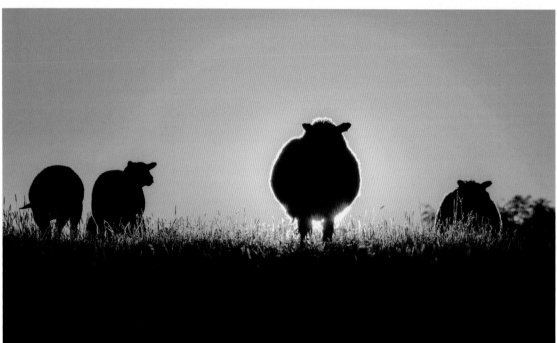

Above, top: SHREWSBURY. The view at sunrise from near Shrewsbury School. From left are St Chad's Church, the Market Hall and St Mary's Church, which at 138ft has one of the tallest spires in England.

Above, bottom: CLUNTON. Sheep silhouetted against the setting sun near this hamlet in the Clun Valley.

Right: THE LONG MYND. A spectacular sunset reflected in a pool at Pole Bank, which is the highest point on this heath and moorland plateau.

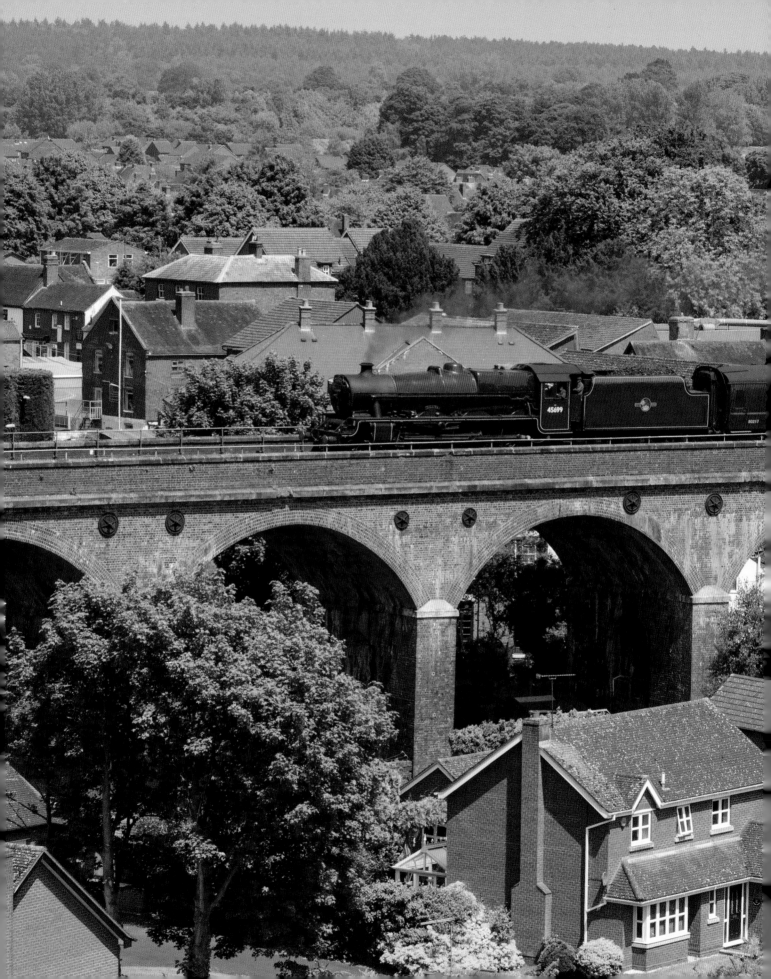

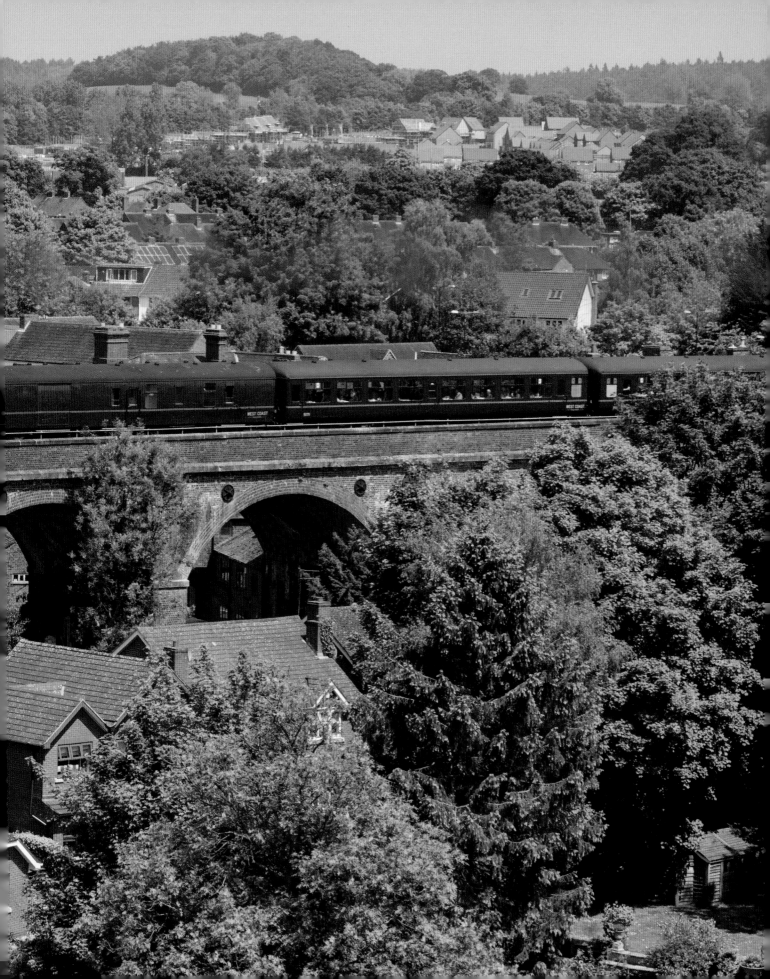

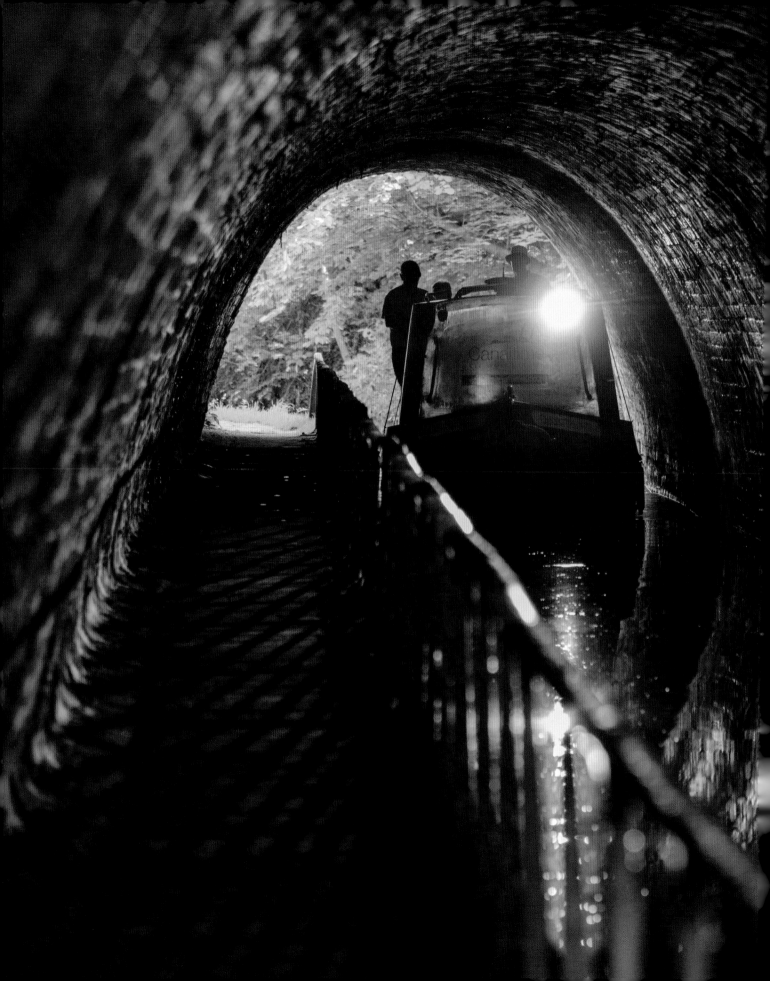

Previous page
SHIFNAL

Steam locomotive *Galatea* powers across the viaduct, seen from the tower of St Andrew's Church.

Left
ELLESMERE

A narrowboat makes its way through a tunnel on the Llangollen Canal, which crosses the border between England and Wales. The canal links Llangollen in Denbighshire with Hurleston in Cheshire, passing through Ellesmere and Whitchurch.

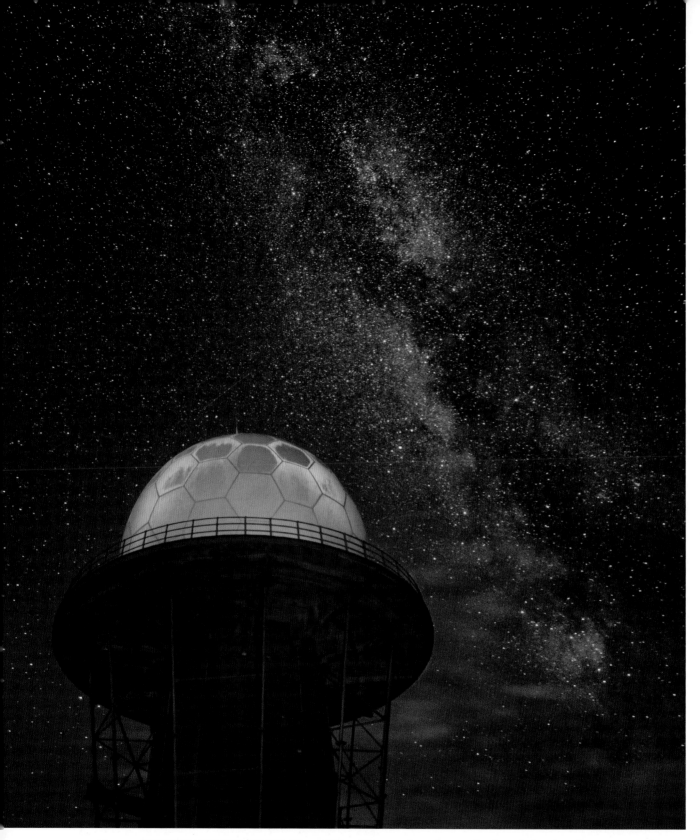

Above: TITTERSTONE CLEE. The Milky Way arches through the night sky above one of the radar domes on the summit.

Right: FLOUNDERS' FOLLY. This landmark stone tower stands 80 feet above Callow Hill, near Craven Arms. It was built in 1838 by Benjamin Flounders and offers wonderful views of the Malverns, the Black Mountains and Cader Idris.

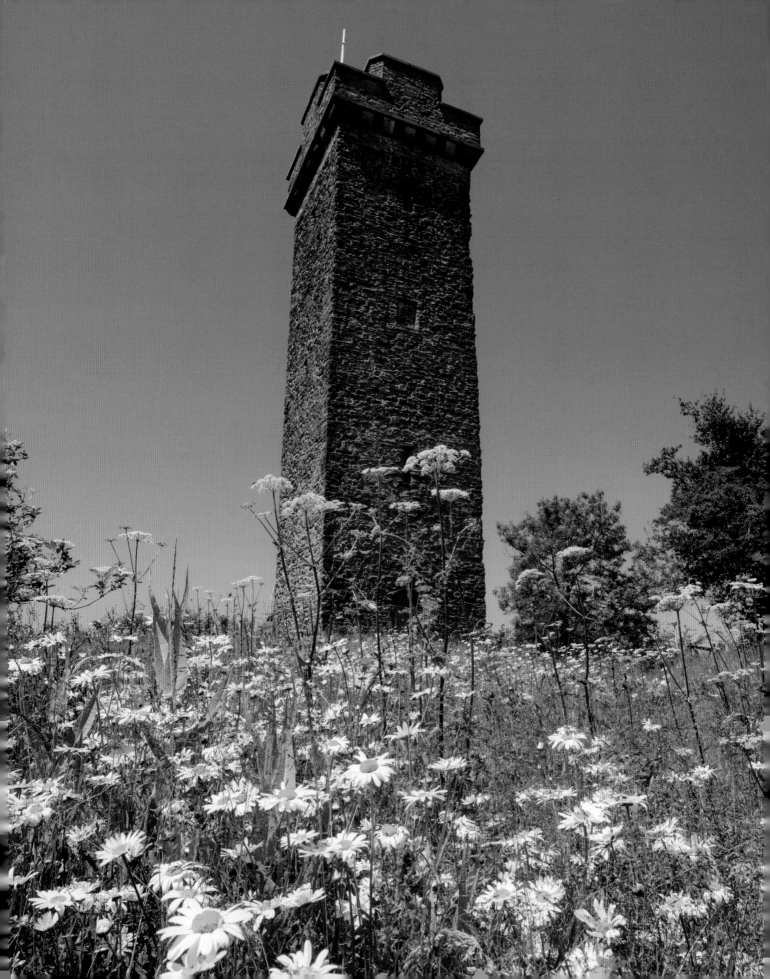

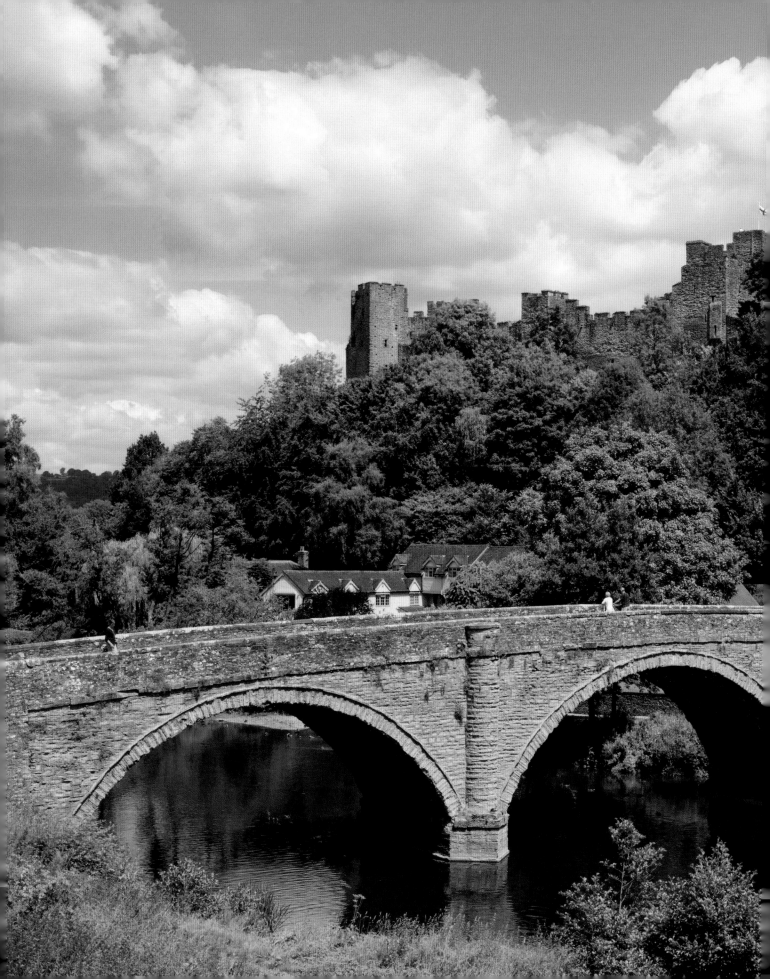

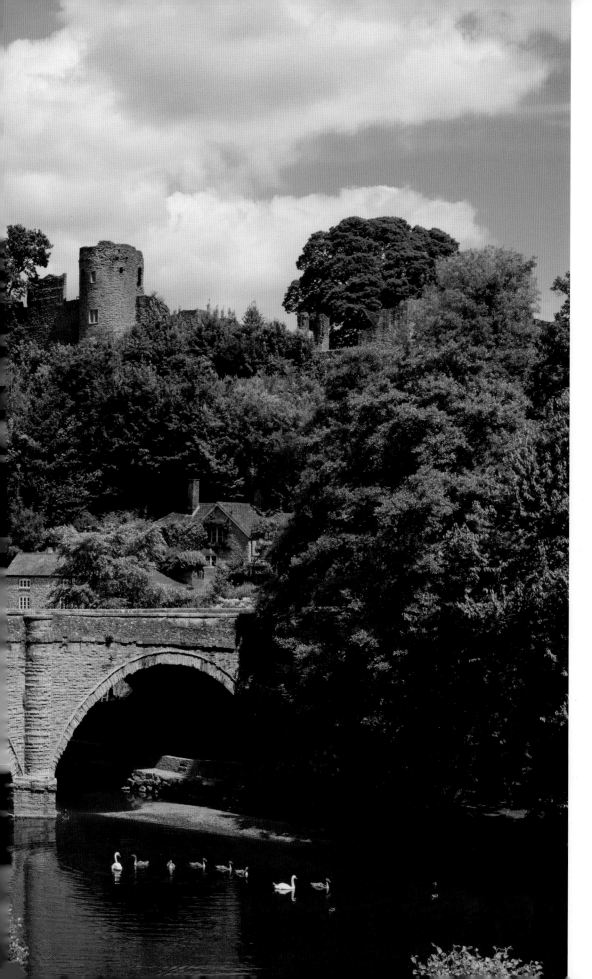

LUDLOW

A family of swans on the River Teme at Dinham Bridge, with the castle's towers and battlements rising above the trees. The bridge is believed to have been built in 1823, replacing a much older structure.

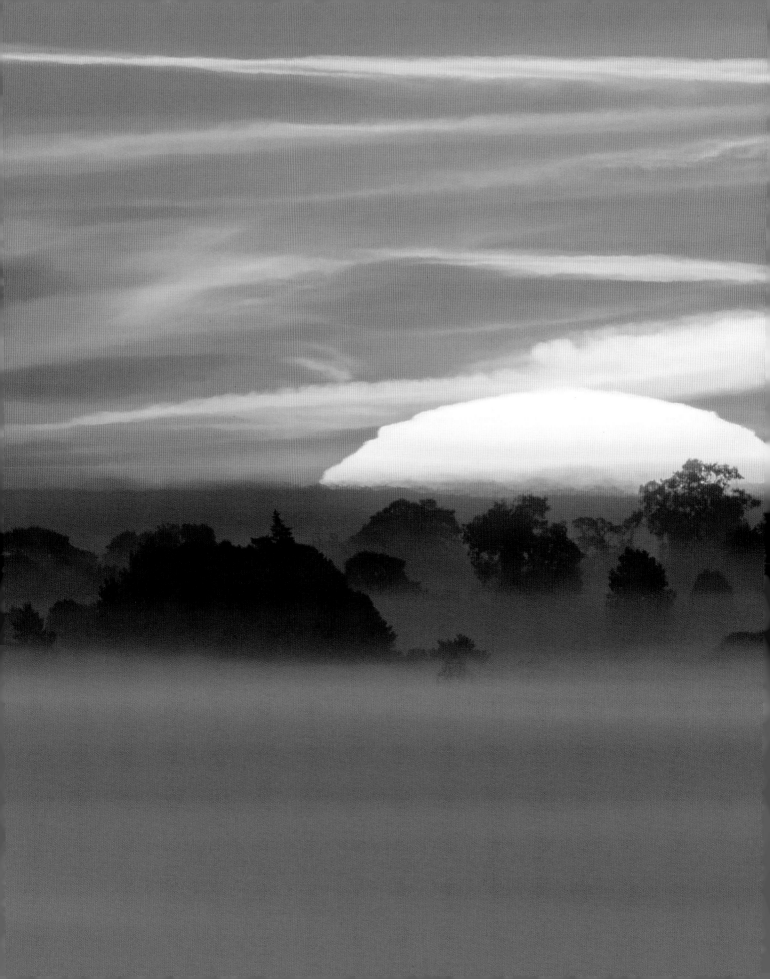

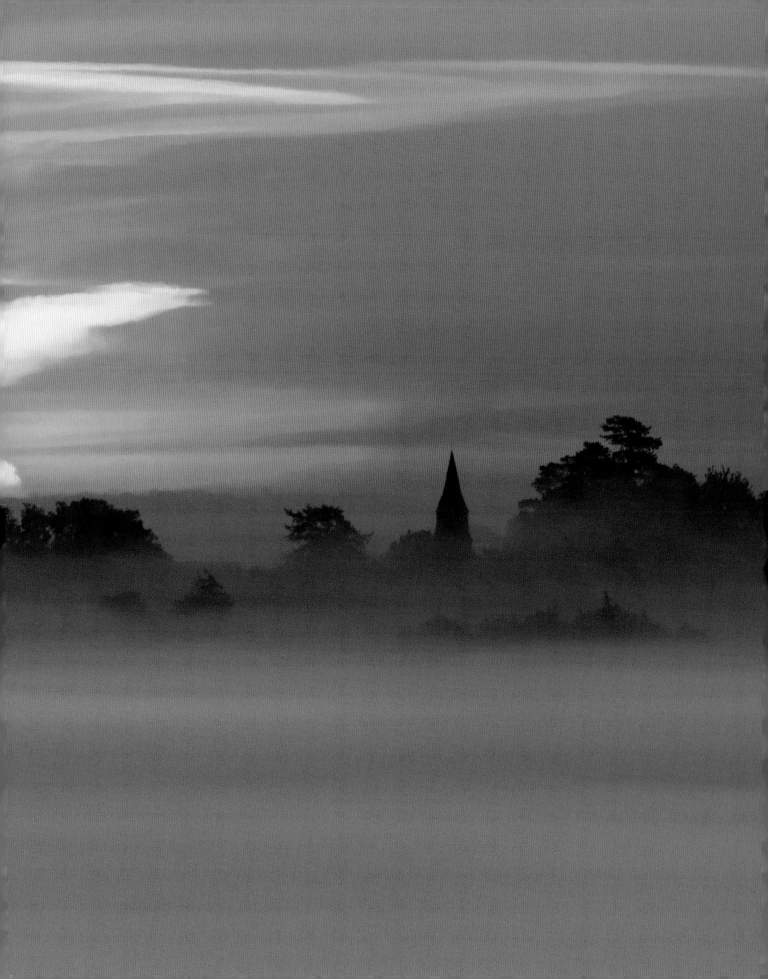

Previous page
WELSH FRANKTON

The spire of St Andrew's Church emerges above the mist at sunrise, seen from Old Oswestry hill fort.

Right
SHREWSBURY

St Julian's Church and historic Fish Street, which takes its name from the open air fish market held here until Victorian times. Thomas Farnolls Pritchard, who designed the Iron Bridge, was born in Shrewsbury and baptised at St Julian's in 1723.

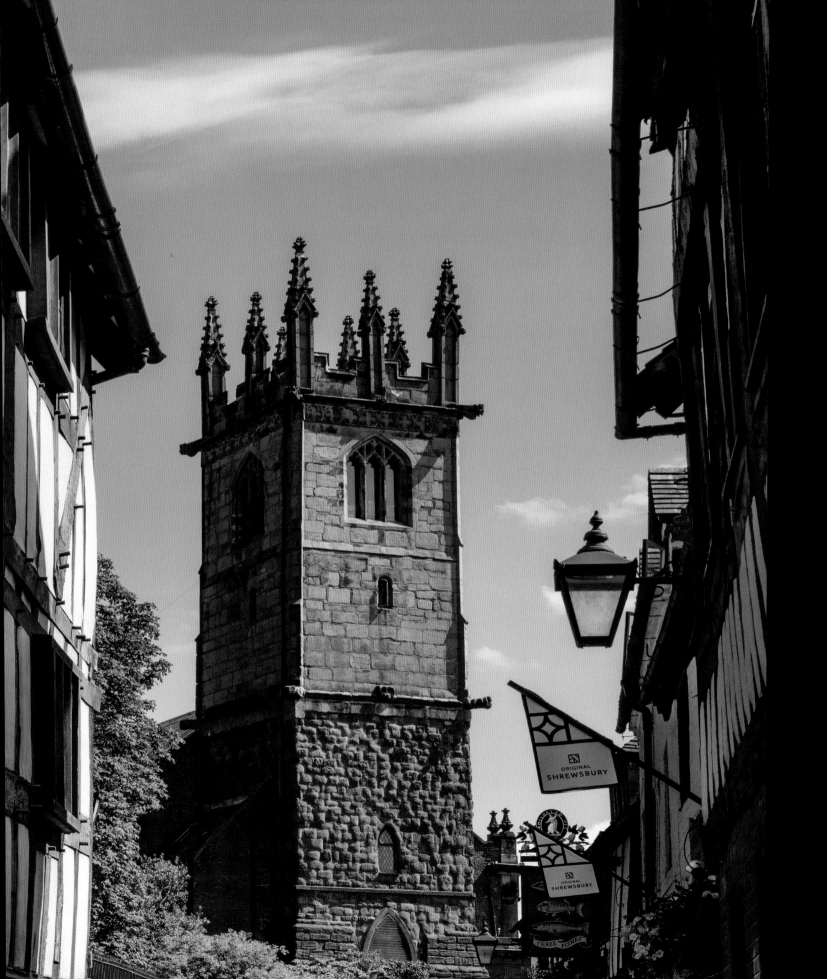

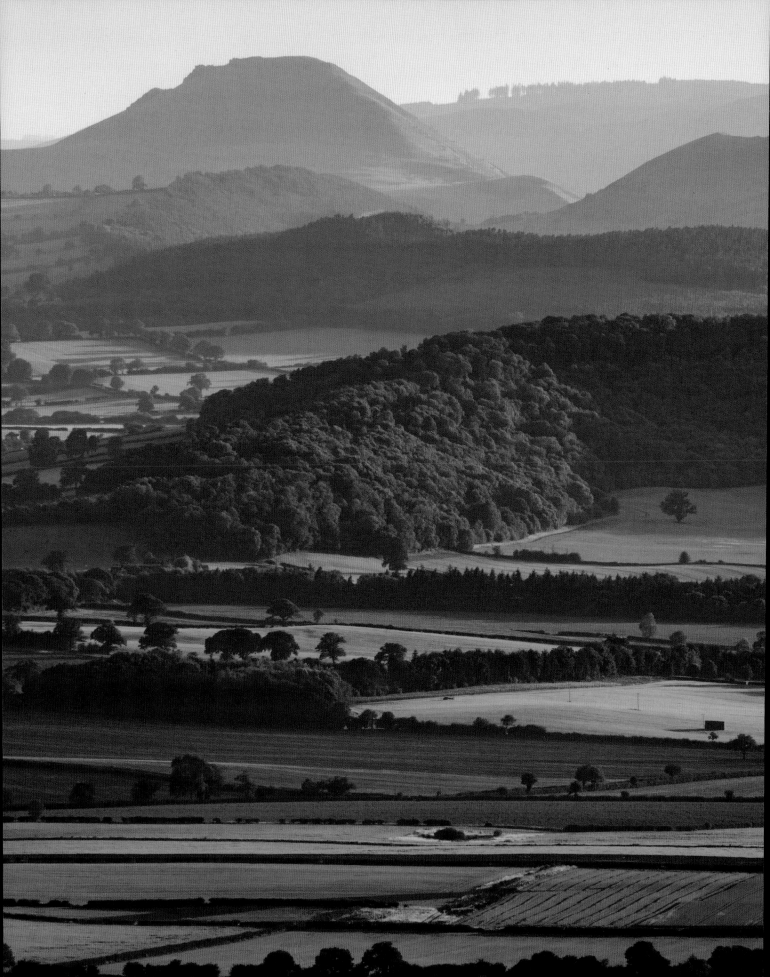

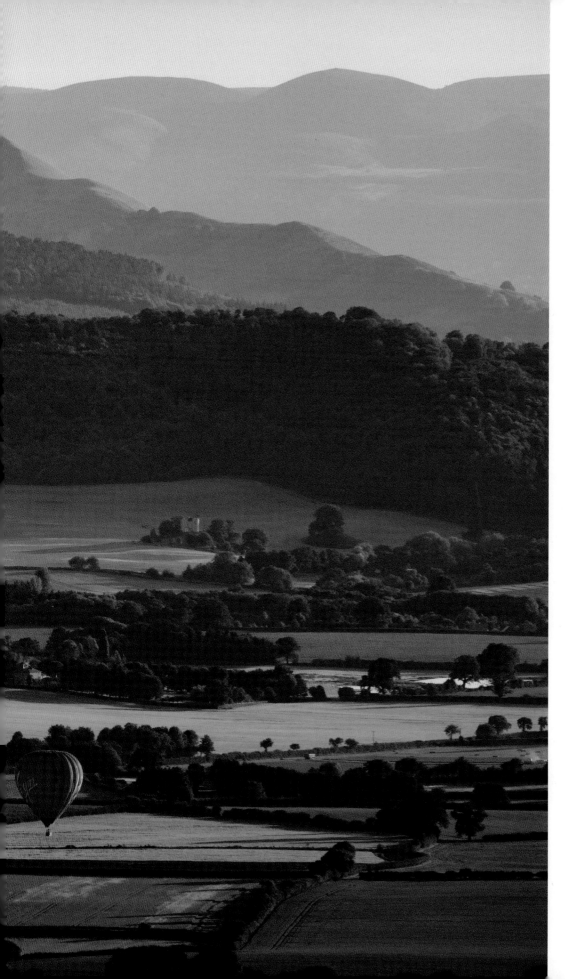

THE STRETTON HILLS

Fields beneath the Wrekin bathed in golden evening light as a hot air balloon comes in to land.
Caer Caradoc is on the left and the Lawley to the right, with the Long Mynd seen in the distance.
The woodland is Park Wood which encloses Cronkhill Castle, part of the Attingham estate.

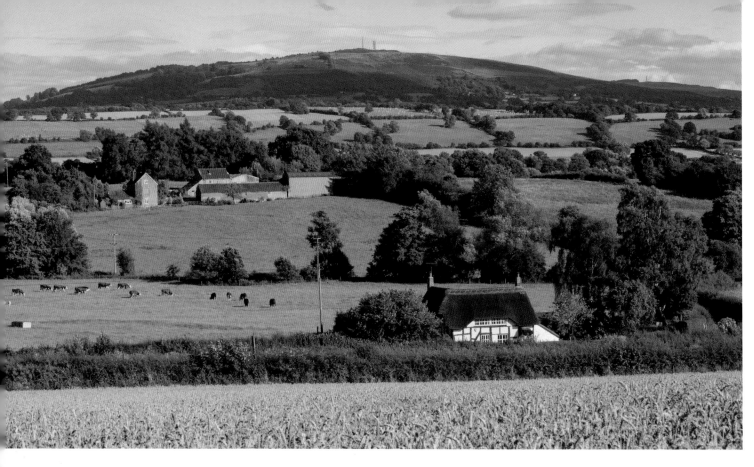

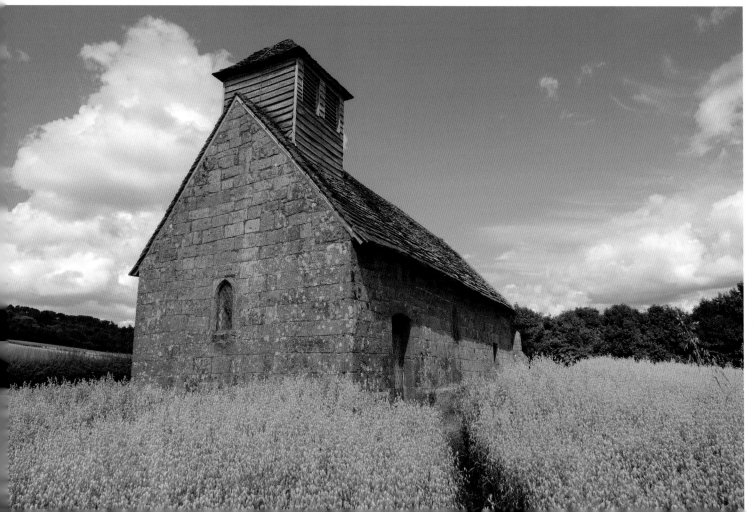

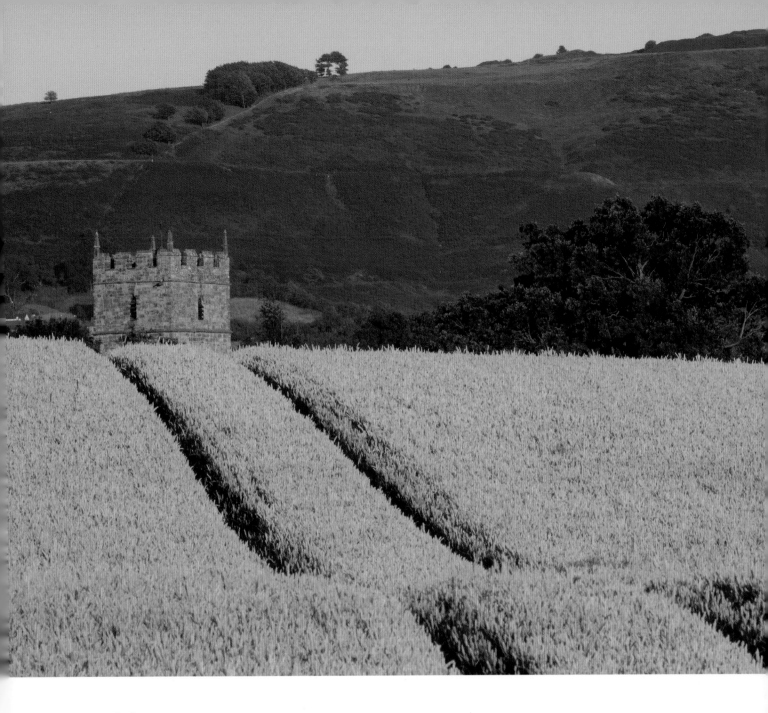

Left, top
SHIPTON. A thatched cottage nestles beneath Brown Clee, which is the highest summit in Shropshire.

Left, bottom
LANGLEY. This beautiful little chapel, set in tranquil countryside near Acton Burnell, dates from the early 14th century. The last regular church service was held here in 1871.

Above
HOLDGATE. The tower of Holy Trinity Church stands out above a field of gold beneath Brown Clee.

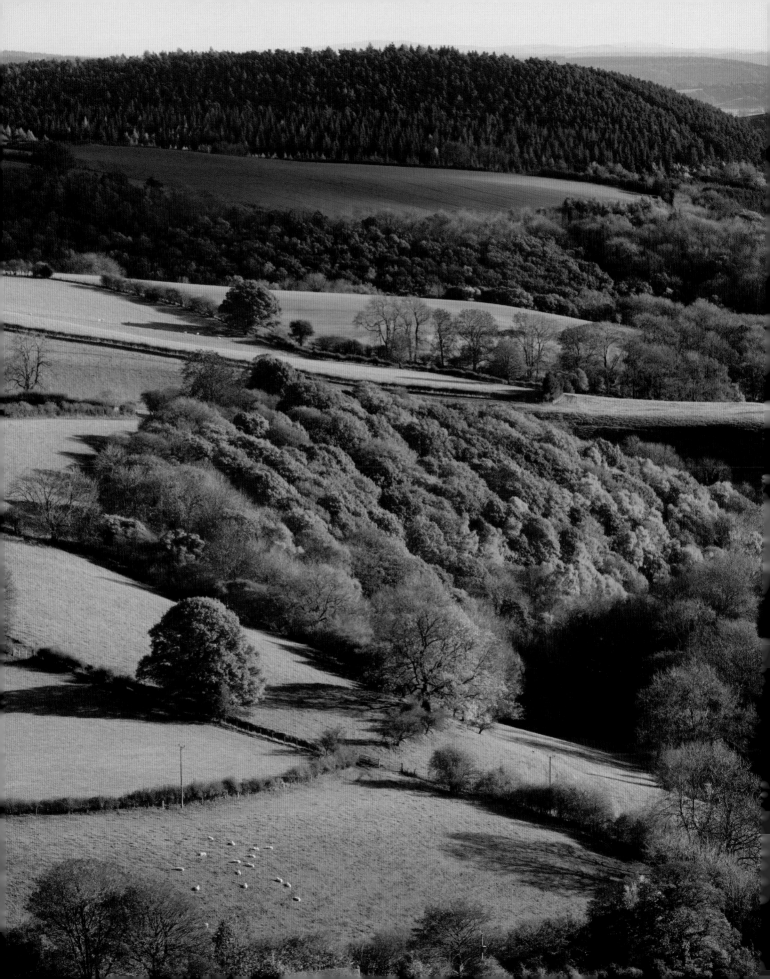

AUTUMN

Previous page
CLUN VALLEY. Autumn colours highlight this undulating landscape near the Welsh border.
In the foreground can be seen the hamlet of Obley, which was once known as Obelie. This is the view from Black Hill.

Above
SHREWSBURY. Autumn colour in the Dingle, the beautiful sunken garden at the heart of
The Quarry.

Right, top
WEM. A feast for the senses at the Sweet Pea Festival. The first modern sweet peas were cross-bred in 1887 by Henry Eckford, who lived in Wem.

Right, bottom
BROOK VESSONS. An inviting pathway leads through this hauntingly beautiful nature reserve on the Stiperstones, which includes the remains of smallholdings that once belonged to lead miners and their families.

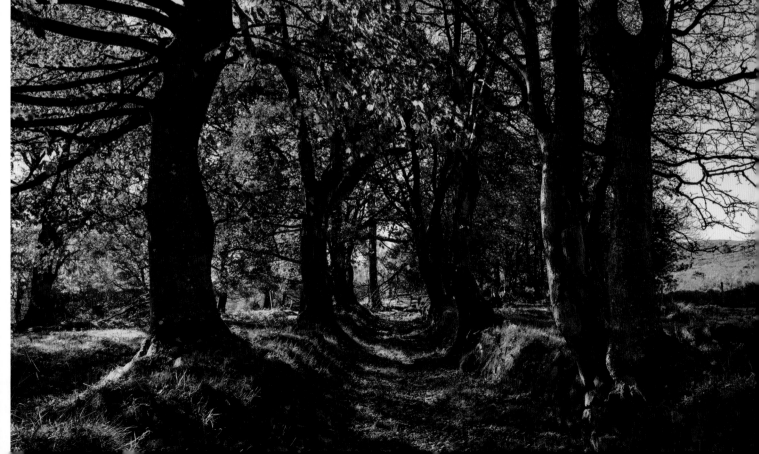

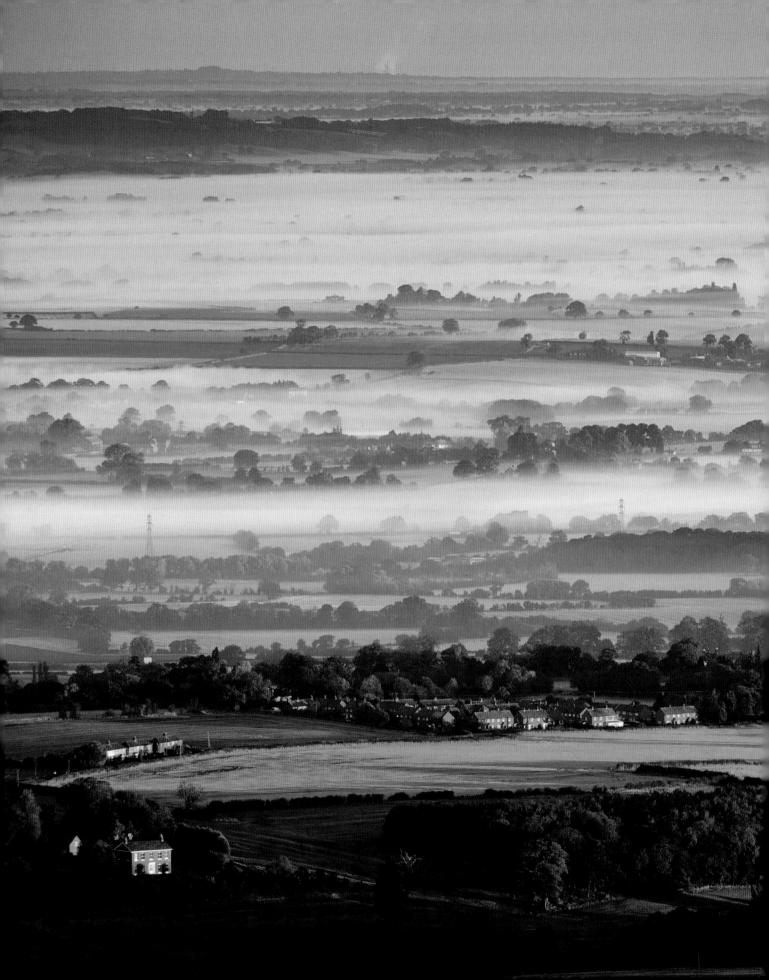

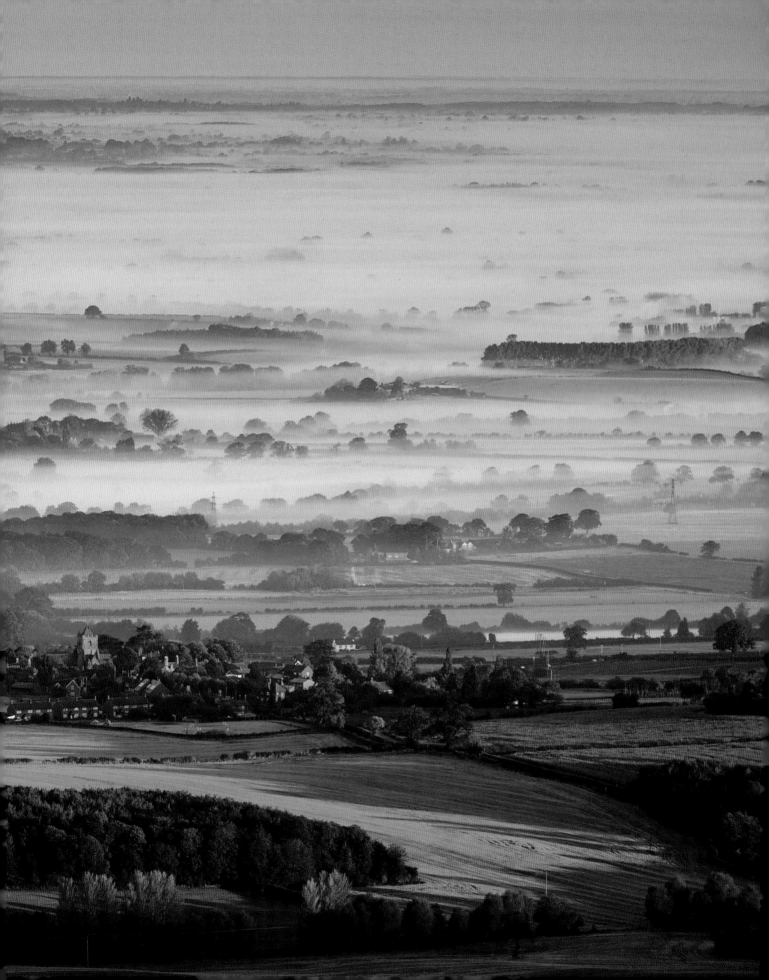

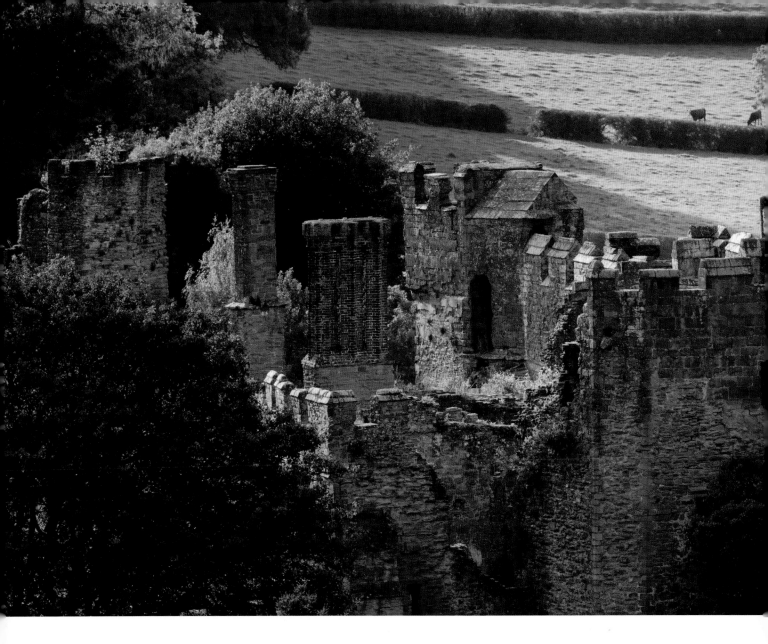

Previous page
WROCKWARDINE. Layers of early morning mist seen from the summit of the Wrekin, with the tower of St Peter's Church standing out in the sunshine.

Above
LUDLOW. The mighty walls of the castle emphasise its origins as a Norman fortress.

Right
LUDLOW. The soaring interior of St Laurence's Church, which is sometimes described as 'the Cathedral of the Marches'.

Following page
REDLAKE VALLEY. A timeless landscape bathed in golden morning light as the sun rises directly over Titterstone Clee. This is the view from the ramparts of the Iron Age fort on Caer Caradoc, a name it shares with the larger hill near Church Stretton.

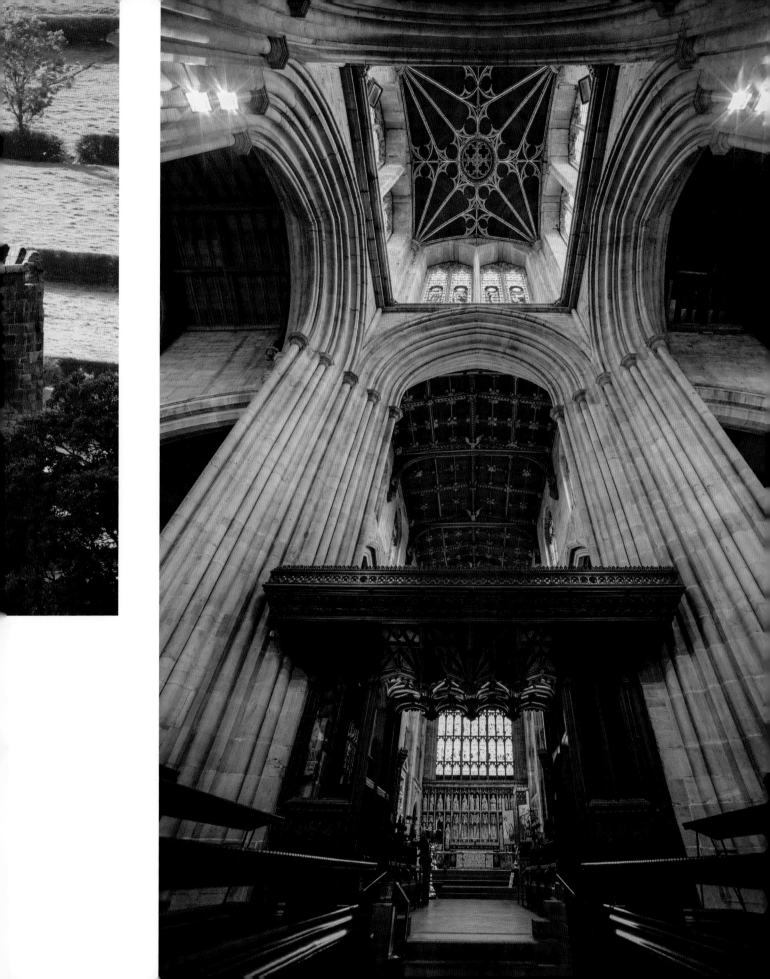

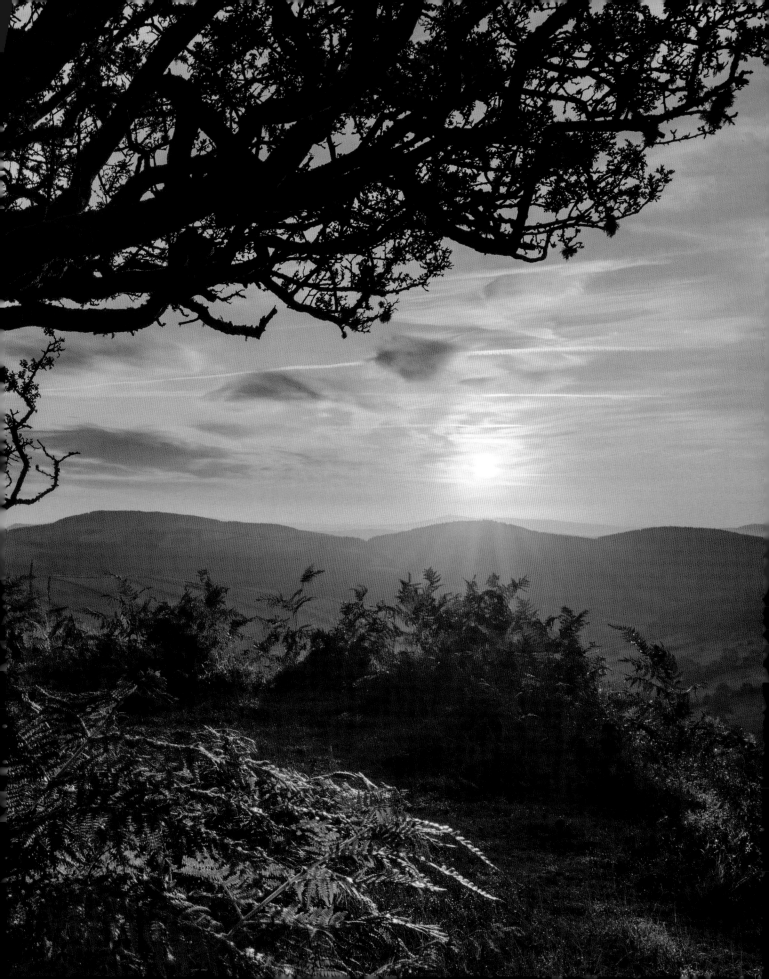

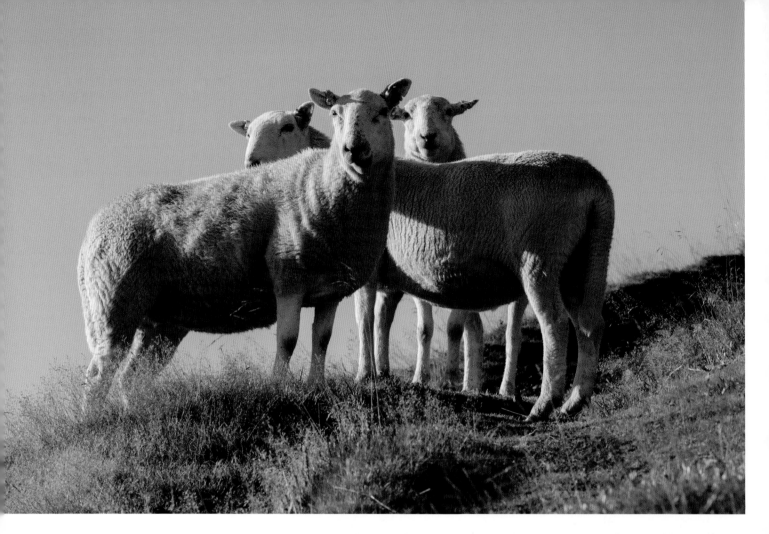

Above
CAER CARADOC
A trio of sheep in
perfect harmony near
the summit.

Right
THE HOLLIES
Early morning light
intensifies the vibrant
autumn colours of beast
and backdrop on the
Stiperstones.

Far right
BURROW HILL
Shy roe deer pause
momentarily before
racing away into the
bracken.

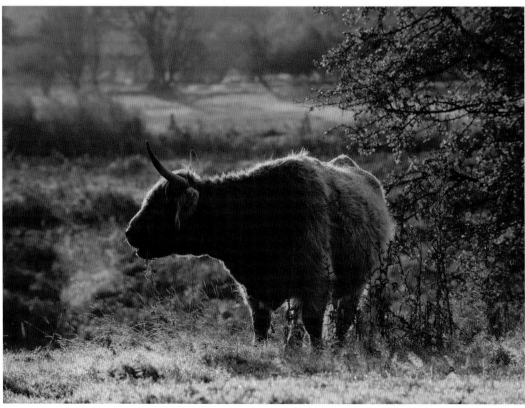

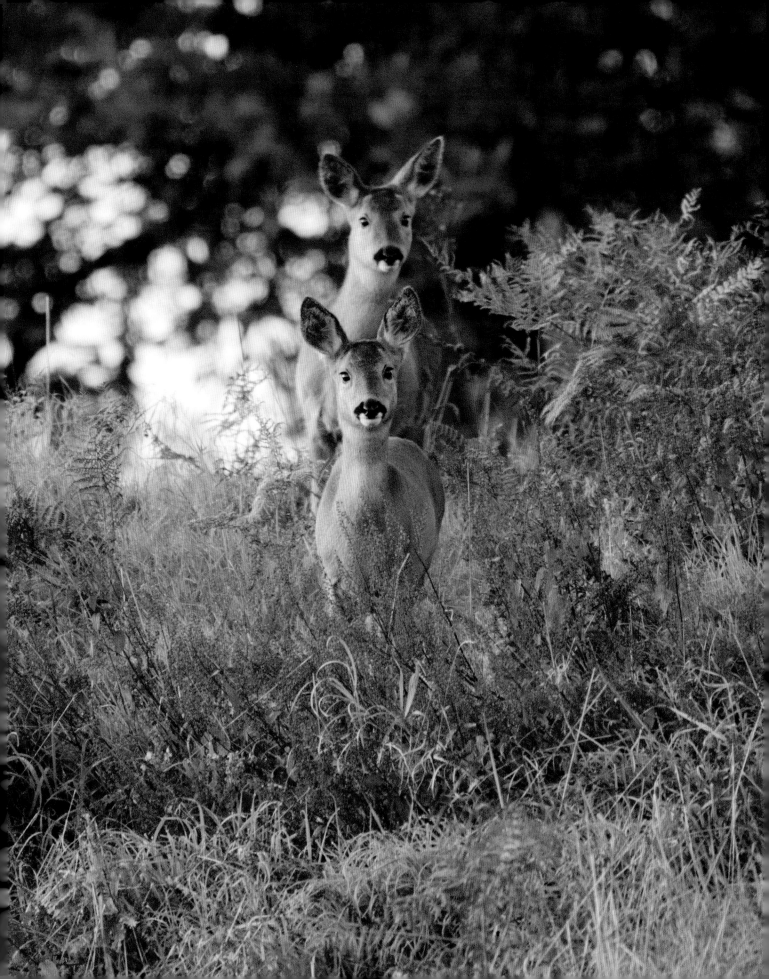

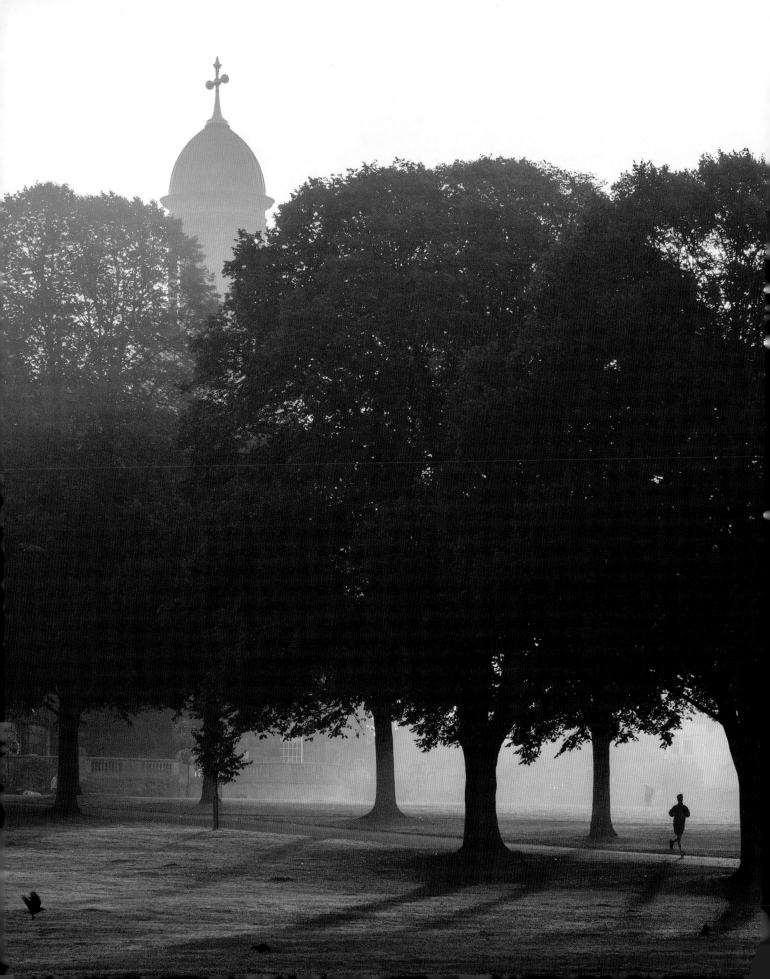

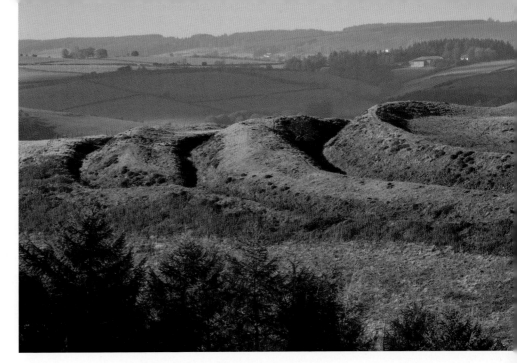

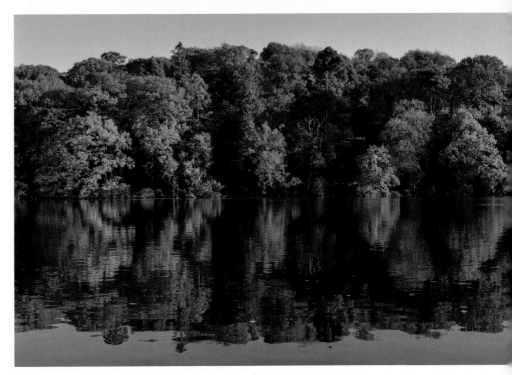

Left
SHREWSBURY. An early morning runner in The Quarry, with St Chad's Church seen rising above the trees.

Above, top
REDLAKE VALLEY. The sharply delineated ramparts of Shropshire's 'other' Caer Caradoc near Chapel Lawn.

Above, bottom
BLAKE MERE. Autumn reflections seen from the towpath alongside the Llangollen Canal.

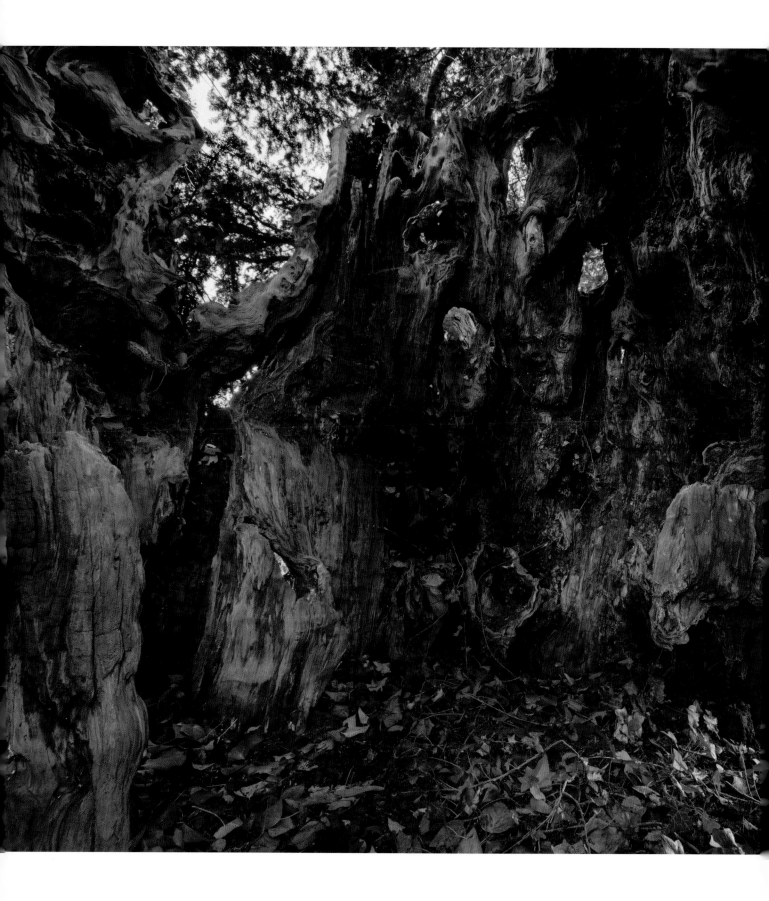

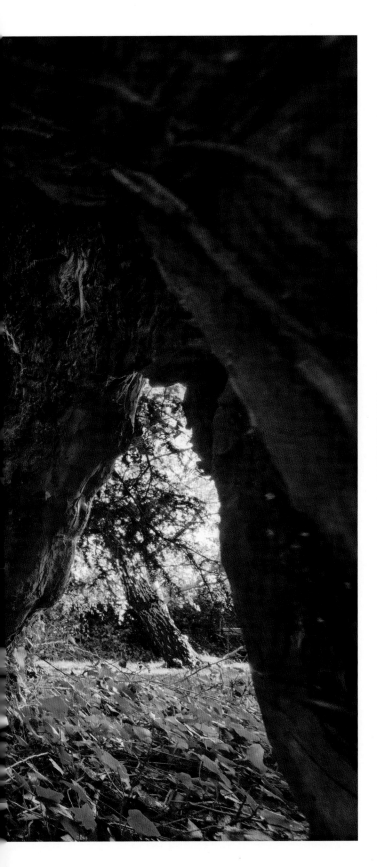

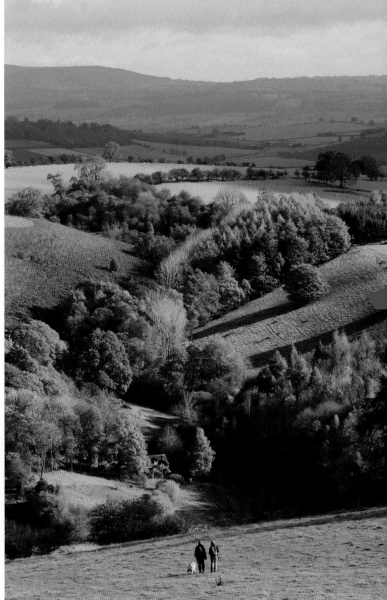

Left
UPPINGTON. One of Shropshire's many ancient yew trees is to be found in the churchyard at Holy Trinity. It has a girth of around 29 feet and is completely hollow, with plenty of space to stand inside. This magnificent specimen is thought to be at least 1,000 years old.

Above
HOPESAY. Walkers make their way down Burrow Hill and head off through the fields towards Hopesay Common. On the horizon is Brown Clee which, with Titterstone Clee, marks the eastern edge of the Shropshire Hills Area of Outstanding Natural Beauty.

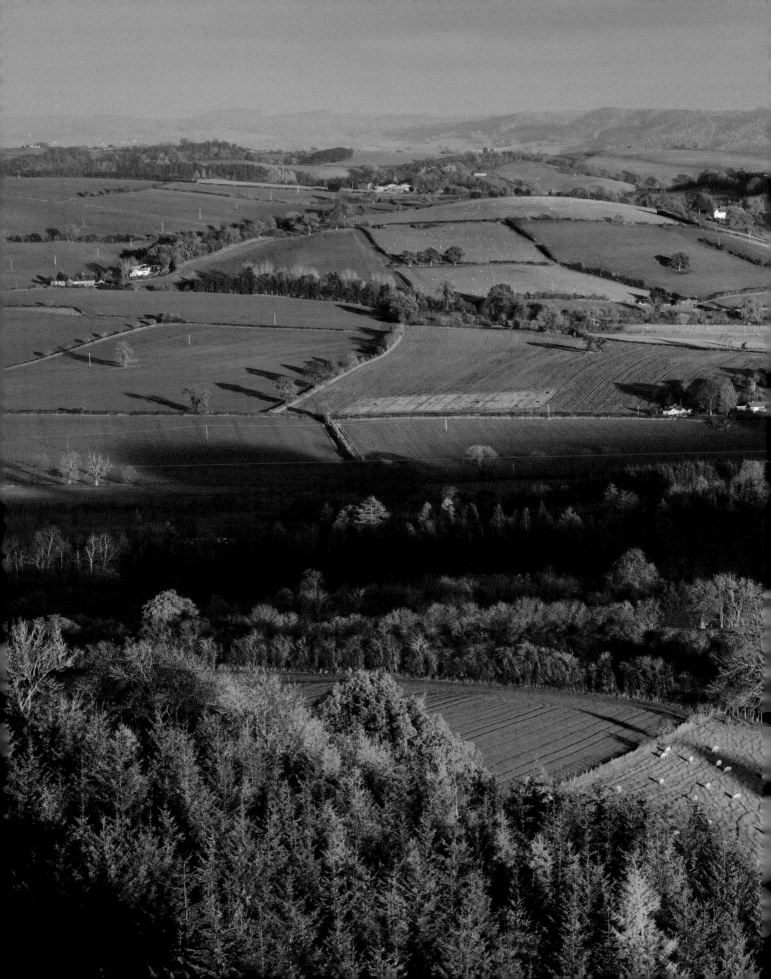

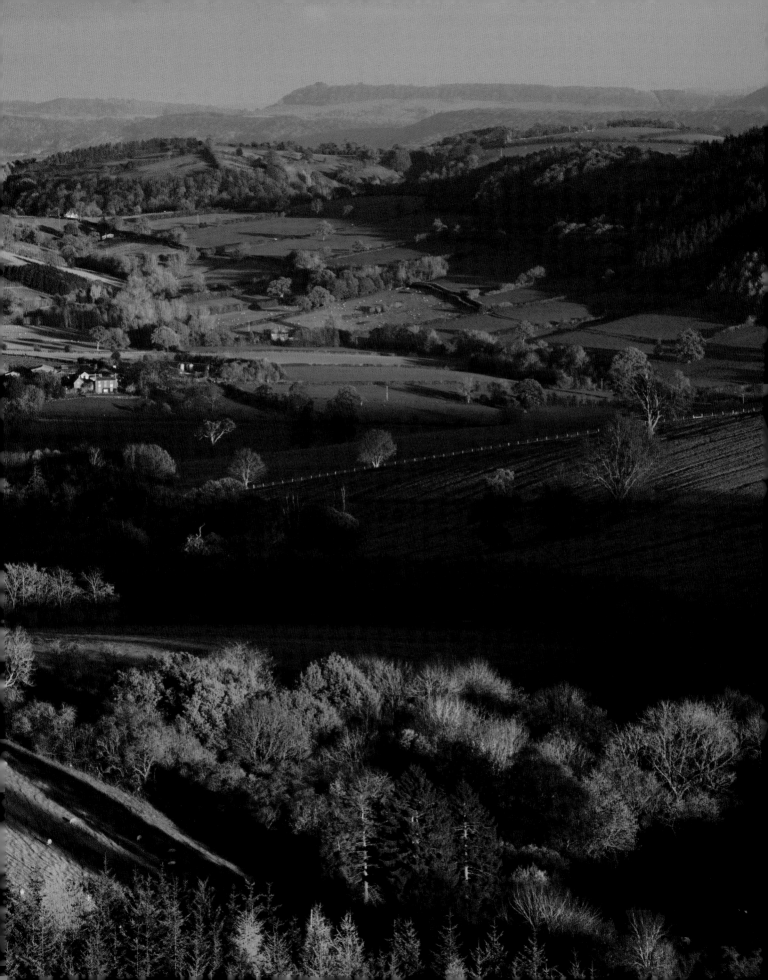

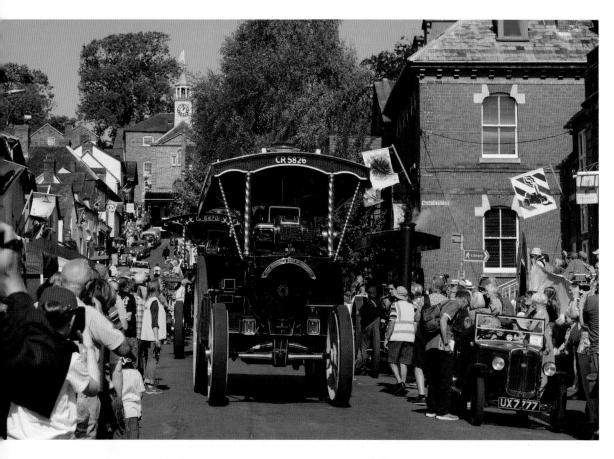

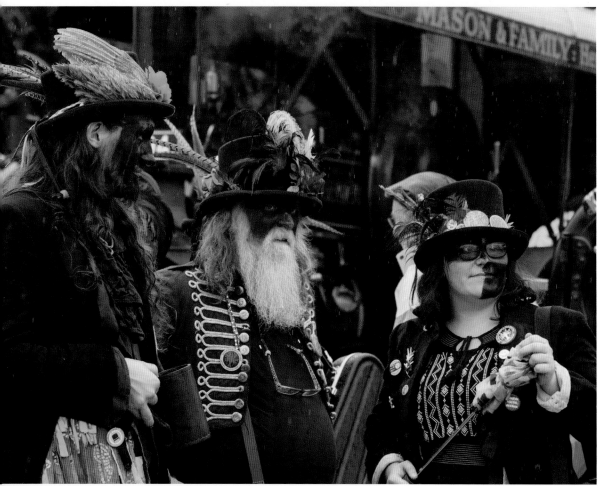

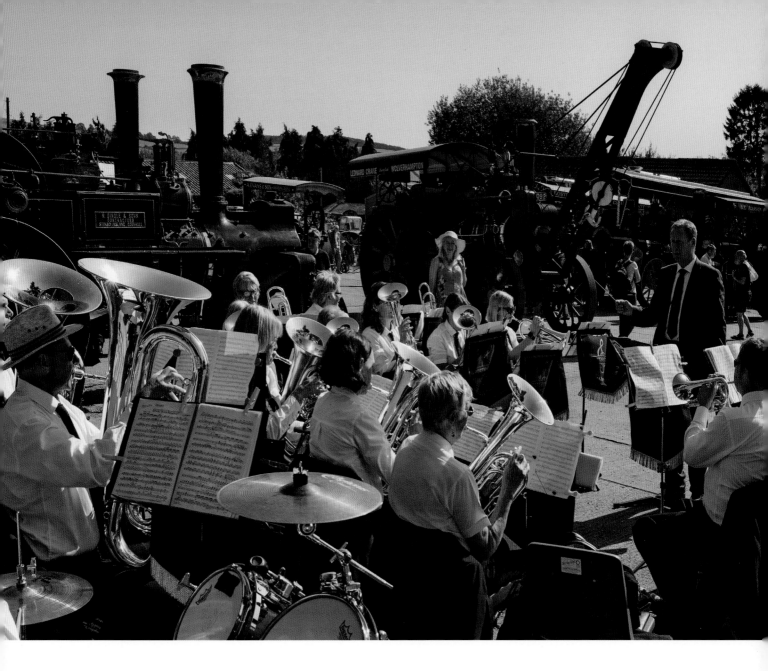

Previous page
BURY DITCHES

The view from the Iron Age hill fort, which is said to be one of the finest of its kind in the country. Wenlock Edge can be seen on the horizon.

These pages
BISHOP'S CASTLE

Traction engines parade down High Street at the Michaelmas Fair, while members of Beorma Border Morris get ready to perform. Meanwhile, Porthywaen Silver Band sparkles in the September sunshine.

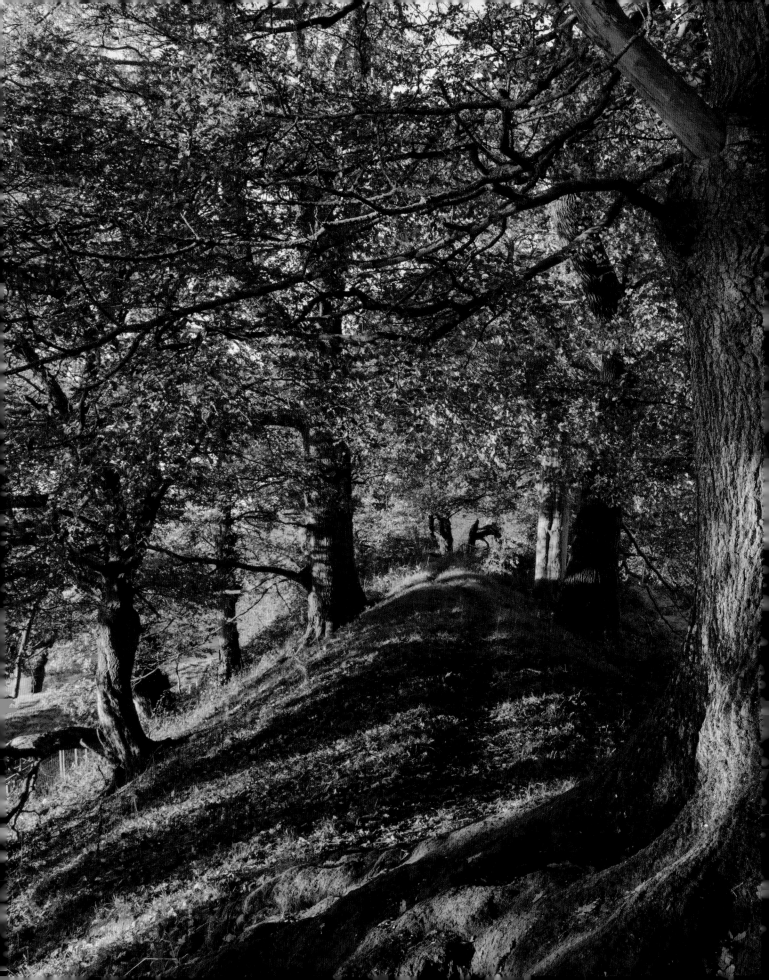

CAYNHAM CAMP

Mature trees have staked their claim on the ramparts of this Iron Age hill fort, which covers around eight acres. Local tradition says that Parliamentarian forces used Caynham as a base before their attack on Royalist-held Ludlow Castle in 1646.

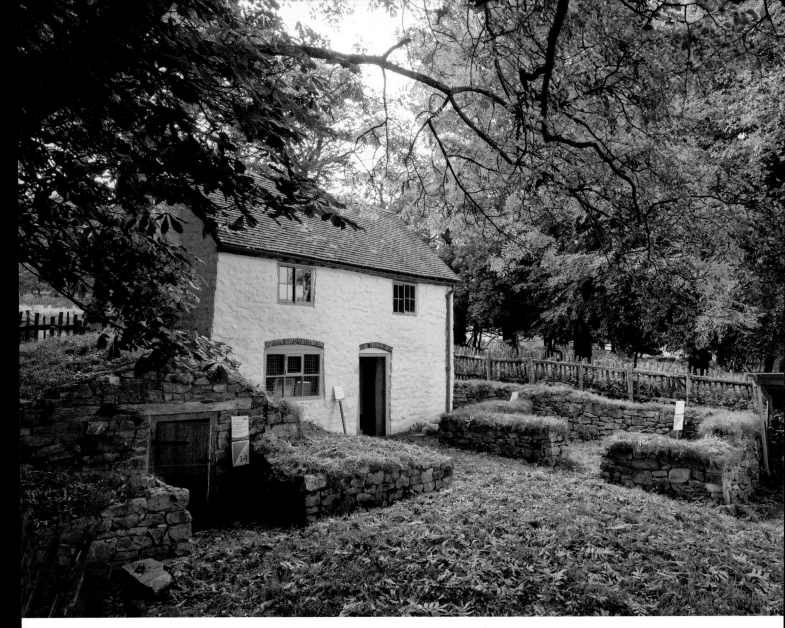

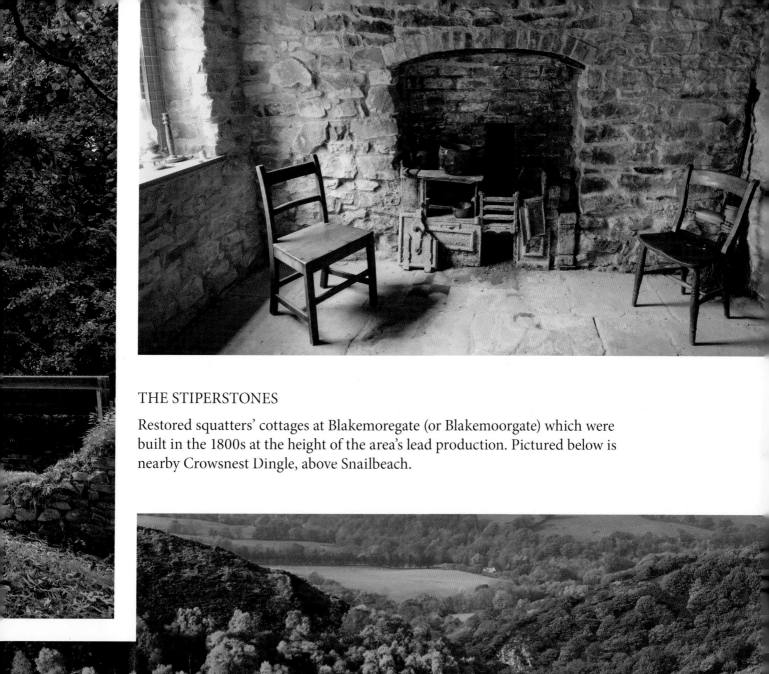

THE STIPERSTONES

Restored squatters' cottages at Blakemoregate (or Blakemoorgate) which were built in the 1800s at the height of the area's lead production. Pictured below is nearby Crowsnest Dingle, above Snailbeach.

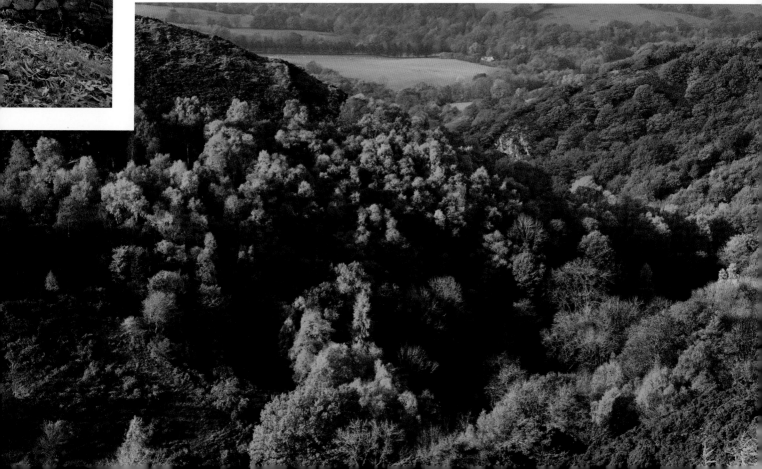

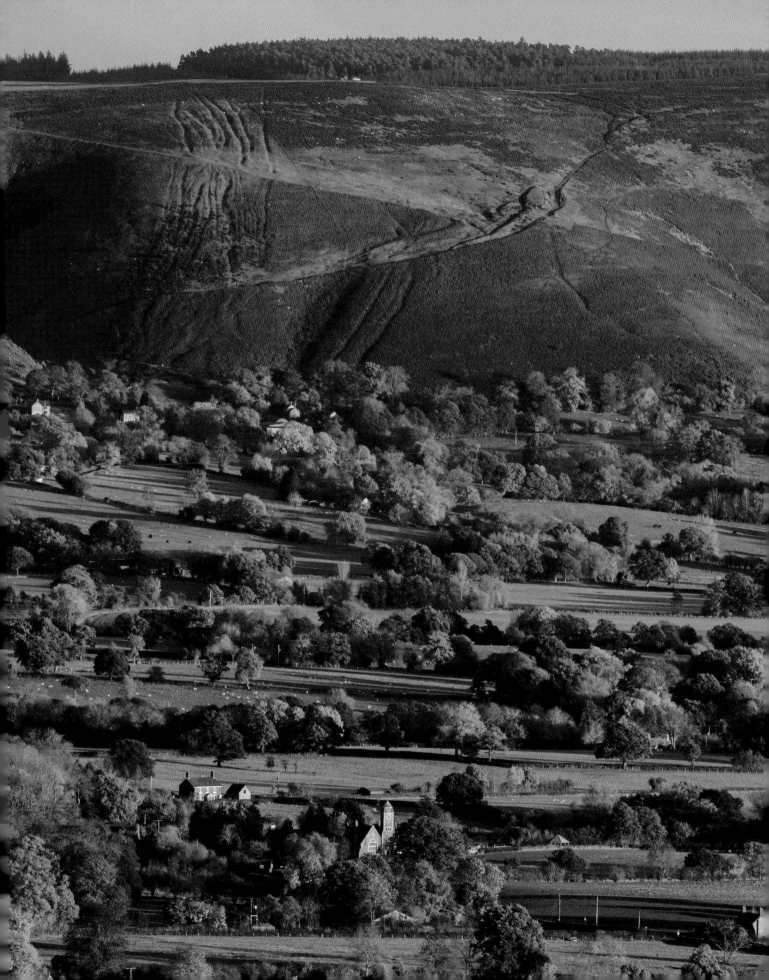

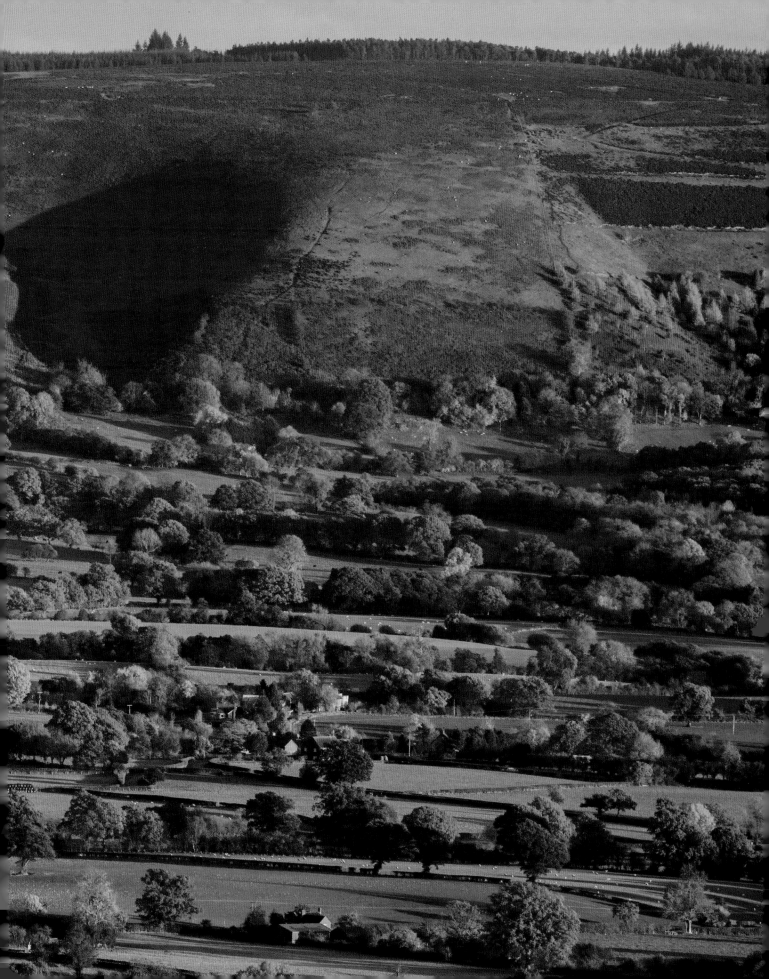

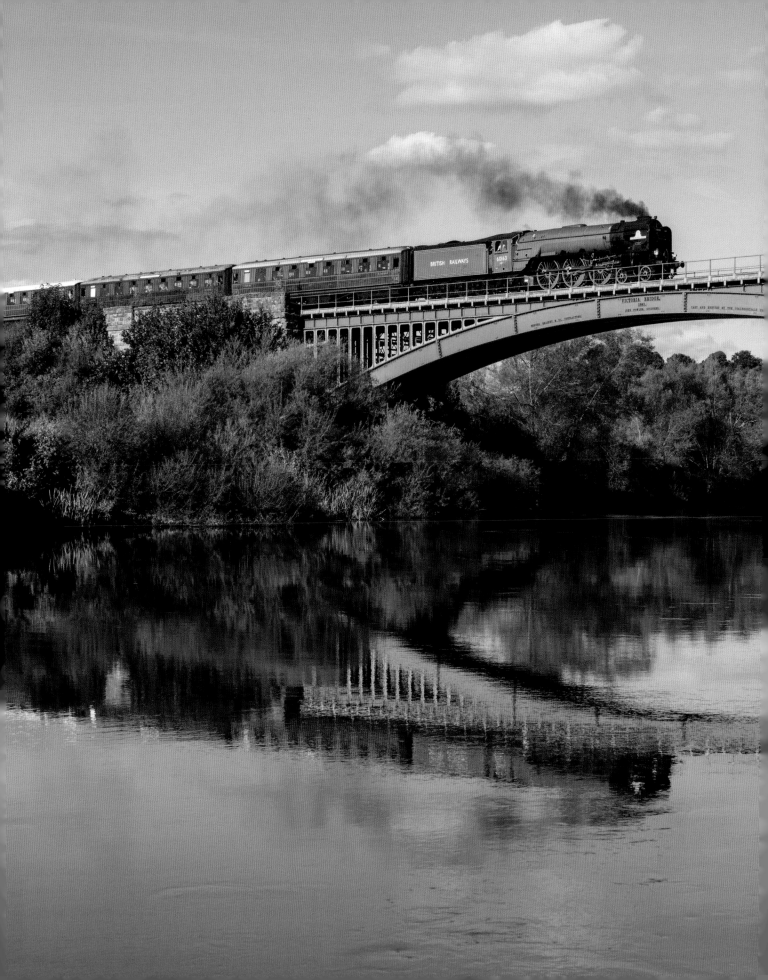

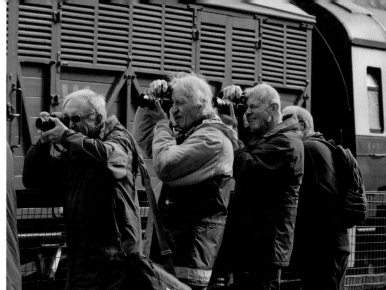

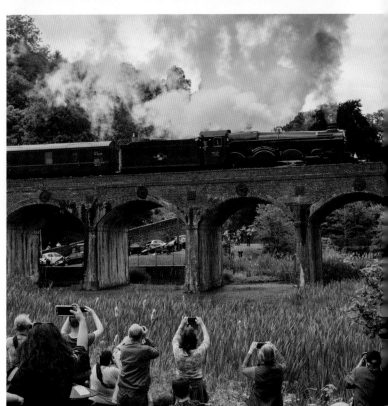

Previous page: THE LONG MYND. Autumn colour beneath the western slopes, seen from Heath Mynd.

Left: SHROPSHIRE BORDER. Steam locomotive *Tornado* crosses Victoria Bridge on the Severn Valley Railway near Arley.

Above, top: HIGHLEY. Steam enthusiasts line up at the railway station.

Above, bottom: COALBROOKDALE. Eager photographers capture *Clun Castle* as it steams across the viaduct.

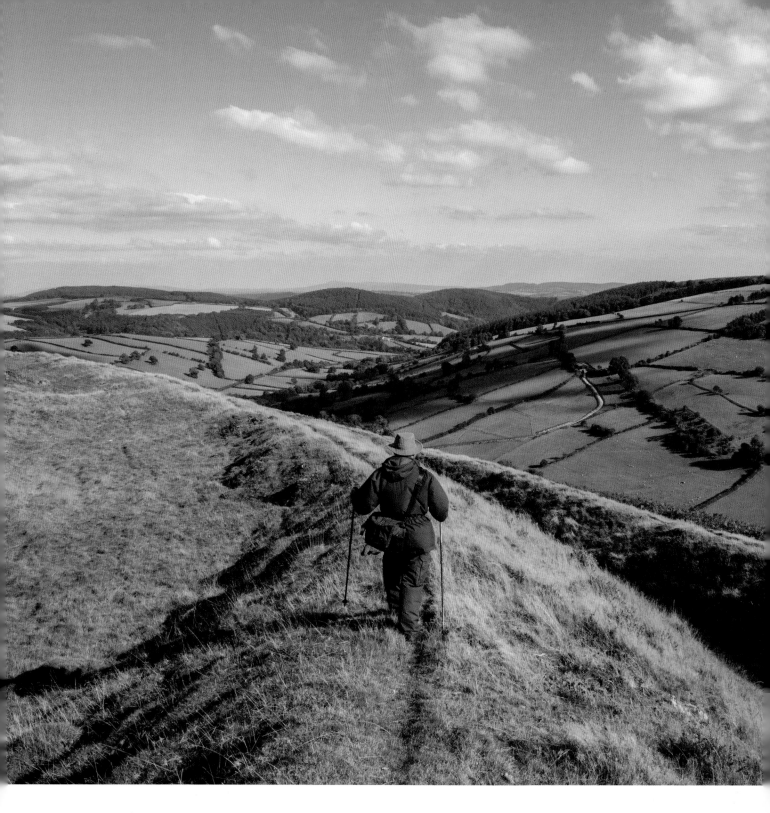

Above
REDLAKE VALLEY

A walker strides out along the ramparts of Caer Caradoc, above the village of Chapel Lawn. This hill fort has a better-known namesake 16 miles away in Church Stretton.

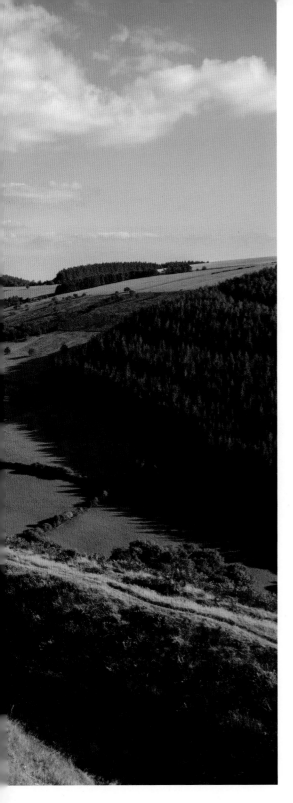

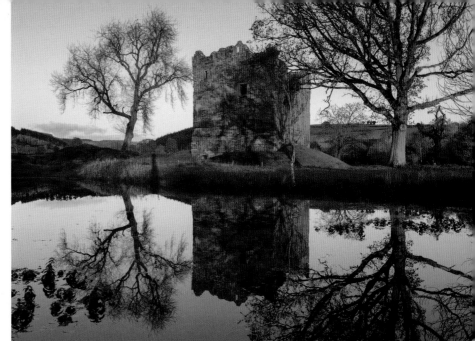

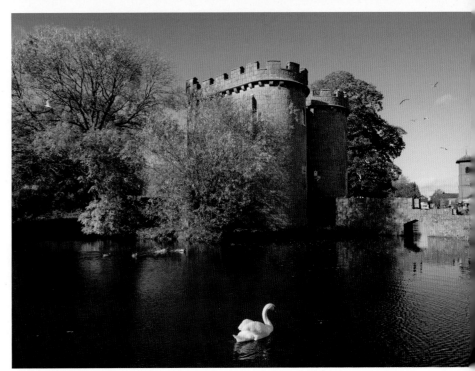

Above, top
HOPTON CASTLE

Sunrise over the ruins of the medieval castle that stands in the village of the same name.

Above, bottom
WHITTINGTON

The castle dates back to the 12th century and is owned and run by the local community.

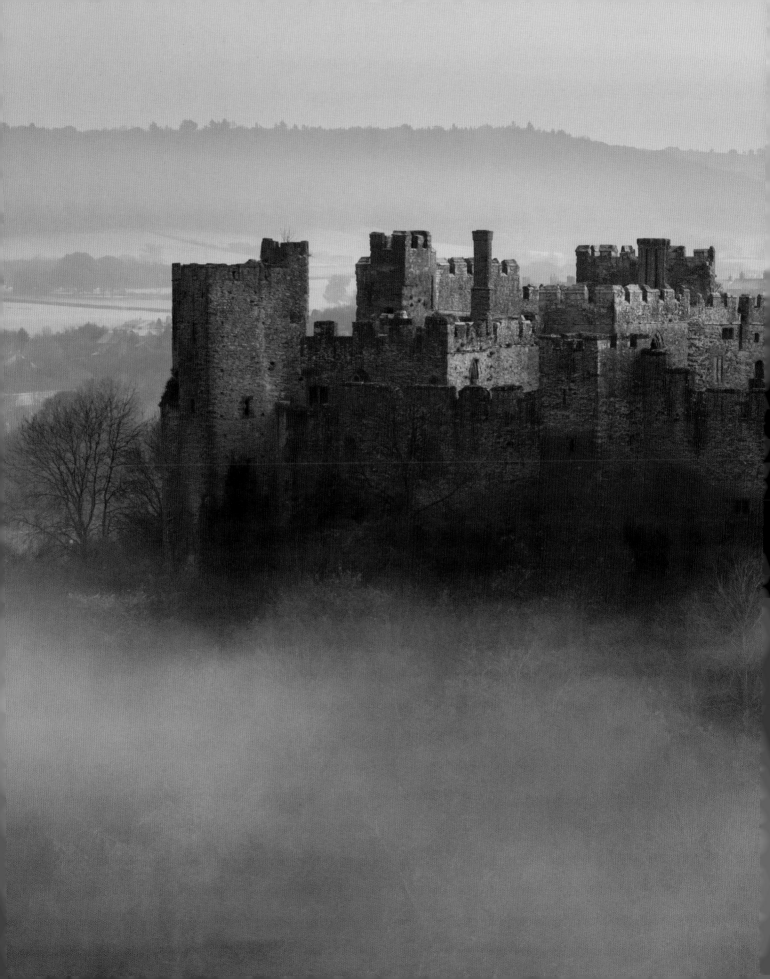

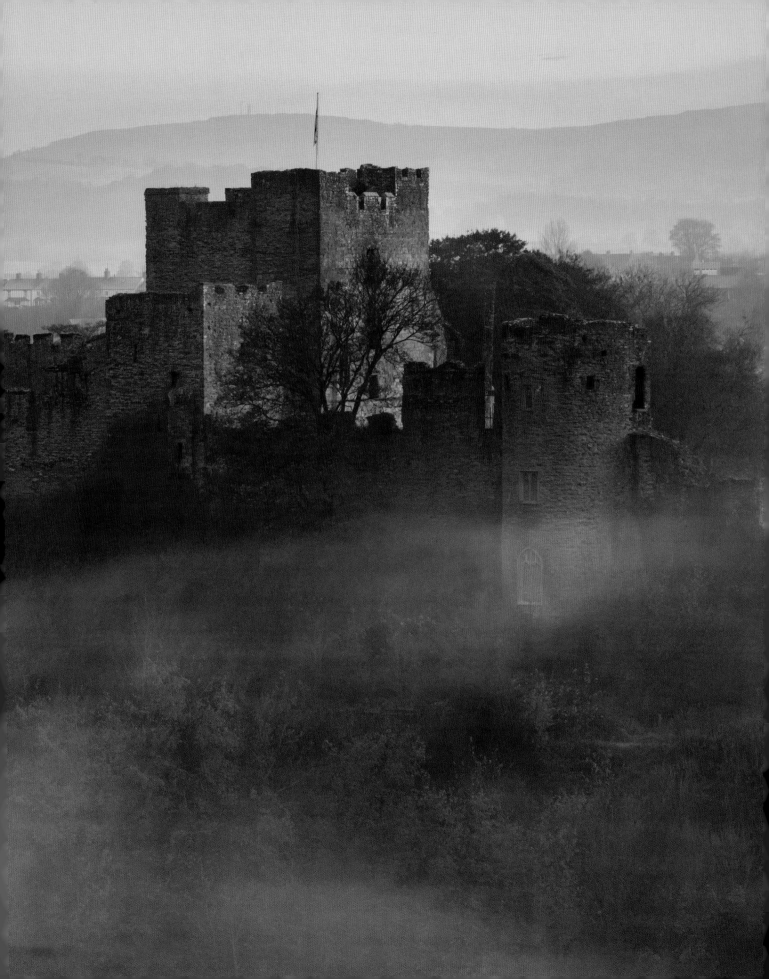

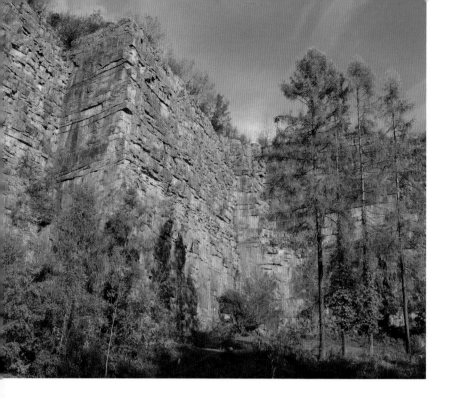

Previous page: LUDLOW. Dawn mist swirls around the castle, one of the finest medieval ruins in England.

Above: LLANYMYNECH ROCKS. The cliffs at this nature reserve rise almost vertically to a height of over 200 feet.

Below: NESSCLIFFE HILL. Sunshine and shadows play on the quarried sandstone faces.

Right: WENLOCK EDGE. Vibrant colours at a former limestone quarry.

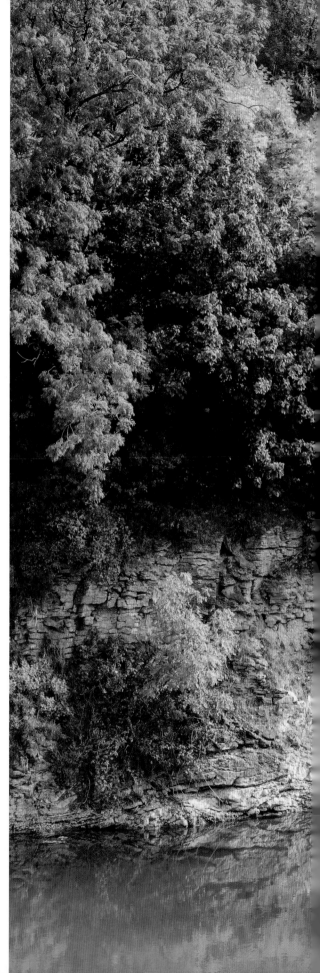

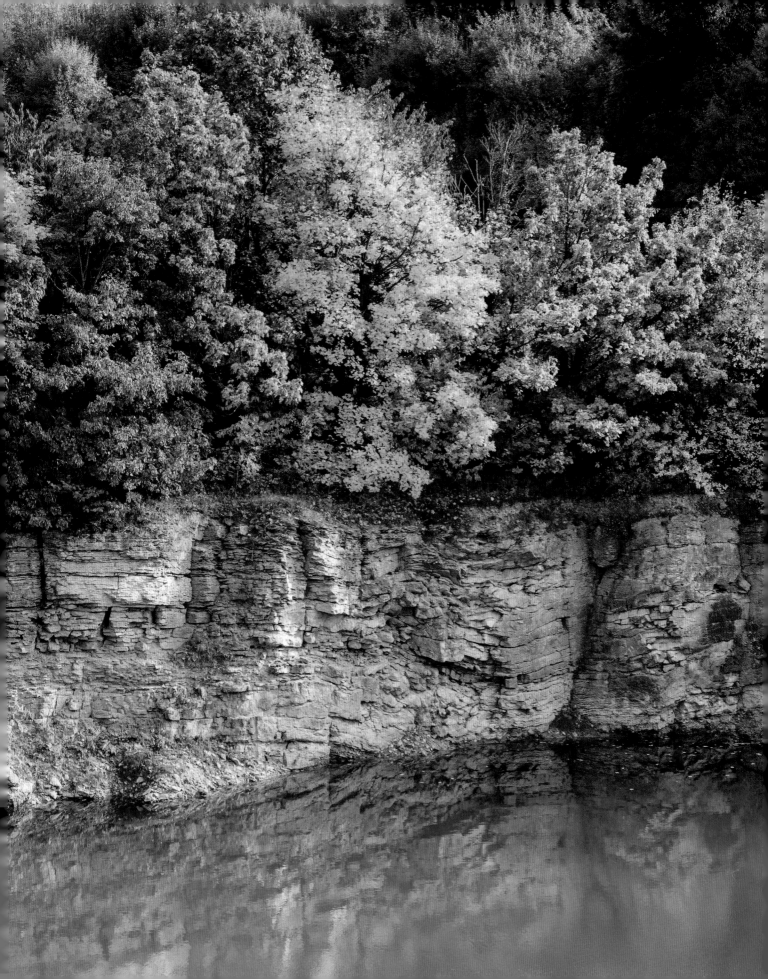

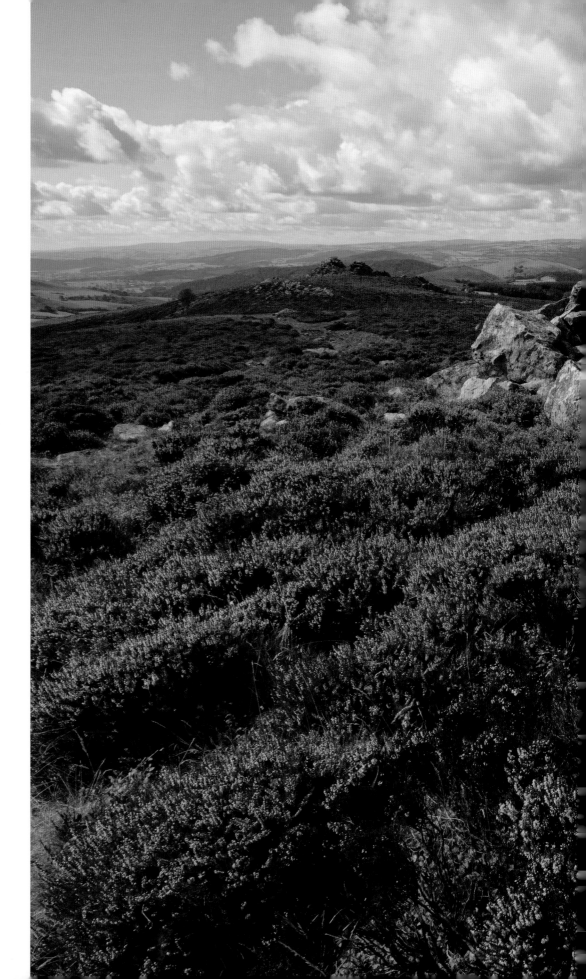

THE STIPERSTONES

A sea of heather
surrounds Diamond
Rock, one of the
spectacular outcrops
to be found on this
magnificent 10-kilometre
quartzite ridge.

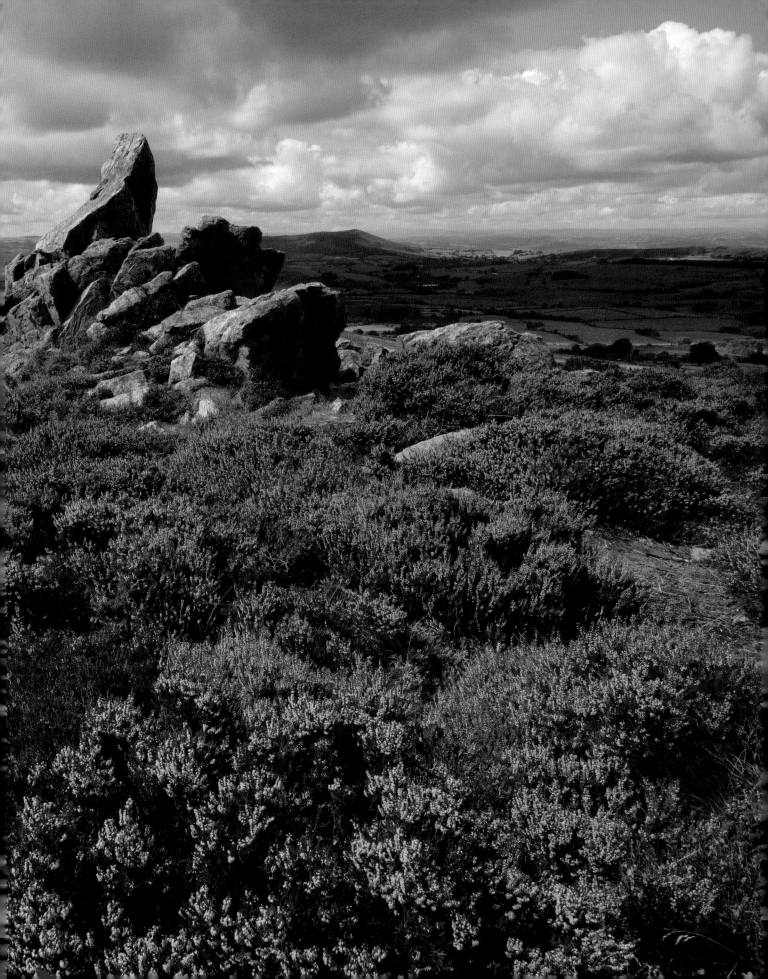

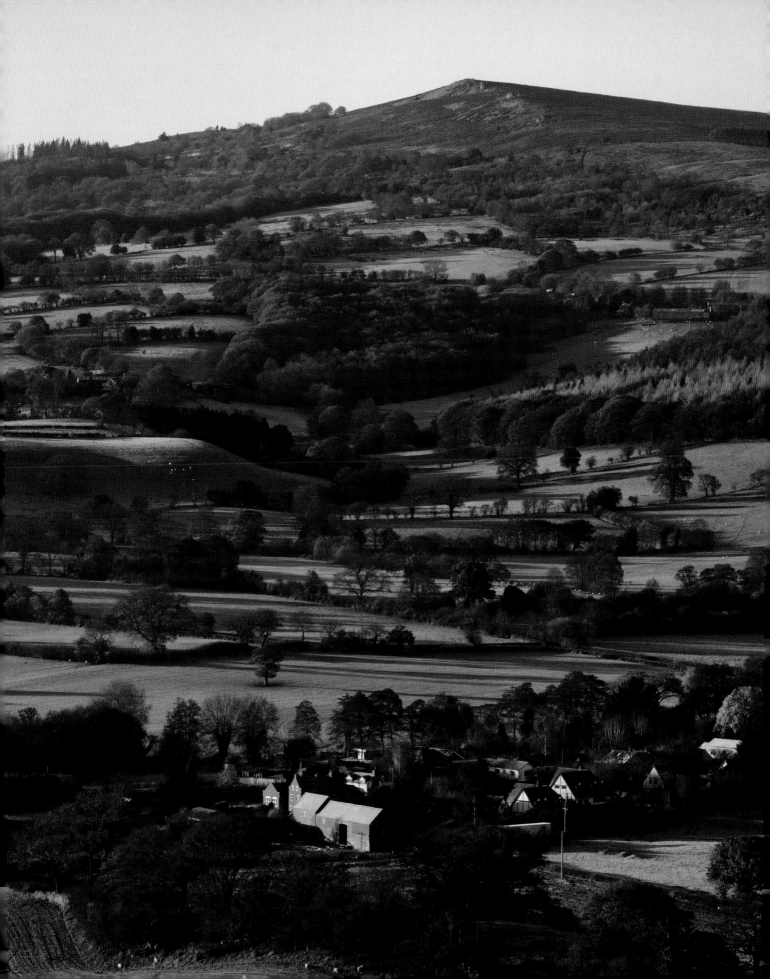

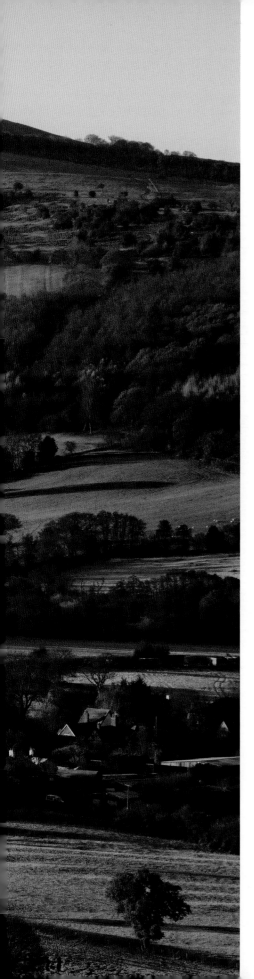

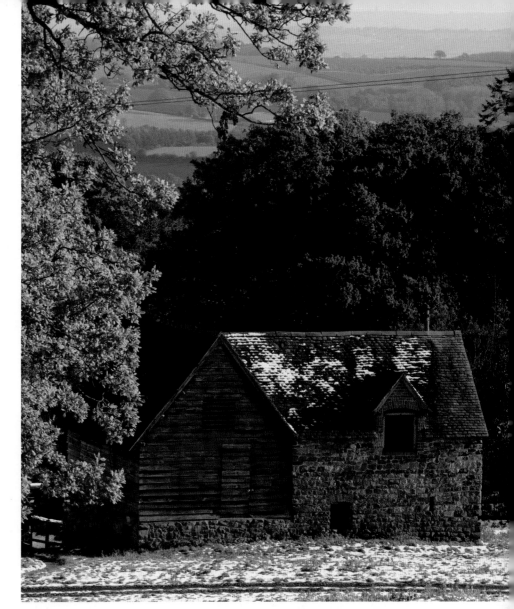

Left
HABBERLEY

A patchwork of fields stretches from the village to the foot of the Stiperstones. 'Mad Jack' Mytton, an eccentric 19th century squire and one of Shropshire's great characters, had an estate here.

Above
BROWN CLEE

A dusting of snow on the lower slopes of the hill, which has two summits – Abdon Burf and Clee Burf.

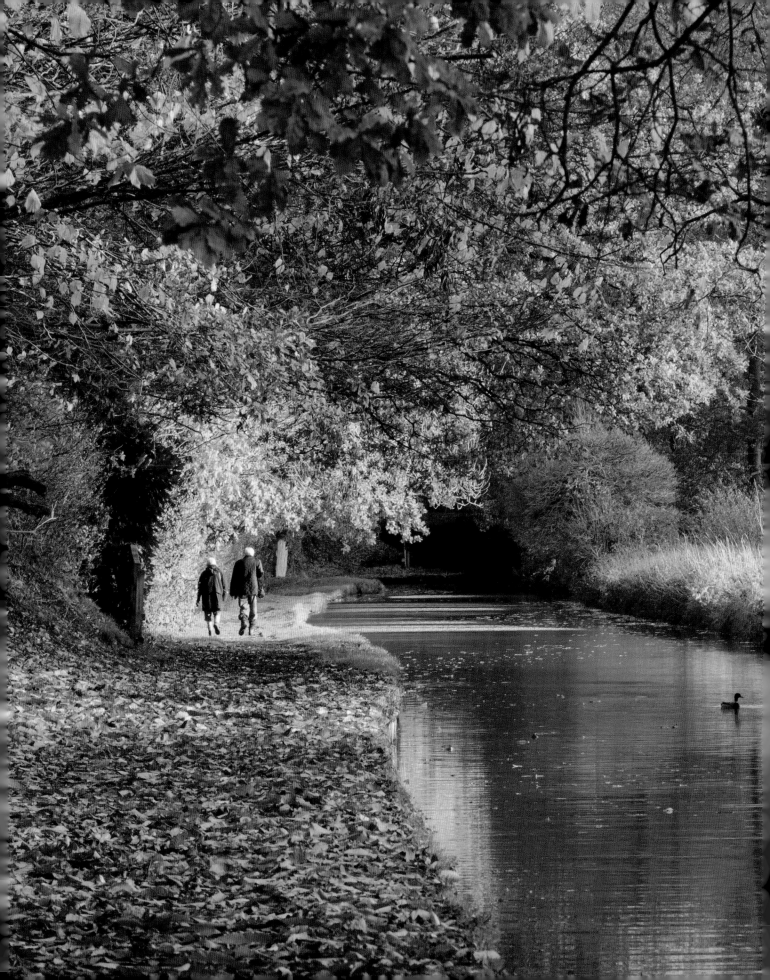

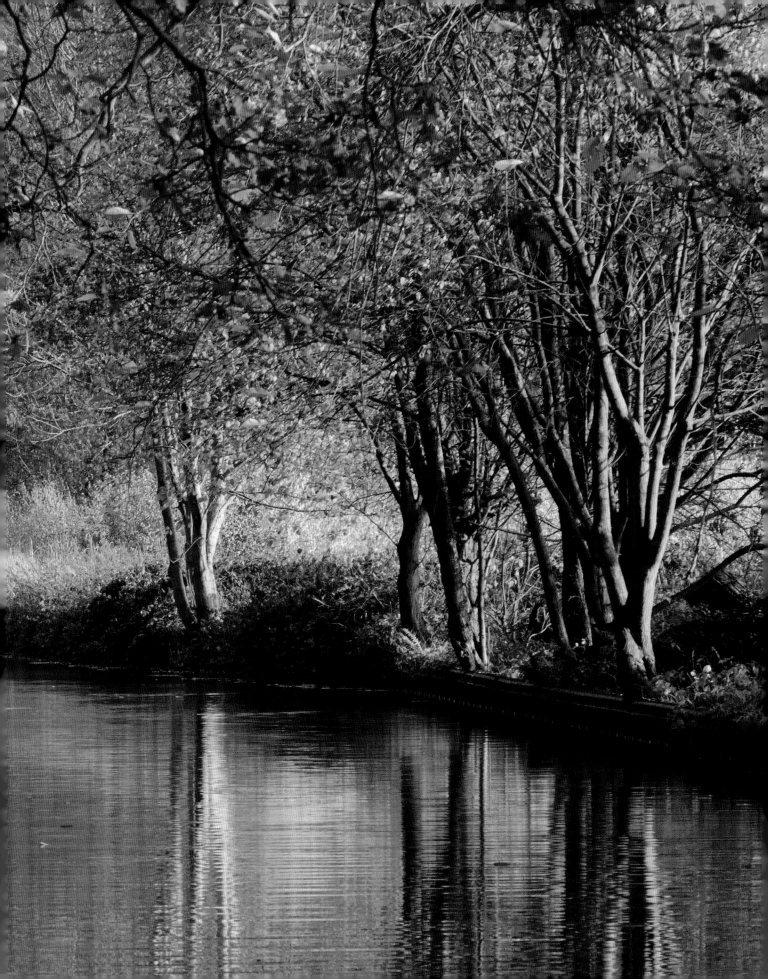

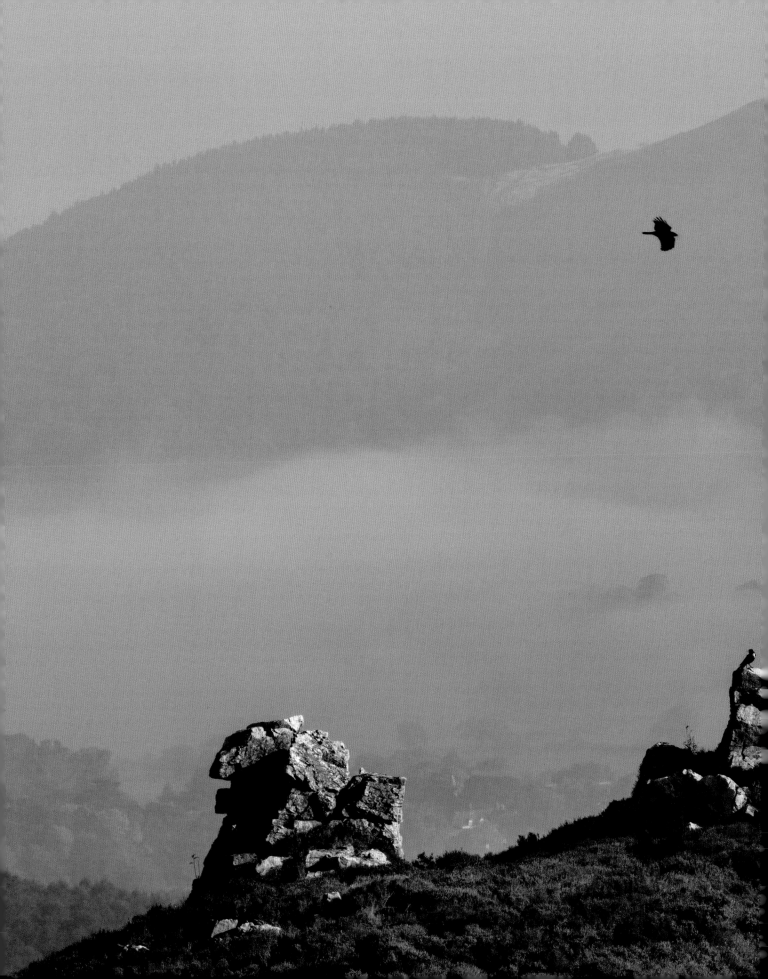

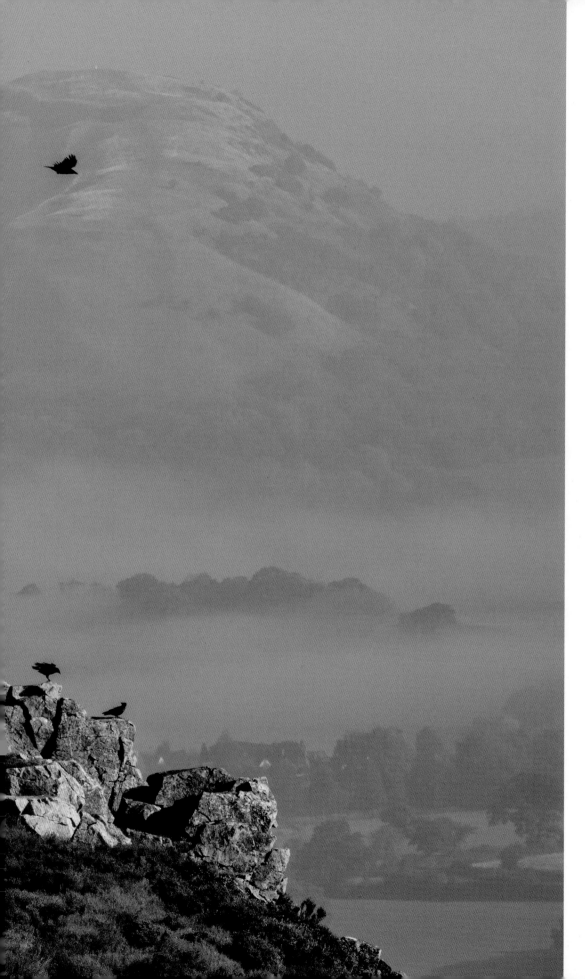

Previous page
ELLESMERE

A leisurely stroll alongside the Llangollen Canal.

Left
HABBERLEY ROCKS

Birds in flight above the Stiperstones, silhouetted against Earl's Hill and Pontesford Hill. Local people see the shape of a sleeping dragon in this distinctive, humped hill, which was formed by a volcano some 650 million years ago. Early morning is a magical time in this special place, and the layers of mist add to its air of mystery.

129

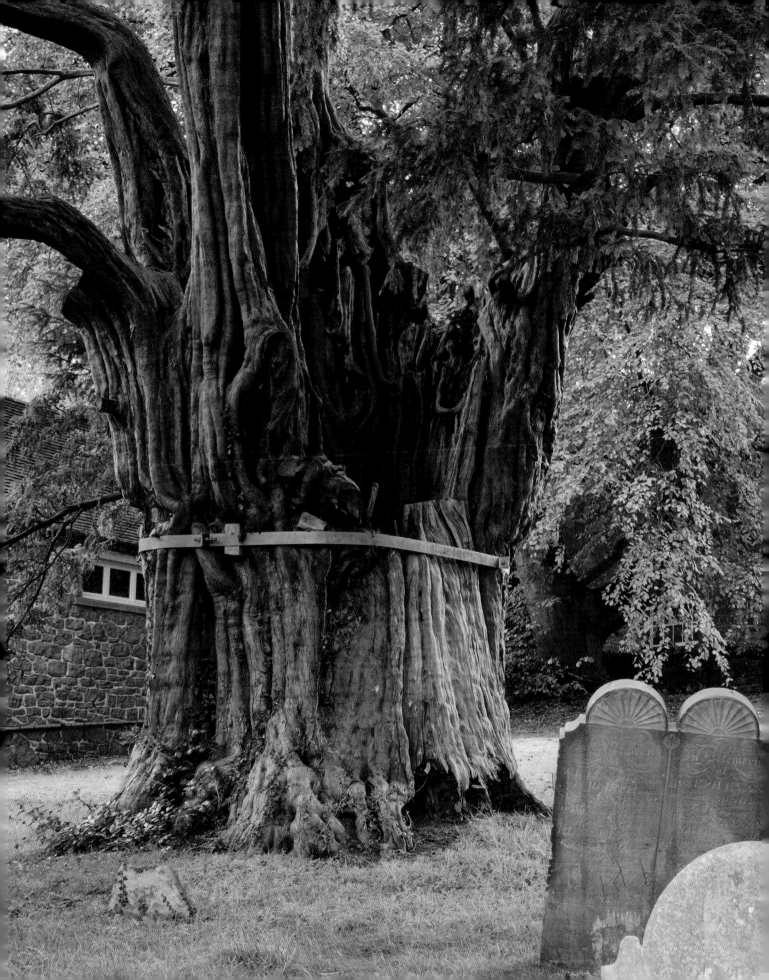

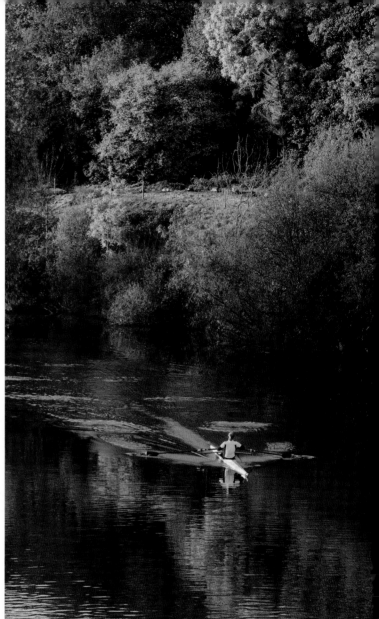

Left: CHURCH PREEN. It is said that 21 people once stood within the hollow trunk of this ancient yew tree in the churchyard of St John the Baptist.

Above: SHREWSBURY. An early-morning rower on the River Severn.

Following page: CORVEDALE. Sunrise seen from the summit of Titterstone Clee, looking towards Wenlock Edge and the Stretton Hills. This is a landscape that would have been familiar to travellers on the Clee-Clun Ridgeway, which was a trading route used by prehistoric man.

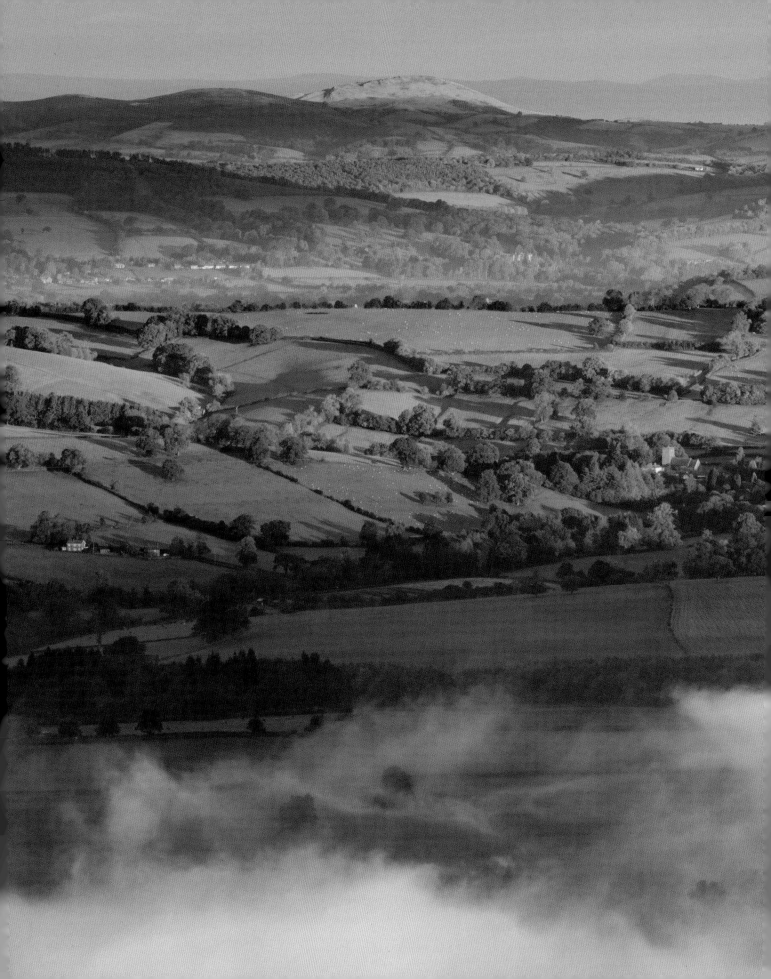

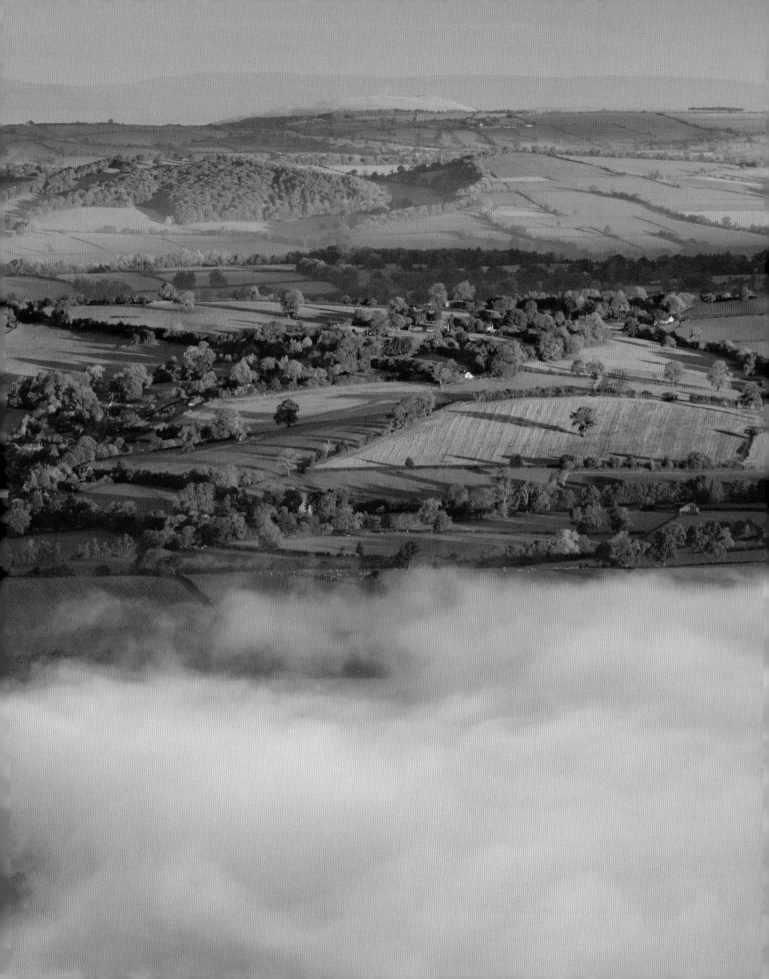

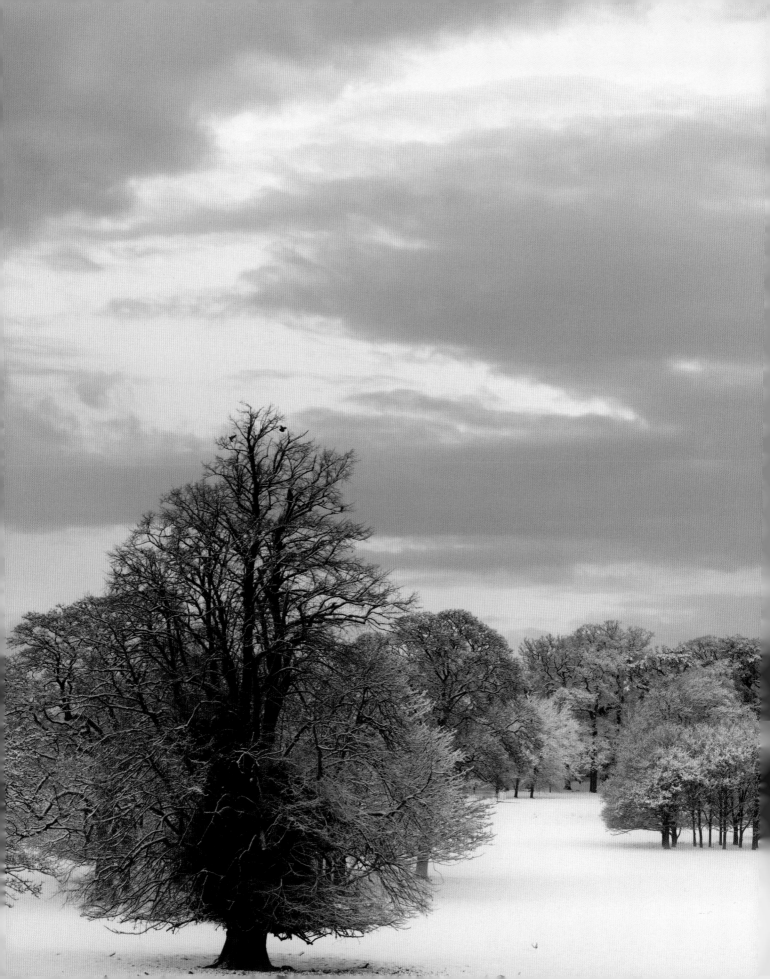

WINTER

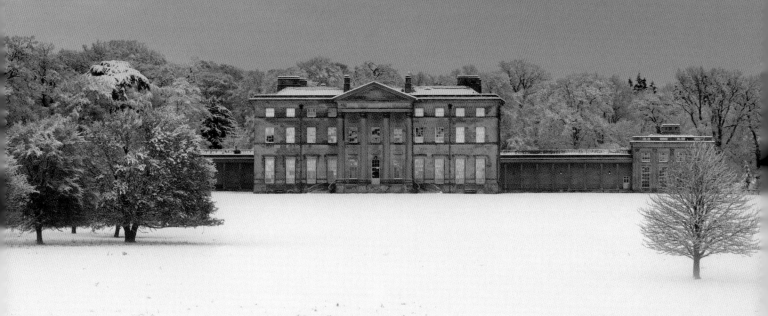

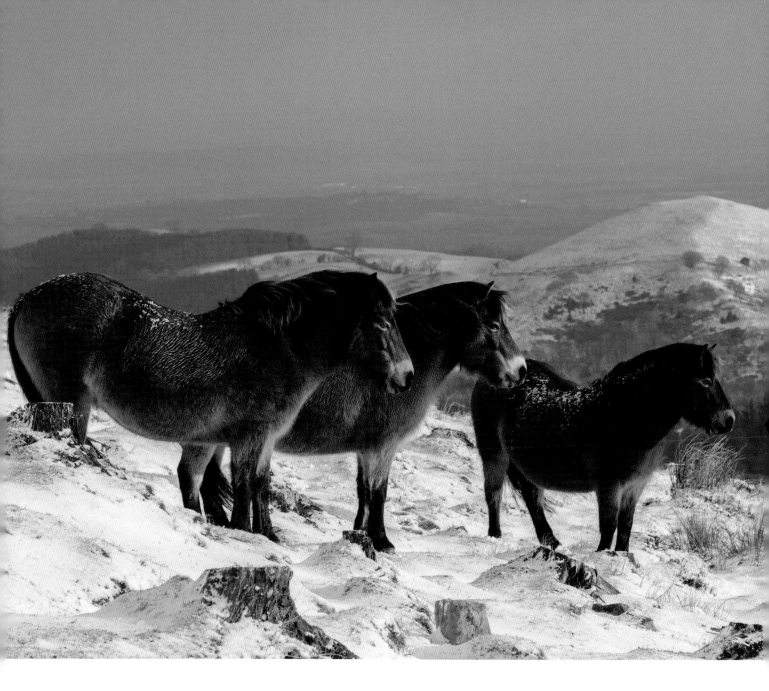

Previous page
ATTINGHAM. Early morning snow blankets the hall and its beautiful parkland, which is the legacy of Humphry Repton, regarded as the last great English landscape designer of the 18th century.

Above
THE STIPERSTONES. Exmoor ponies on the lower slopes, with Paulith Bank seen in the background.

Right
THE STIPERSTONES. Snow crystals sparkle on the quartzite rocks as the sun rises over the Long Mynd.

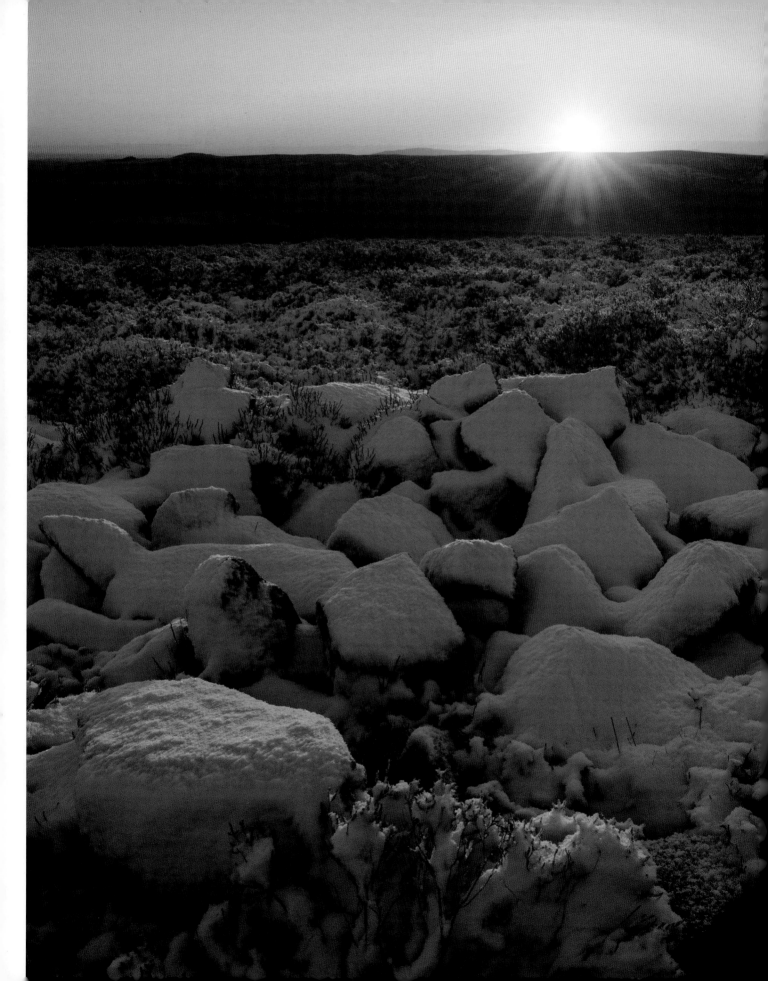

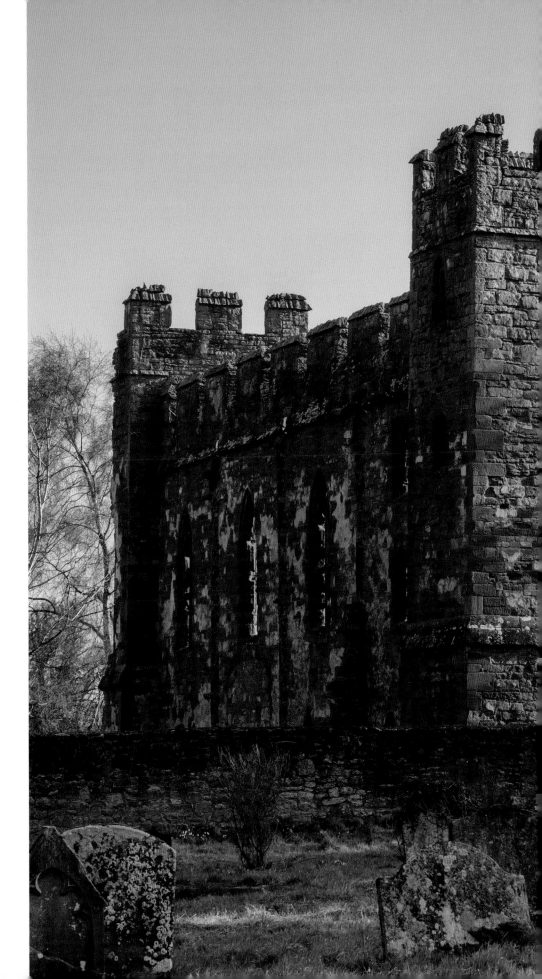

Right
ACTON BURNELL

Today the castle is just a sandstone shell, but it was once witness to a significant event in our nation's history. Edward I visited here in 1283 and held what was said to be the first parliament at which commoners were represented.

Following page
CARDINGTON

A dusting of snow over this quiet village in the Shropshire Hills, which was founded in Saxon times. This is the view from Hill End.

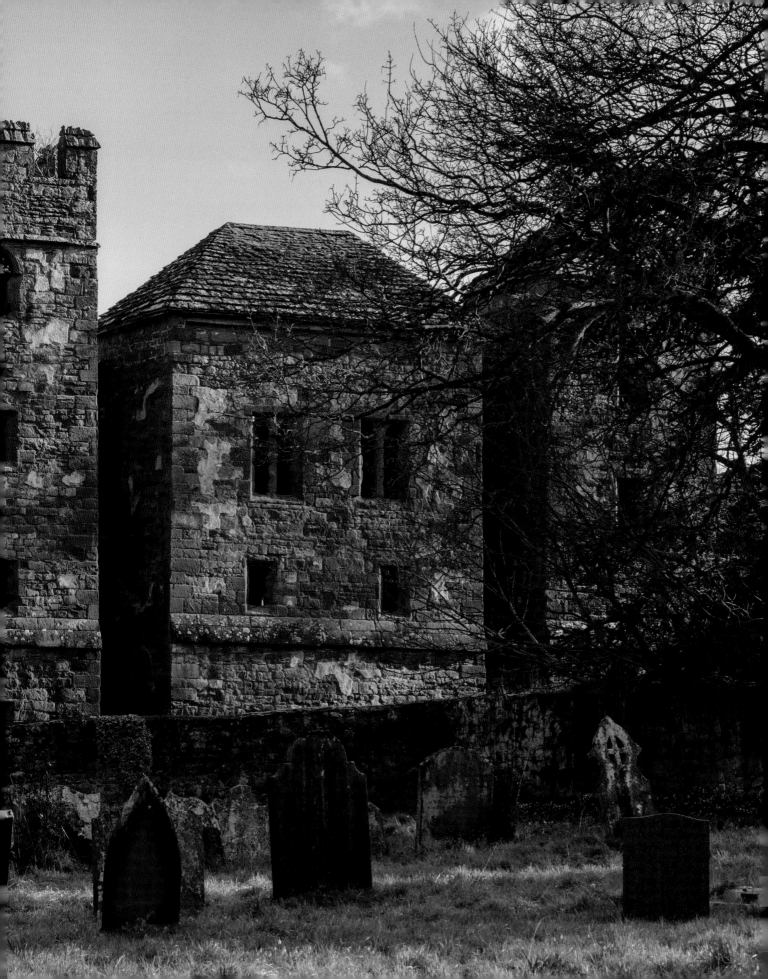

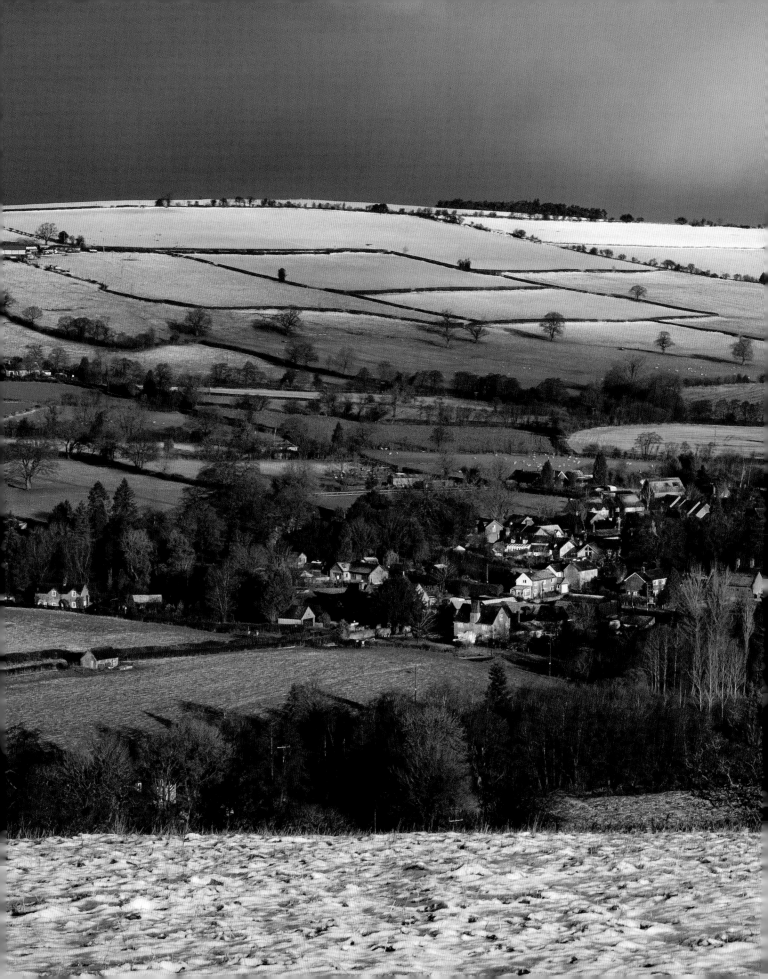

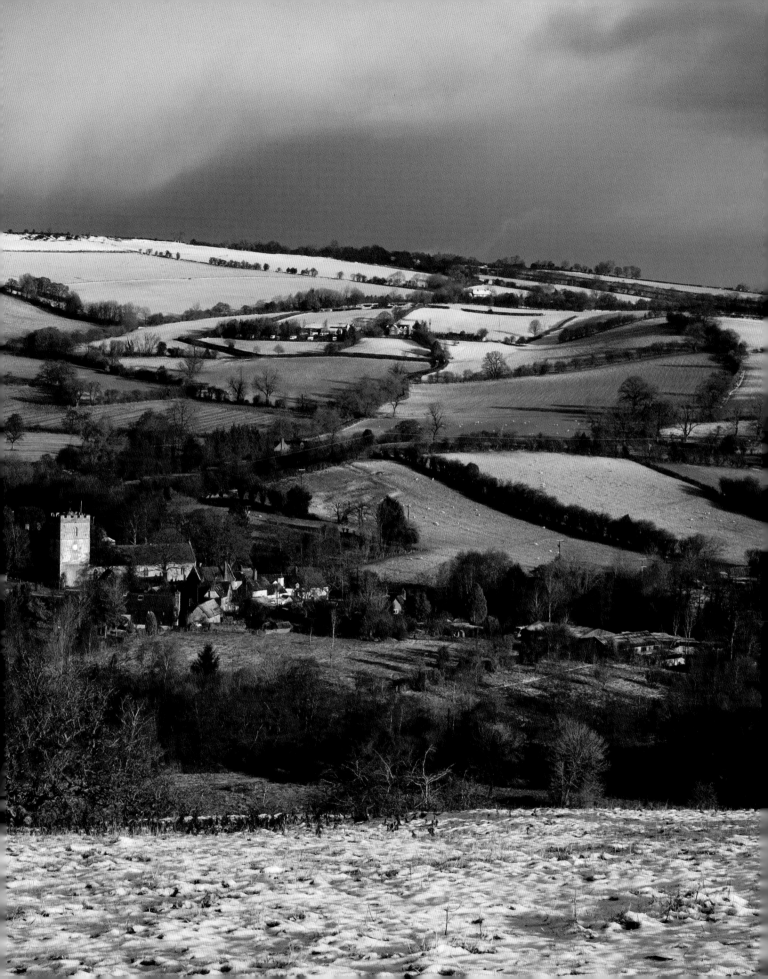

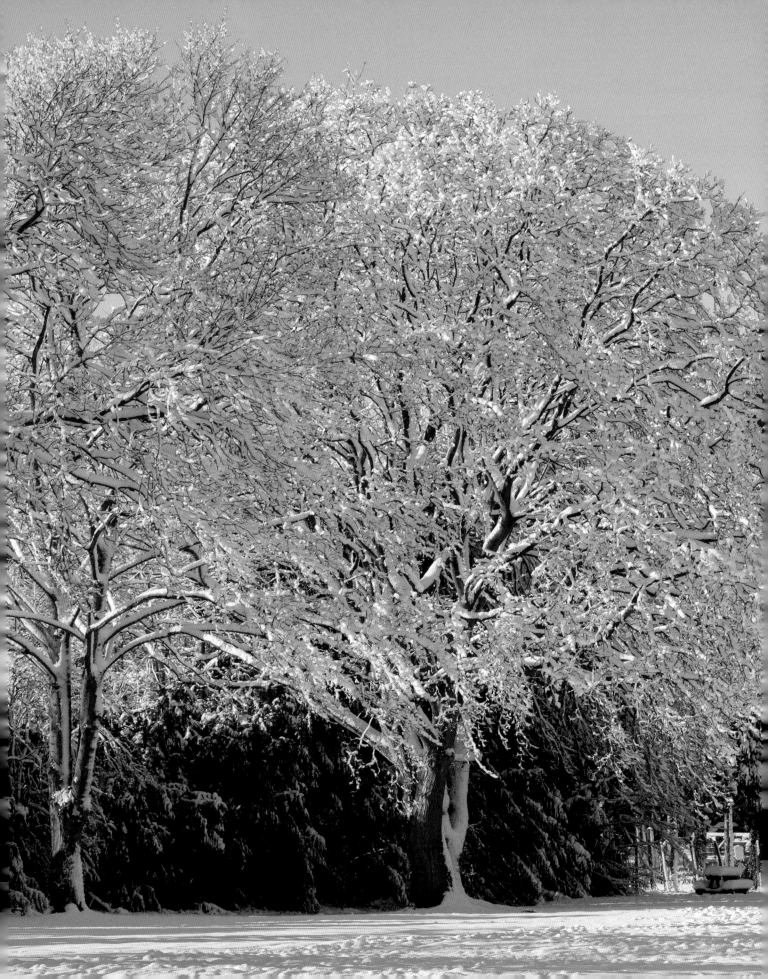

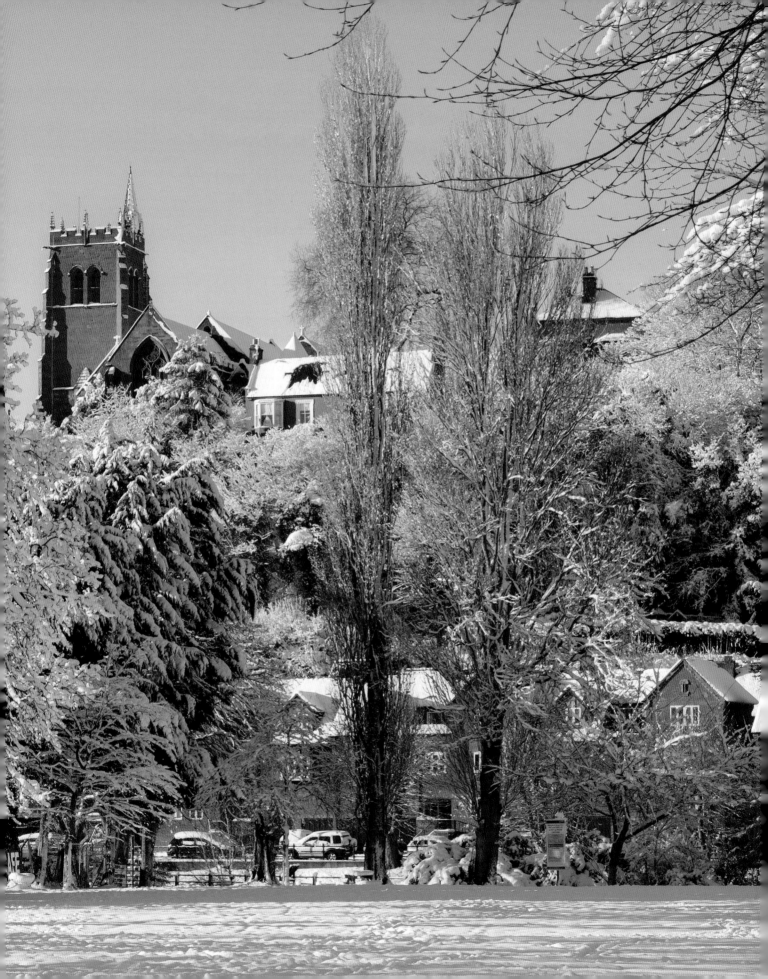

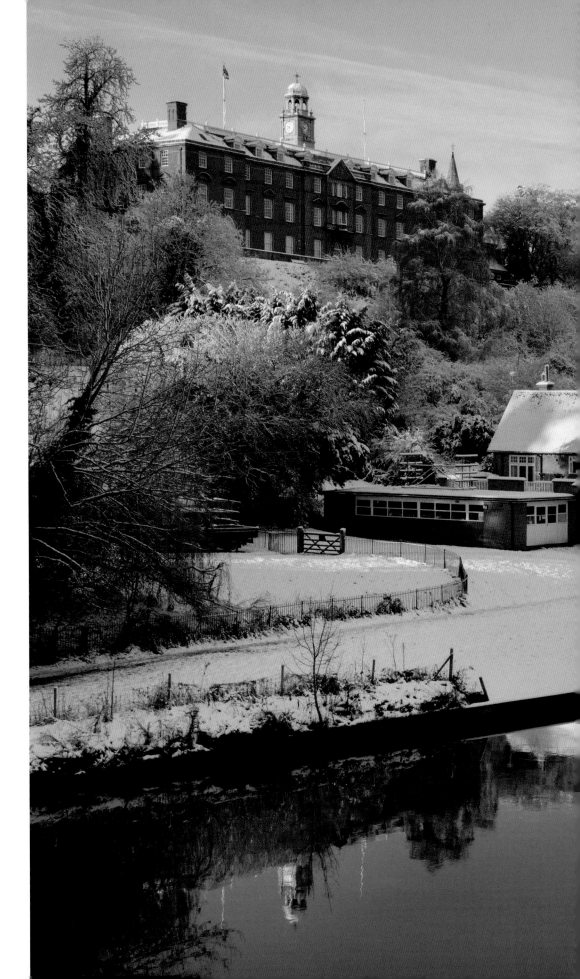

Previous page
BRIDGNORTH

The sandstone tower of
St Leonard's Church
stands out above the
snow-covered trees in
Severn Park.

Right
SHREWSBURY

Shrewsbury School and
Boathouse reflected in
the River Severn.

Following page
CAER CARADOC

A leaden sky full of
snow clouds looms over
this 1506 ft hill that
dominates the south
Shropshire landscape
near Church Stretton.

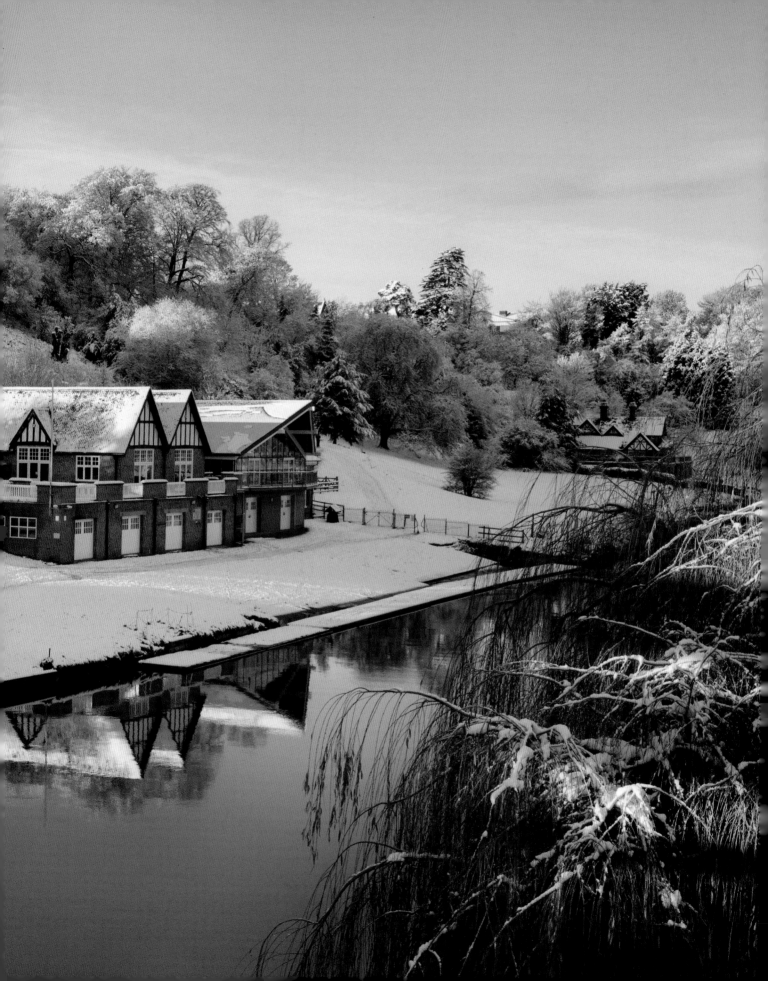

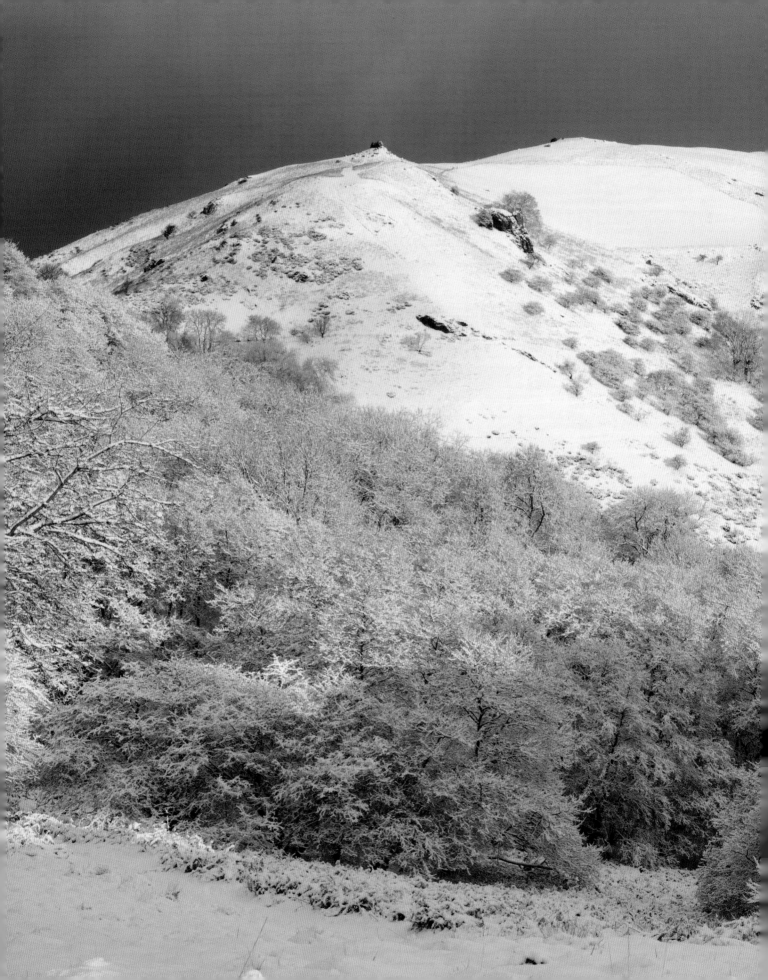

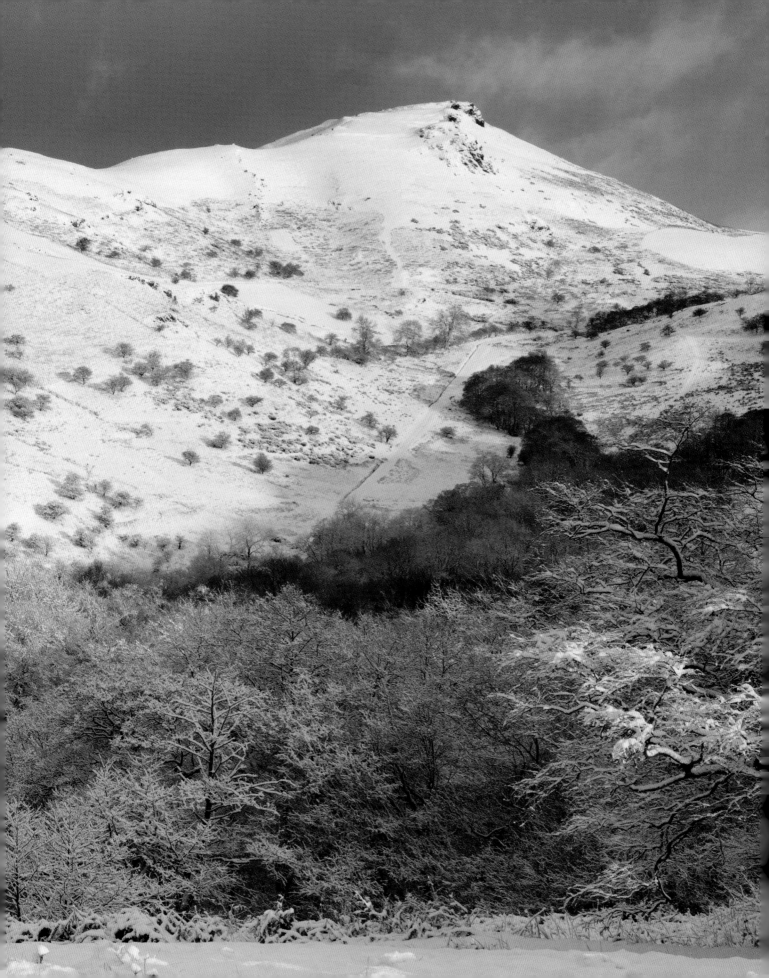

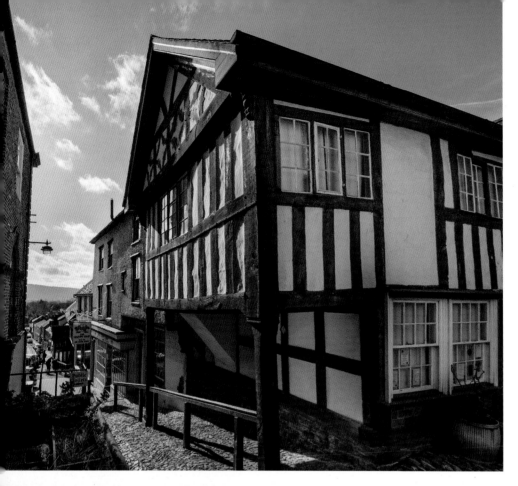

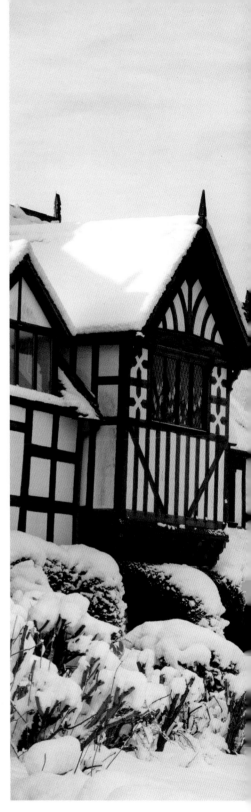

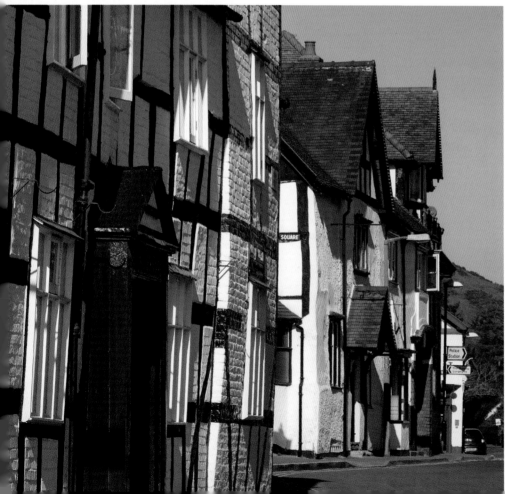

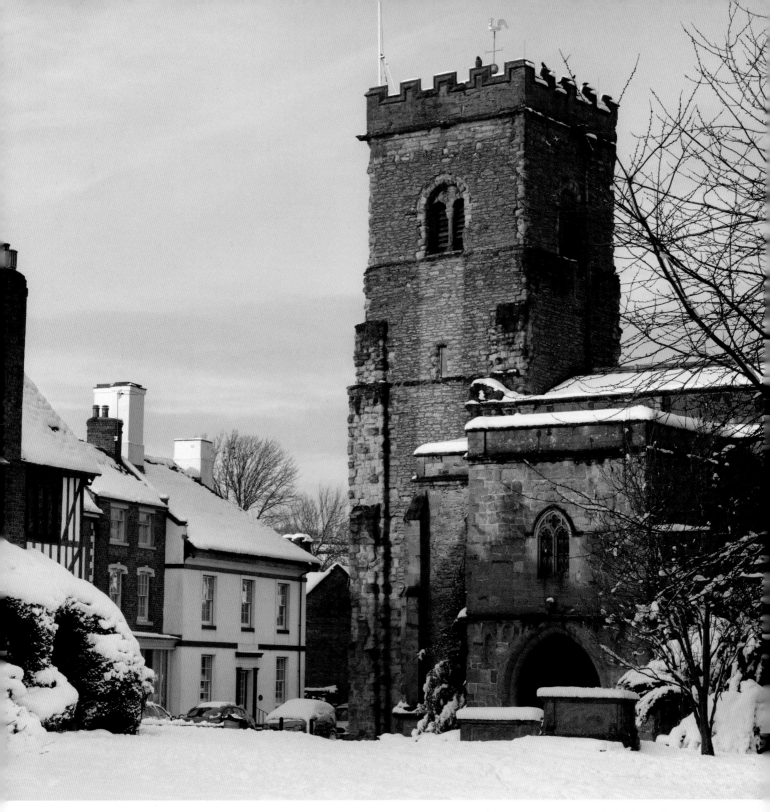

Left, top: BISHOP'S CASTLE. The House on Crutches is a remarkable timber-framed building that dates back to Elizabethan times.

Left, bottom: CHURCH STRETTON. The view along High Street in this historic market town. The building on the left was formerly an inn called *The Raven*.

Above: MUCH WENLOCK. Snow surrounds the half-timbered Guildhall and medieval Holy Trinity Church, whose origins go back to the 7th century.

THE WREKIN

A half-timbered house nestles beneath Shropshire's iconic hill, which may have been the inspiration for JRR Tolkien's Middle Earth in *Lord of the Rings*. The author lived in the West Midlands and made frequent visits to the county, drawing inspiration from its magnificent landscape.

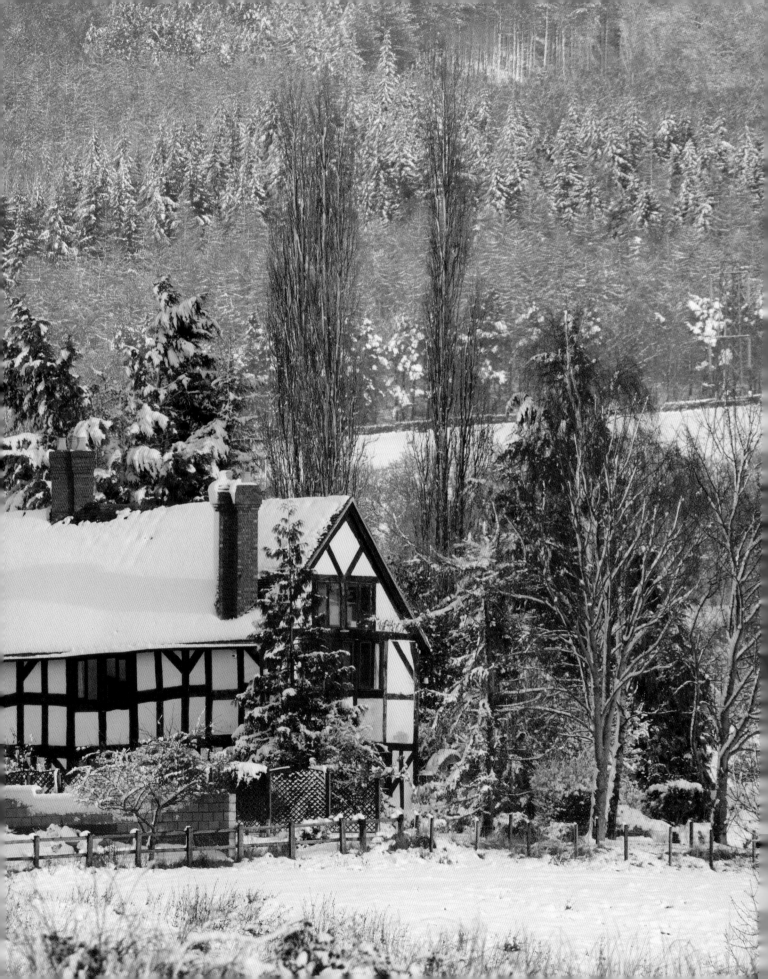

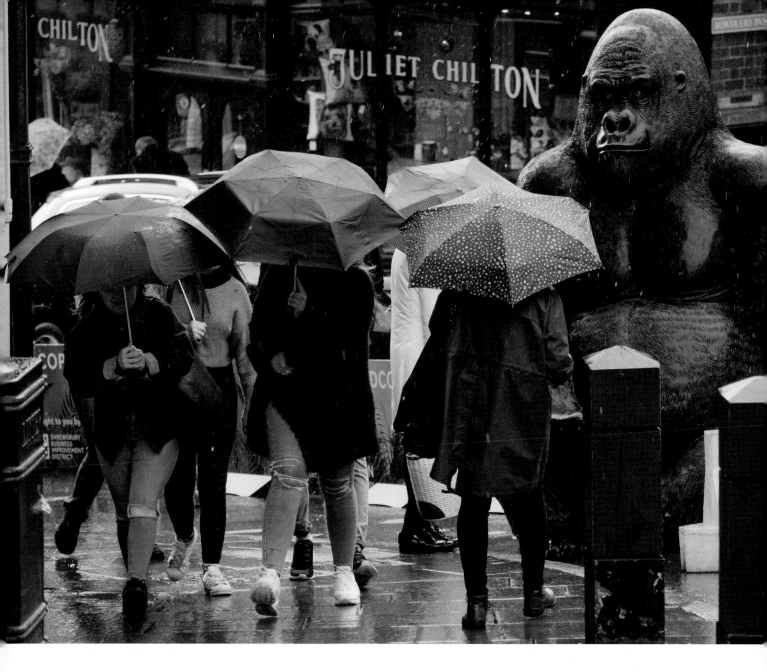

Above
SHREWSBURY. Wyle Cop was temporarily taken over by fibreglass animals as part of a project based on the town's links to naturalist Charles Darwin, who was born at Mount House.

Right (top and bottom)
SHREWSBURY. All is calm, all is bright – the Christmas Tree Festival at St Chad's Church; and festive decorations in The Square.

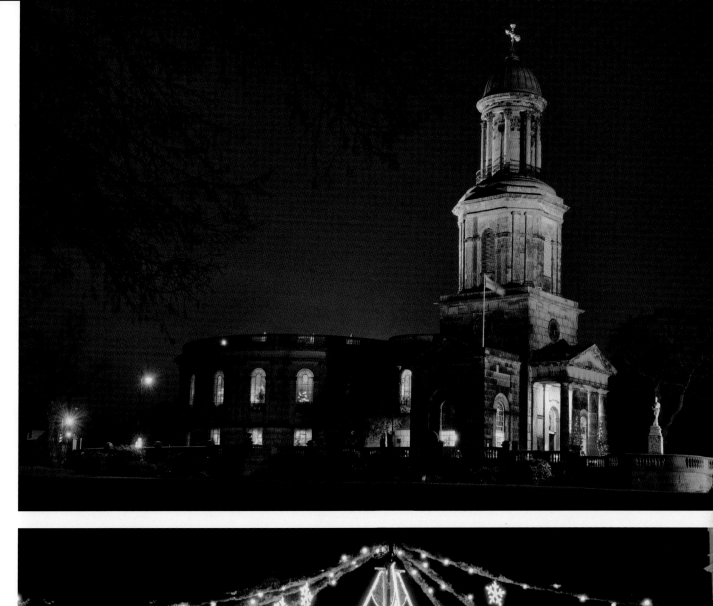
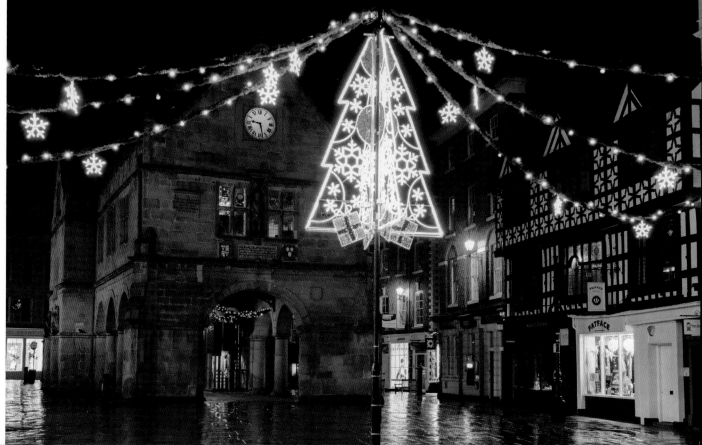

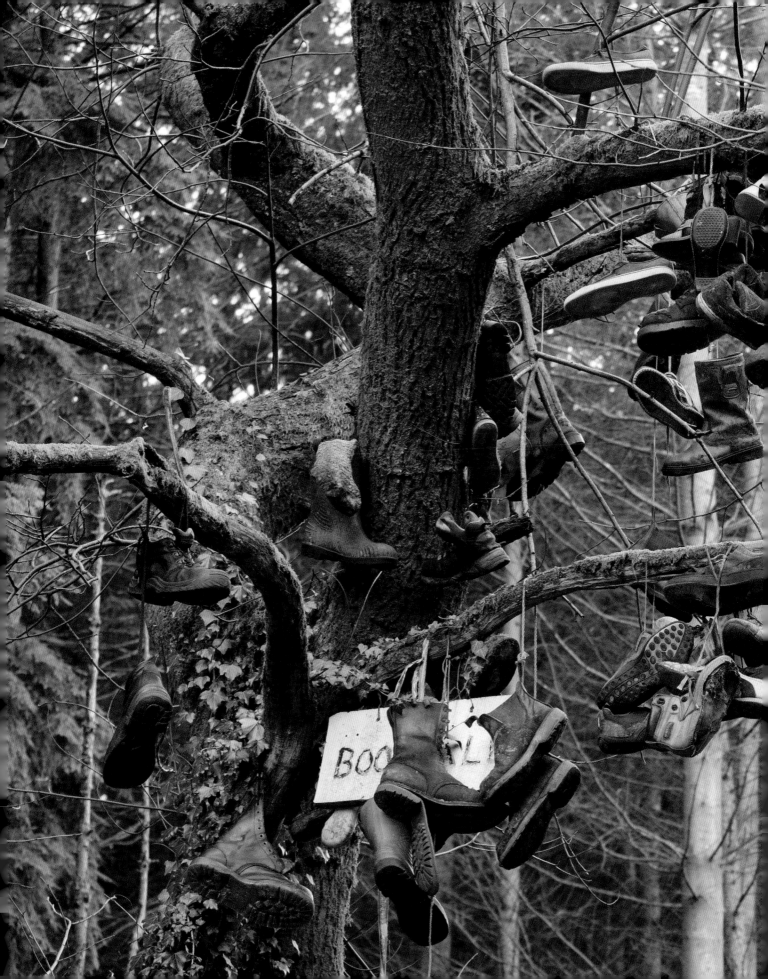

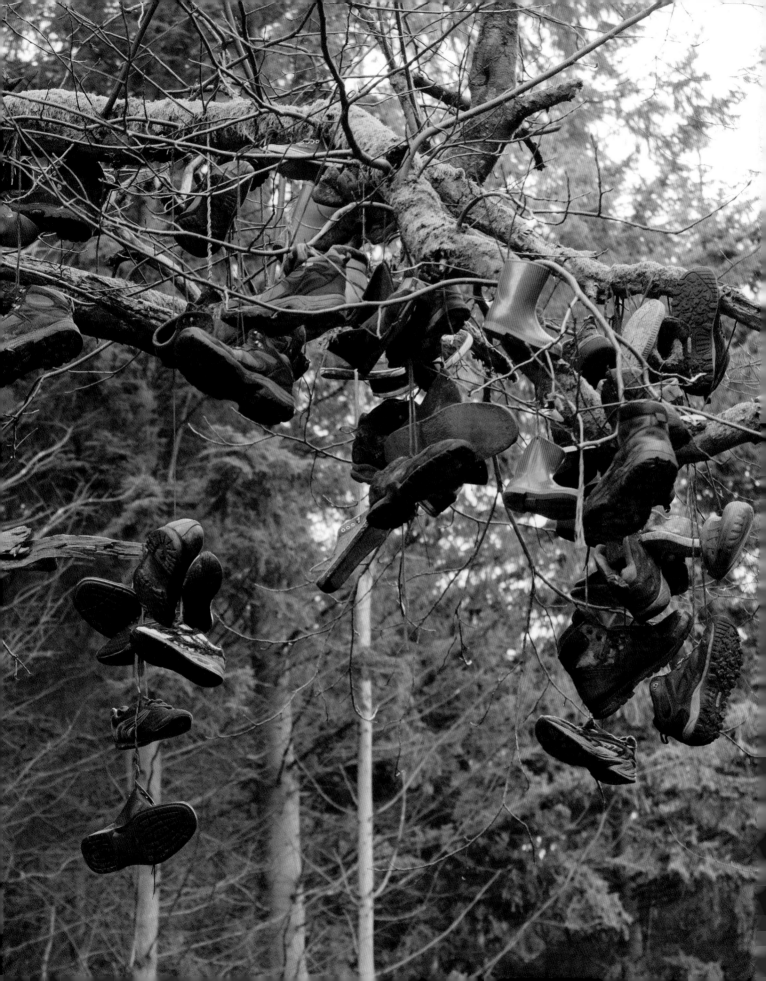

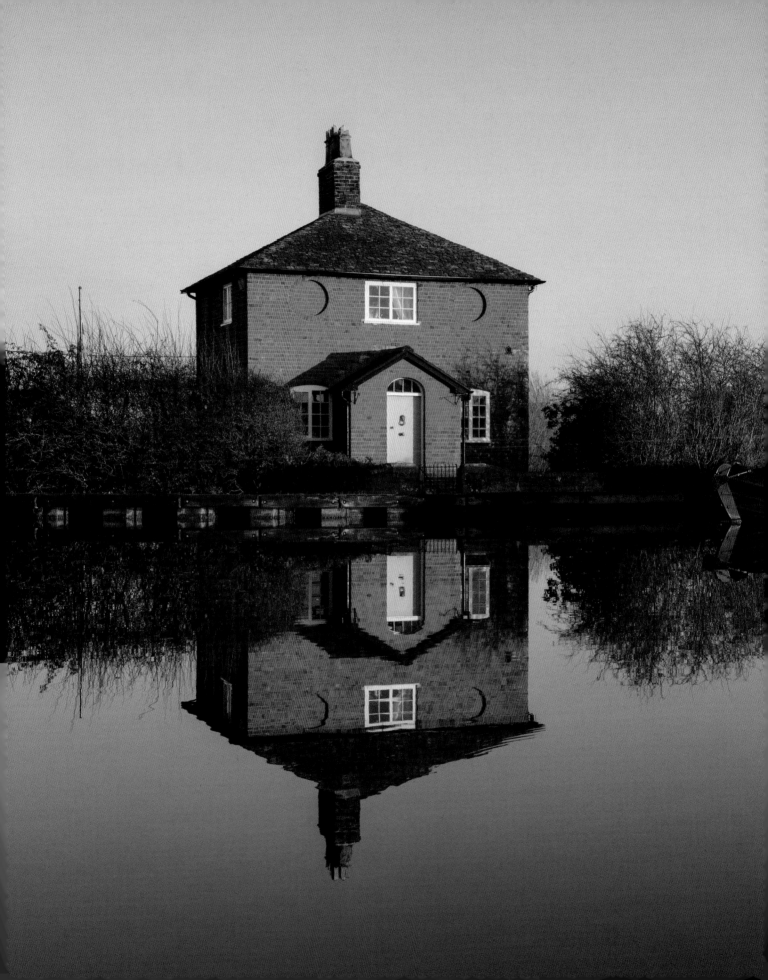

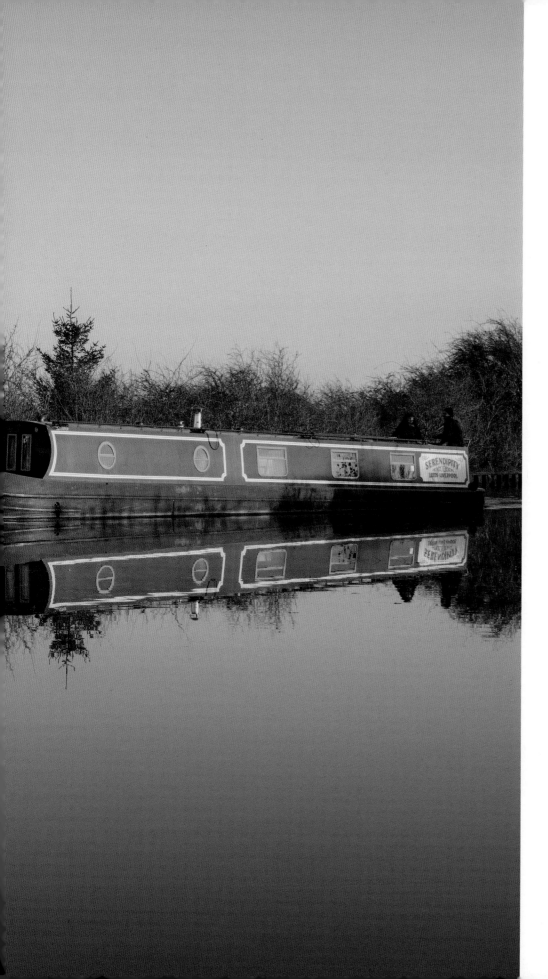

Previous page
BLAKERIDGE WOOD

The so-called Boot Tree is
a well-known sight in this
peaceful spot near Bishop's
Castle. Why and how the
tree has been decorated in
this way is up for debate,
but one story says this
is outgrown footwear
discarded by the younger
members of a very large
family.

Left
WHIXALL

A winter sunset reflected
in the calm waters of the
Llangollen Canal at Whixall
Moss Junction.

Right:
BROMFIELD

An old barn huddles beneath the wintry slopes of Brown Clee. The nearby village stands between the rivers Onny and Teme, which eventually merge a little way downstream.

Following page
CAYNHAM CAMP

An ethereal view of the circular hill fort surrounded by mist, seen from Titterstone Clee. On a clear day it is possible to see the Black Mountains, the Brecon Beacons and the Malvern Hills from this ancient place.

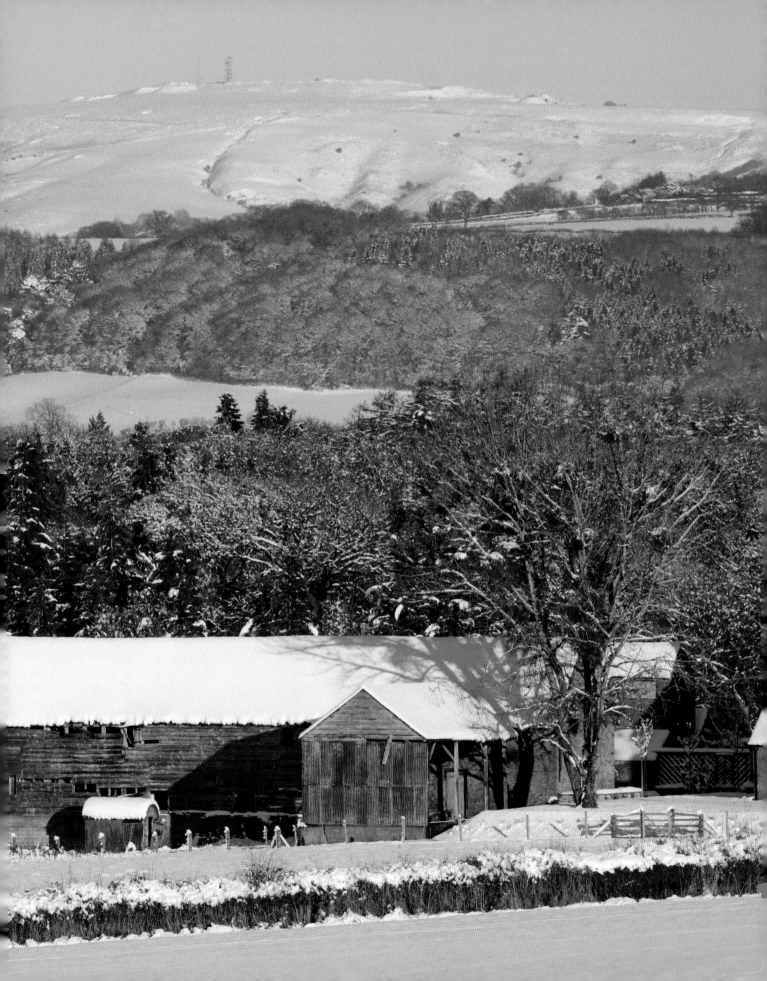

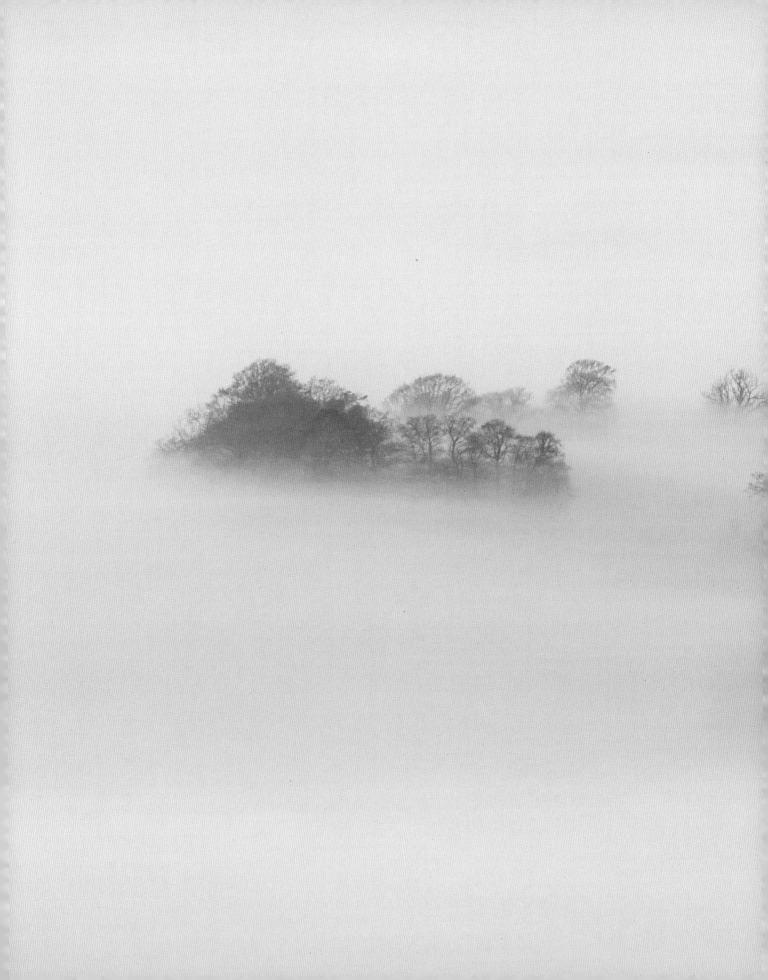

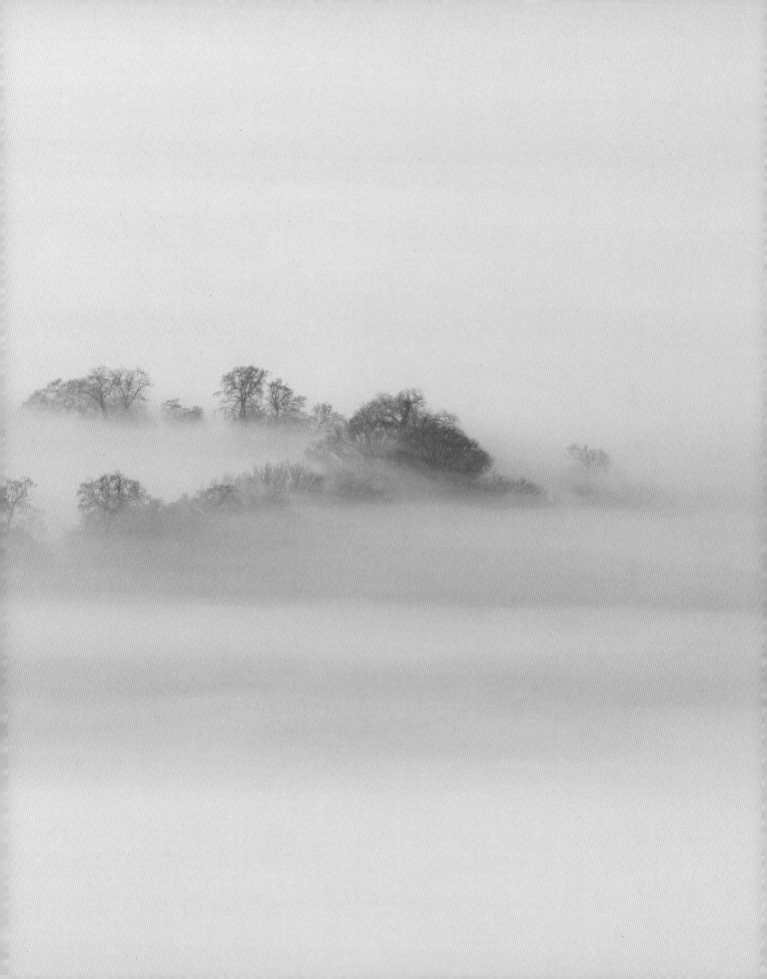

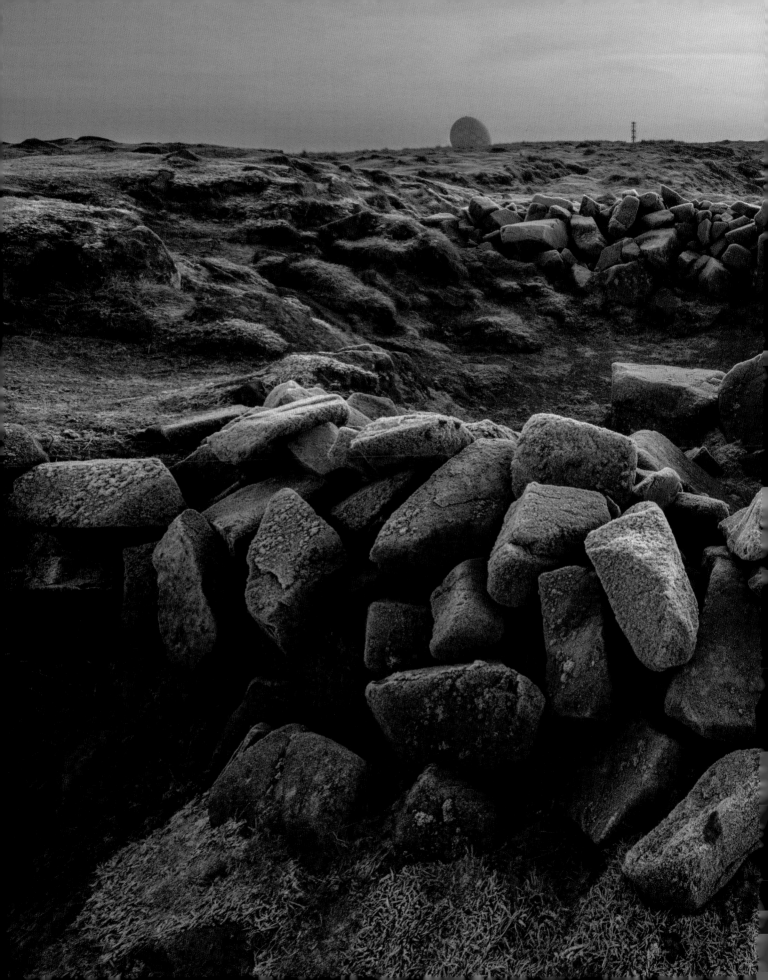

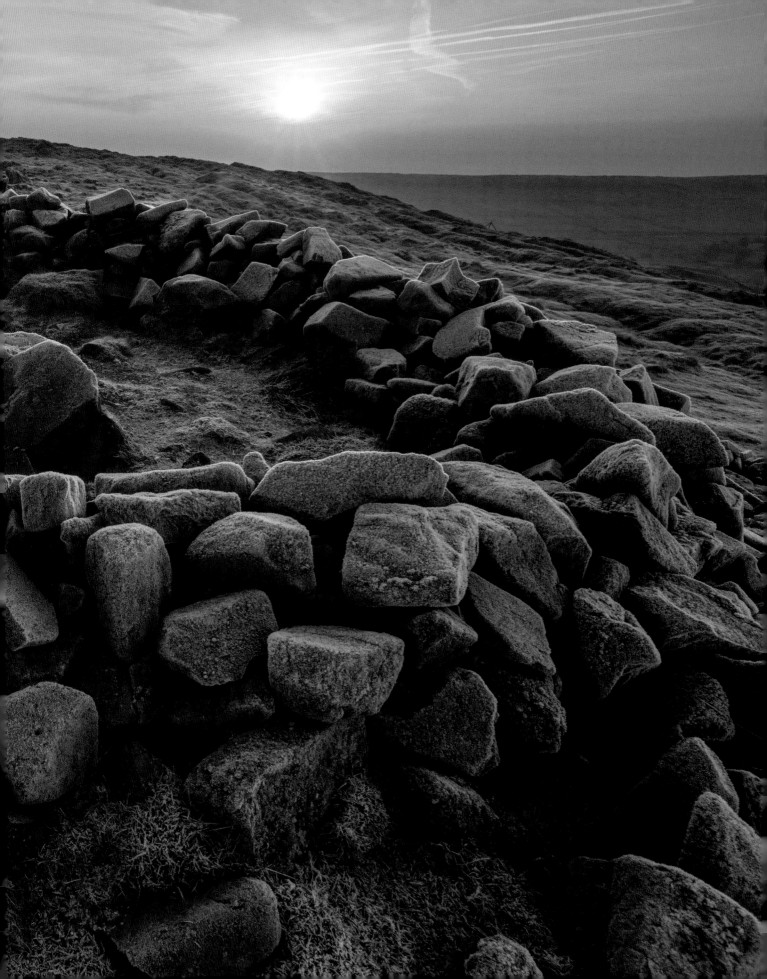

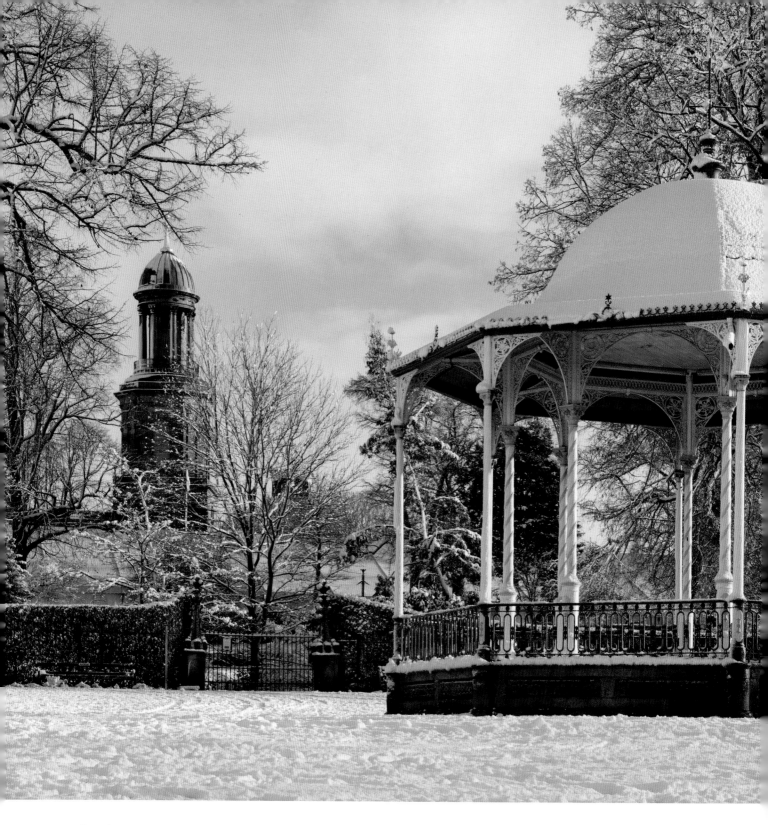

Previous page
TITTERSTONE CLEE

Frost-covered stones at sunrise on the summit. This is the only named hill in England recorded on the Mappa Mundi, the medieval map of the world which is preserved in the library of Hereford Cathedral.

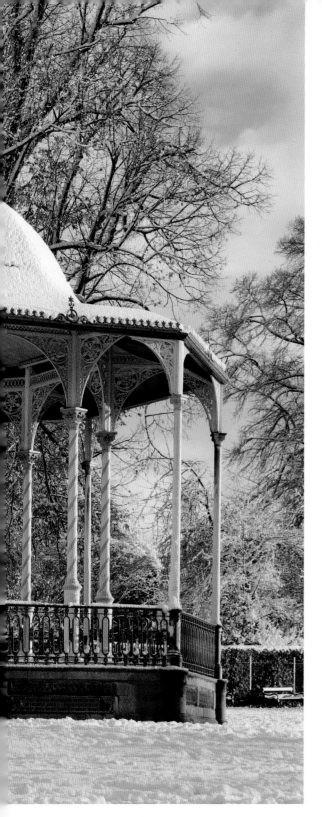
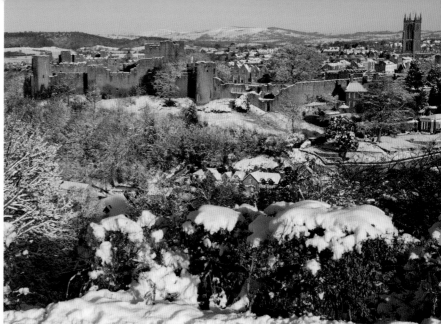
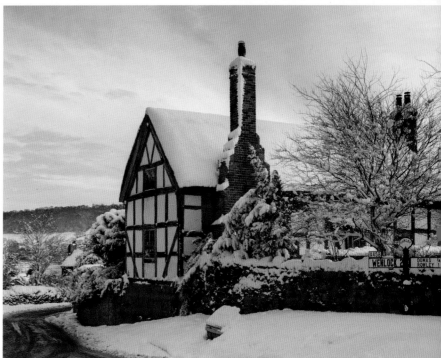

Clockwise, from left
SNOW OVER SHROPSHIRE

The Victorian bandstand in The Quarry at Shrewsbury, overlooked by St Chad's Church; Ludlow seen from Whitcliffe Common, with Brown Clee standing out on the horizon; and a half-timbered cottage at Harley, beneath Wenlock Edge.

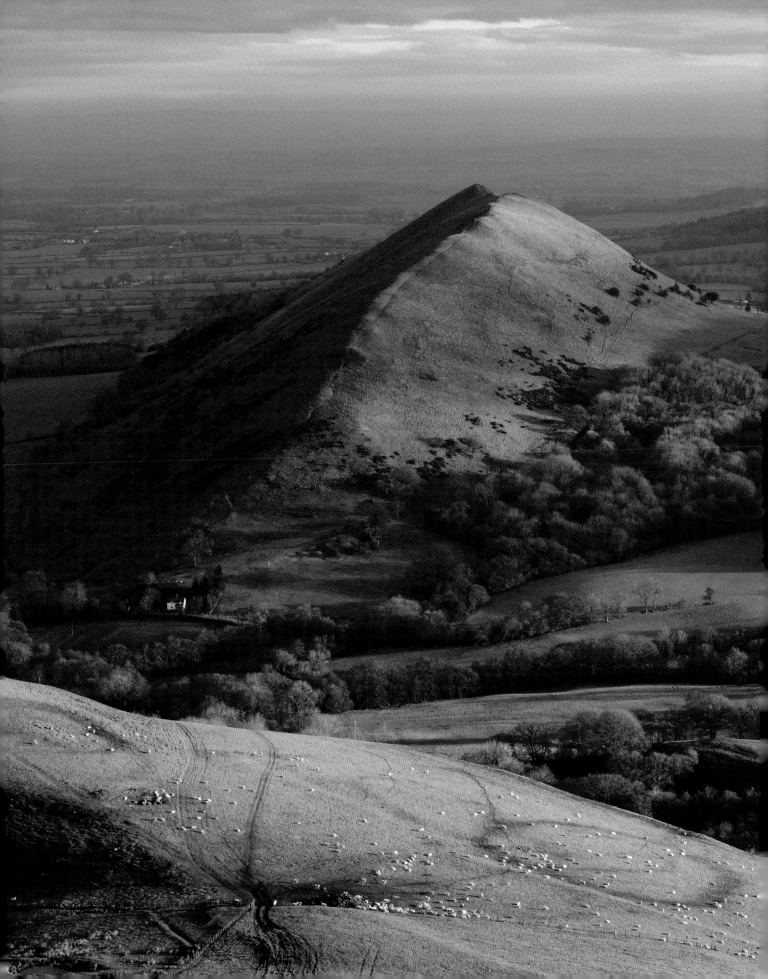

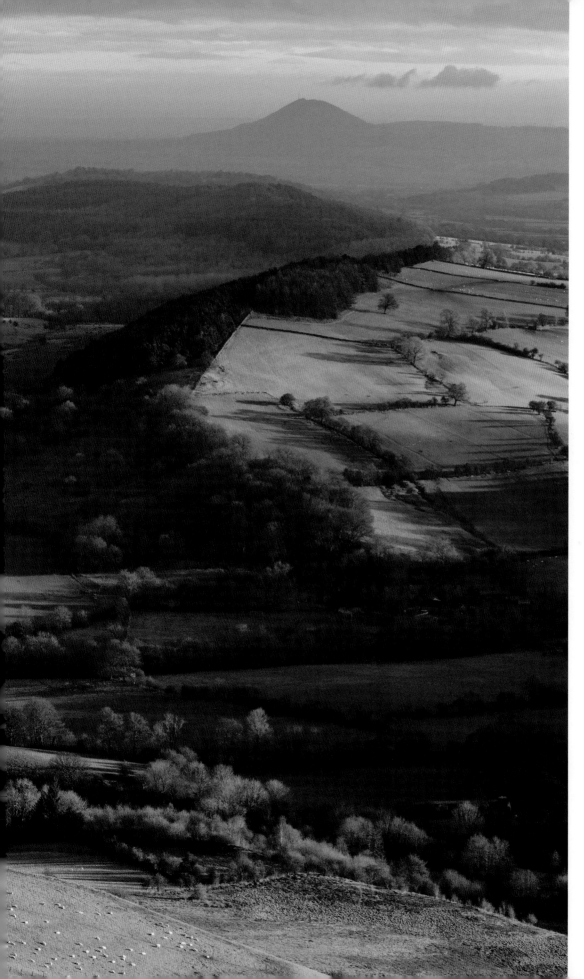

Left
CAER CARADOC

A winter sunrise seen from the summit. Centre left of the picture is the Lawley, with the distinctive outline of the Wrekin standing out in the far distance.

Following page
BITTERLEY

Layers of mist envelop the south Shropshire landscape, as early morning sunshine picks out the shingled spire of St Mary's Church. This is the view from the summit of Titterstone Clee.

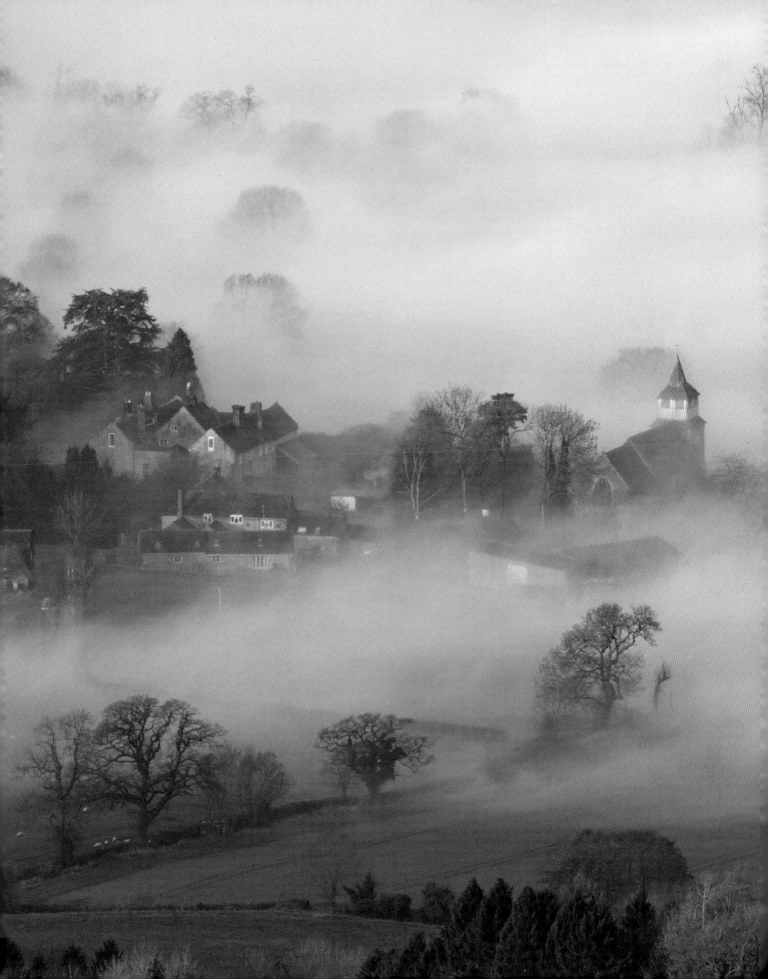

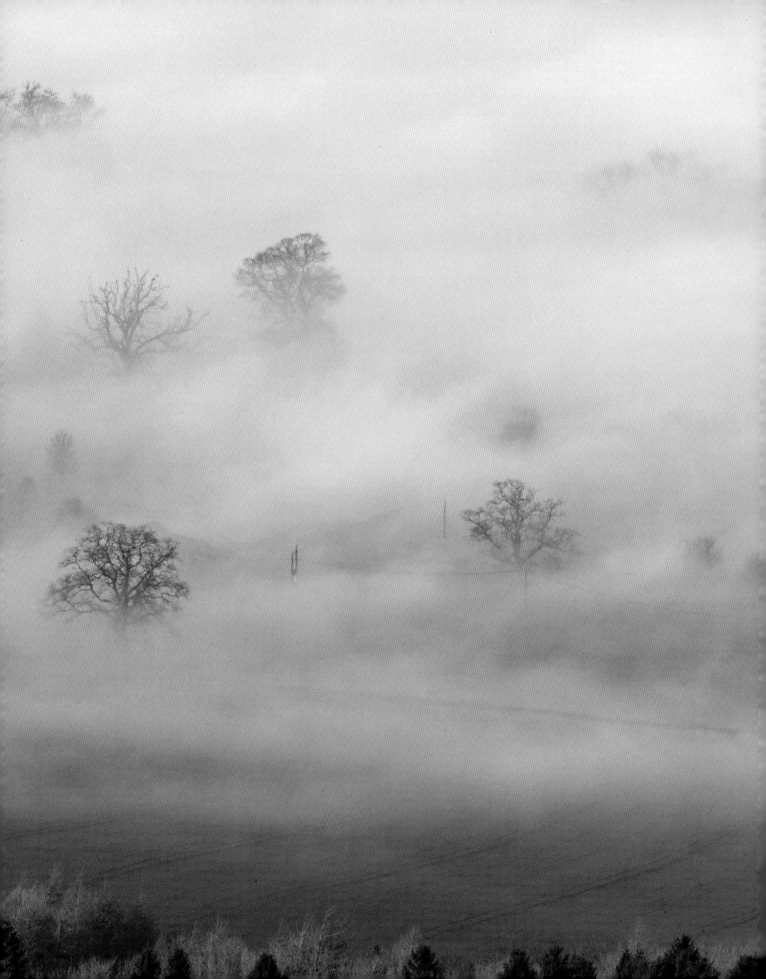

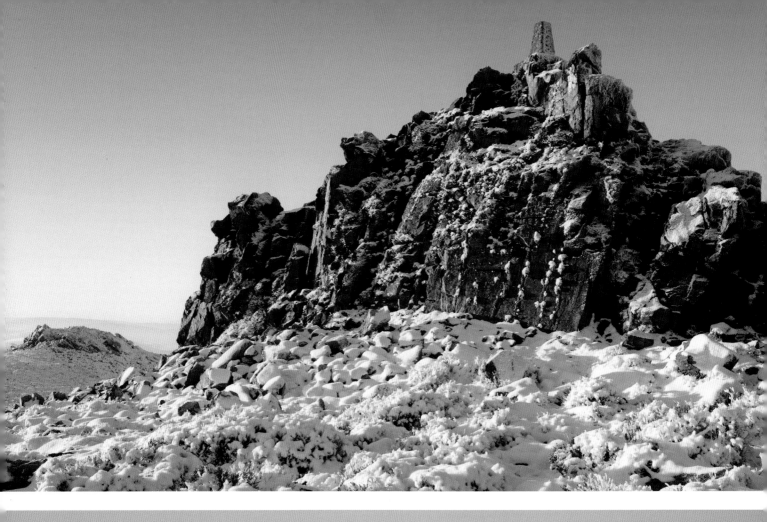

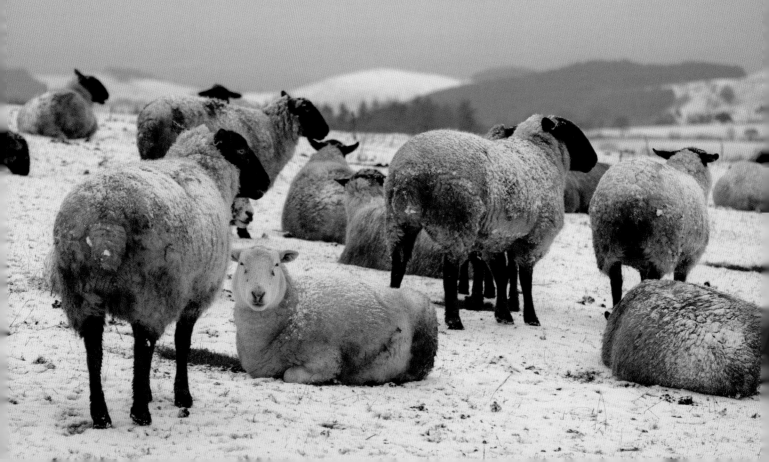

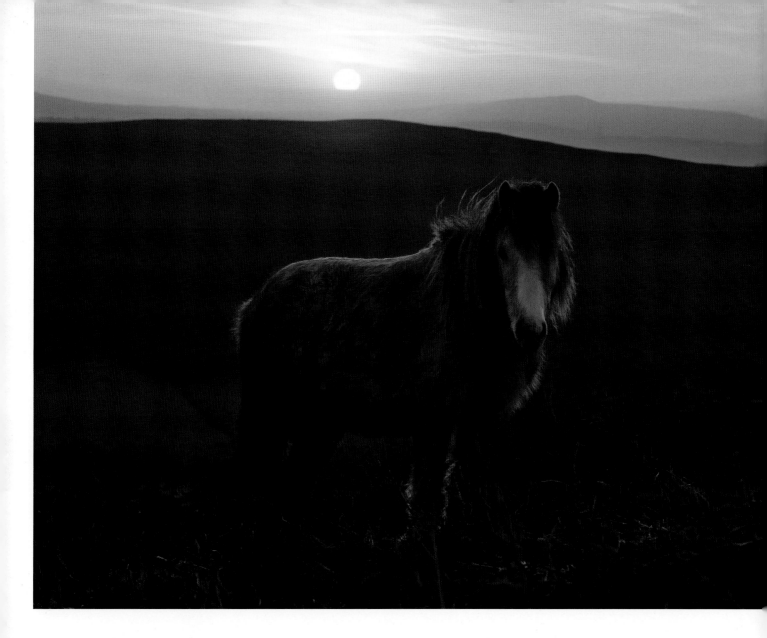

Left, top
THE STIPERSTONES. Manstone Rock is the highest point on this boulder-strewn terrain, which is rich in myth and folklore.

Left, bottom
THE STIPERSTONES. A cold and frosty dawn breaks over a flock of sheep in south-west Shropshire.

Above
THE LONG MYND. A wild pony at sunrise, with Ragleth seen in the background.

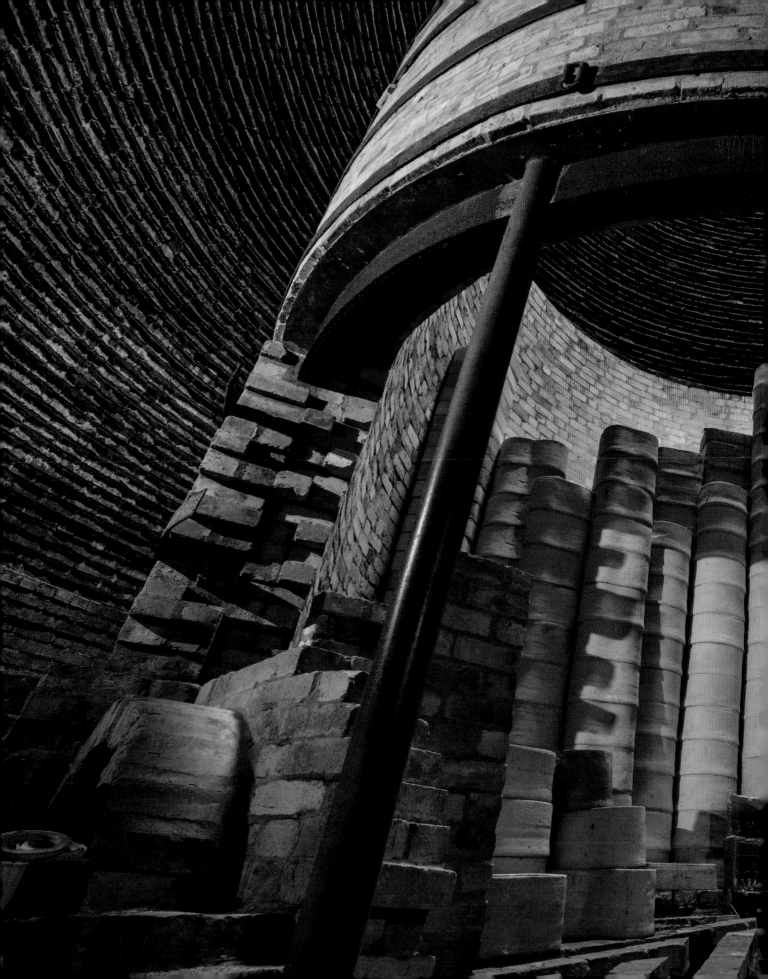

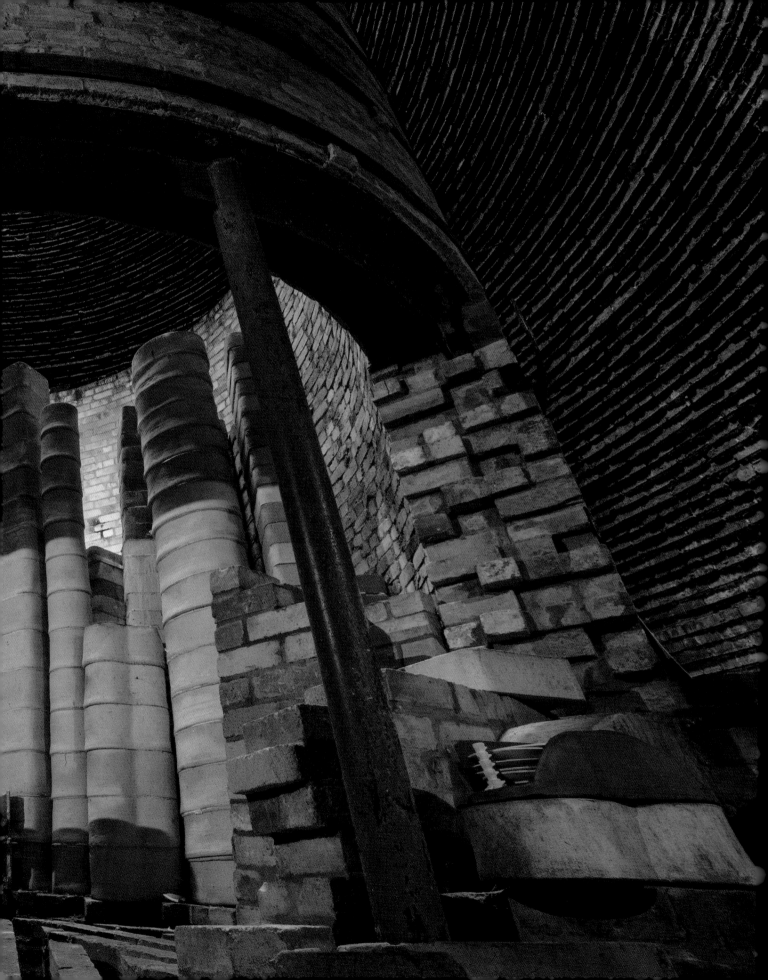

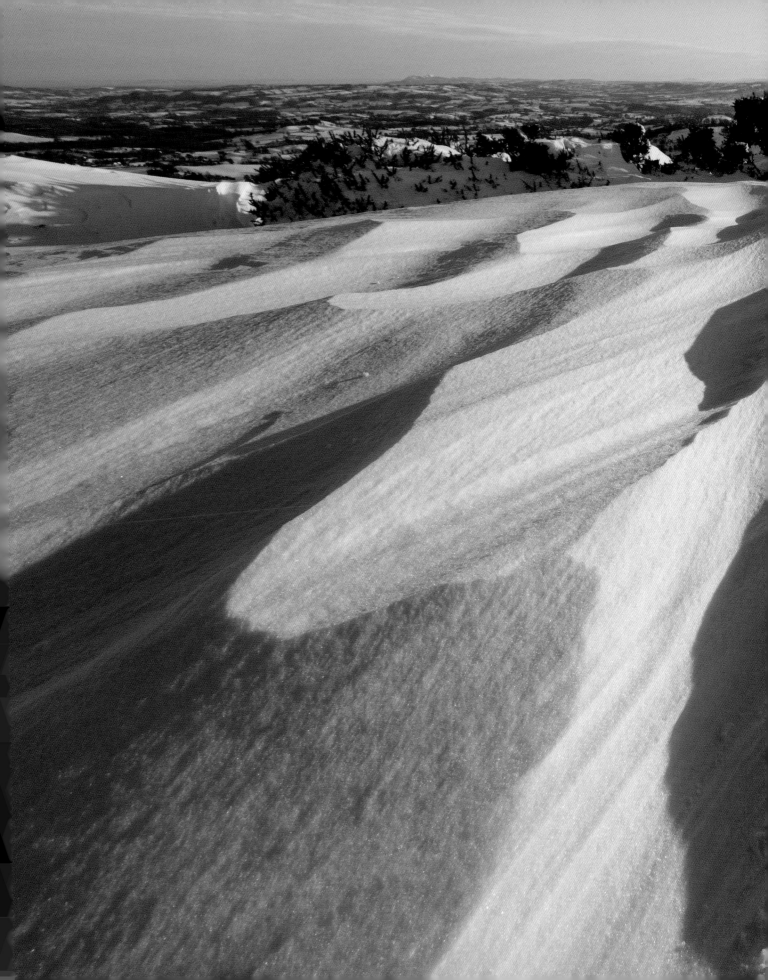

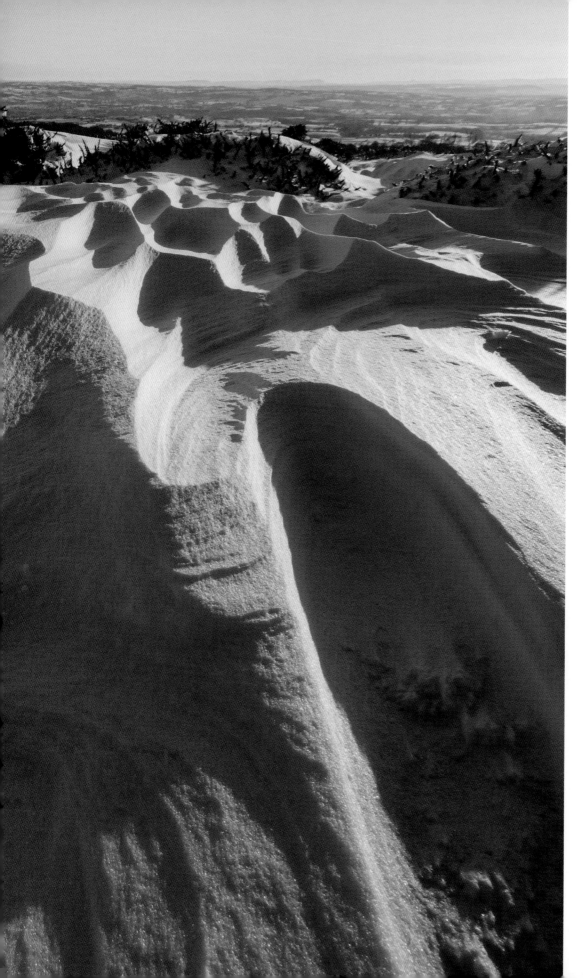

Previous page
COALPORT

The interior of a bottle kiln at Coalport China Museum, a reminder of Shropshire's manufacturing heyday when industrial buildings could be beautiful as well as functional.

Left
CLEE HILL VILLAGE

Deep snow drifts viewed from one of the highest settlements in Shropshire, situated on the slopes of Titterstone Clee.

LUDLOW

The half-timbered Reader's House dates from the early 17th century, although the history of the site can be traced back to the 1300s. It was once the home of the Rector's assistant, known as the Reader, which is how it got its name. Here is the view from the Jubilee Garden, overlooked by St Laurence's Church.

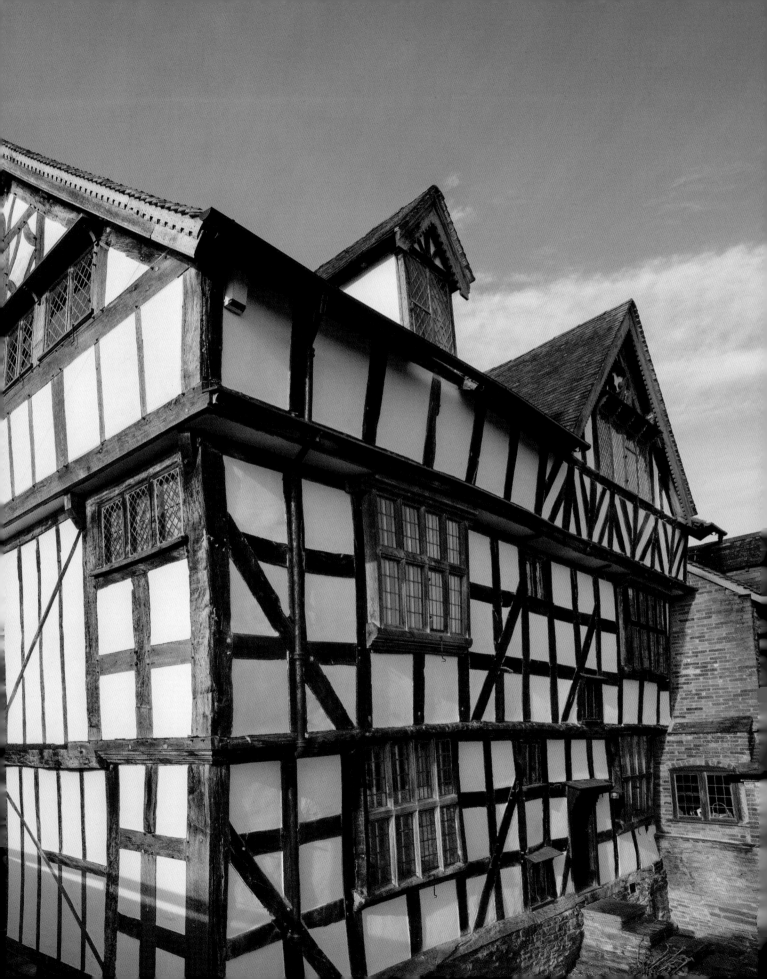

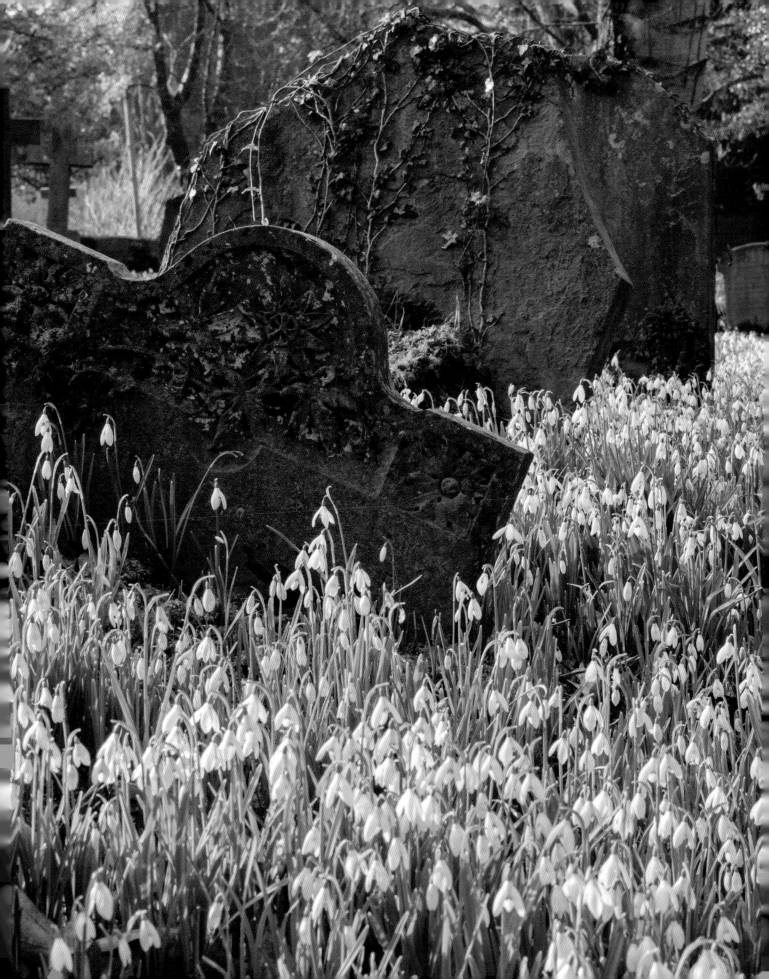

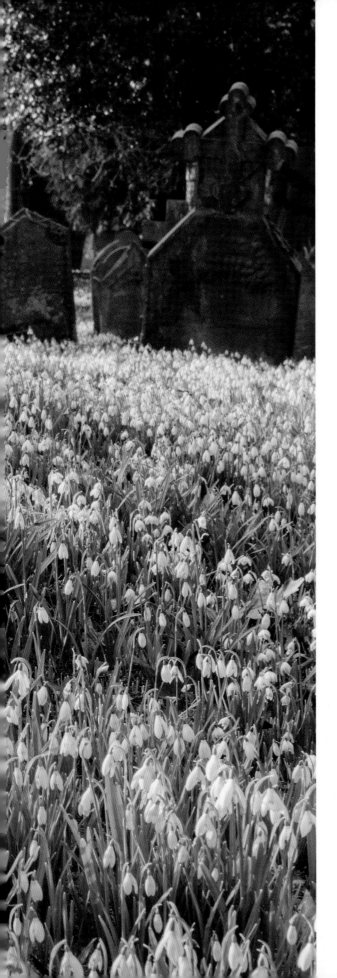

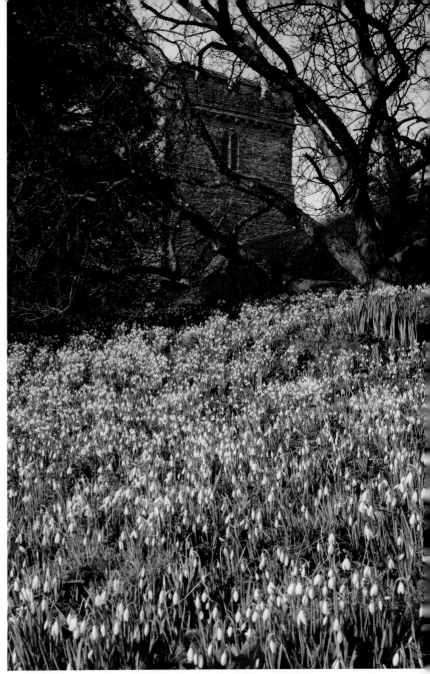

STANTON LACY

The first snowdrops of winter are a welcome sign that spring is only just around the corner. Here is the churchyard at St Peter's, carpeted in a sea of white flowers. The church dates back to about 1050 but it stands within a much earlier Saxon enclosure.

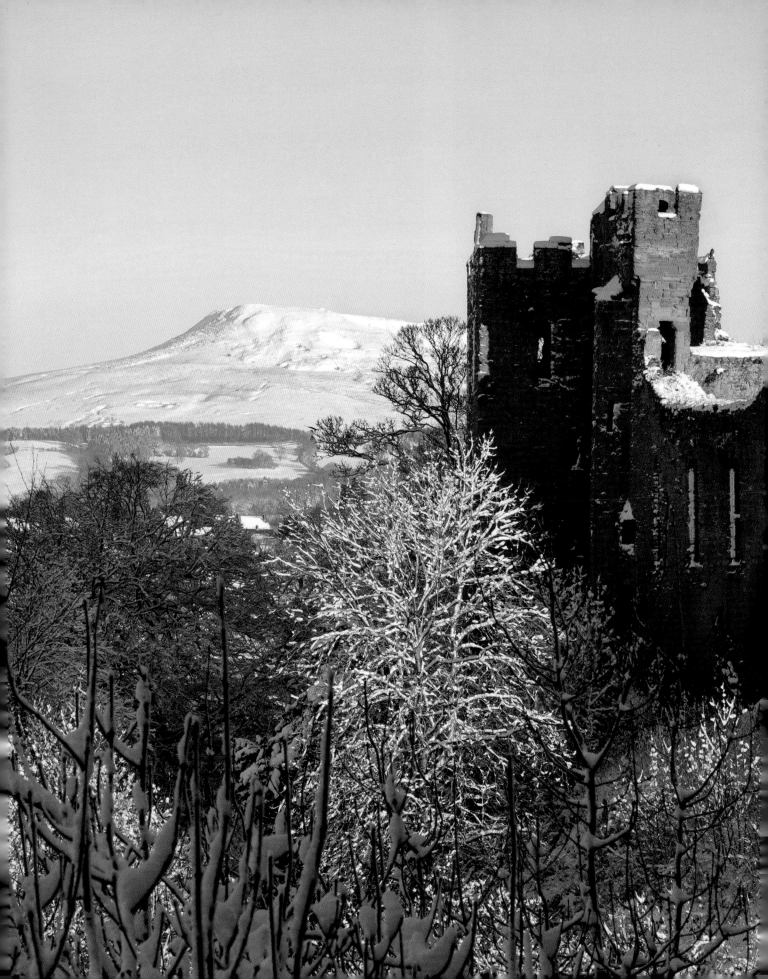

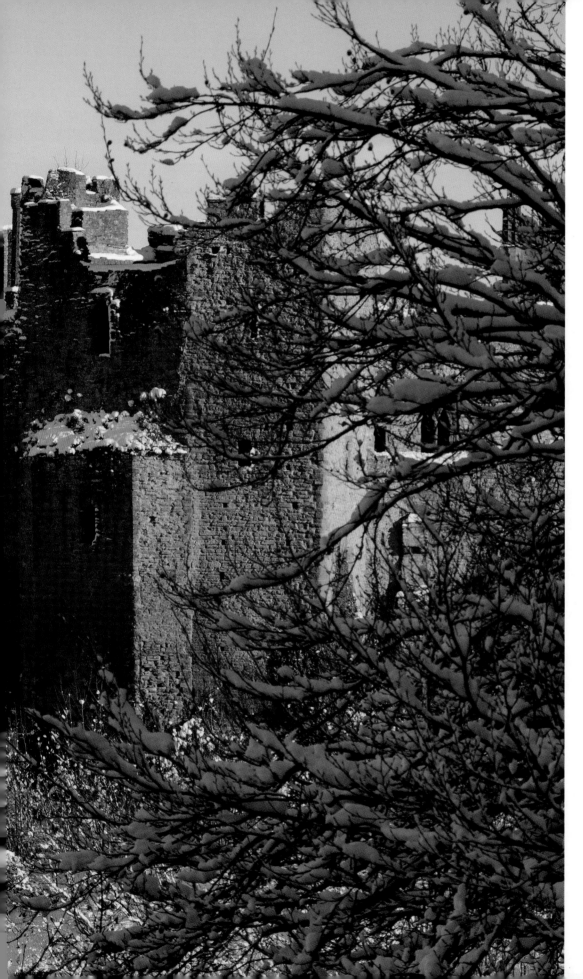

LUDLOW

Bright winter sunshine on the battlements of the castle, with the distinctive summit of Titterstone Clee in the background. Guarded by both the River Teme and the River Corve, the castle has a prominent position on high ground to resist attack by would-be invaders from over the Welsh border.

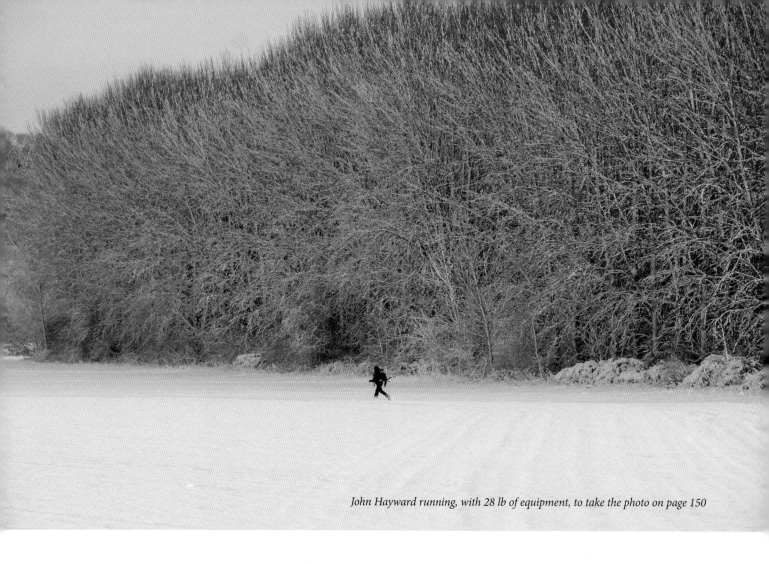

John Hayward running, with 28 lb of equipment, to take the photo on page 150

Photographer's notes – John Hayward

I'm never happier than when I'm out and about in the Shropshire Hills, and I spend a lot of time checking weather forecasts to take advantage of the best conditions.

My favourite time of the day is sunrise. This is not only because the light is at its best but also because it's quiet and I generally have an entire hill to myself.

The early starts are never easy, but sunrise in the warmer months requires a lot of dedication. It involves getting up really early, so my alarm regularly goes off at 3.30am. I like to be in position half an hour before the sun comes up to allow extra time to explore other ideas, or perhaps see a different angle that may be more productive.

My favourite shot in the book is of the two roe deer amid the trees and bluebells on Burrow Hill (page 24). They are very shy creatures who were alert to every sound and movement, so I ended up crawling along the ground to get close to them.

Sometimes you have no time to think as a moment quickly unfolds in front of you. The incident involving two stallions rearing up on the Long Mynd (page 32) lasted a mere three seconds and then it was all over.

Trial and error also plays a part, as I discovered when photographing the Milky Way above Titterstone Clee (page 76). It was a bitterly cold night and the only way I could stop the lens misting up was to attach hand-warmers to it with elastic bands.

I'm always on the lookout for new ways to photograph Shropshire, and I took to the River Severn in a kayak to capture the image of the English Bridge at Shrewsbury (page 54).

Sometimes you are lucky and the weather does absolutely exactly what you want, which was the case at Pole Bank on the Long Mynd (page 71). The sun dipped beneath the horizon and unleashed a spectacular array of colours on the underside of the clouds.

Very often, it's the shots you don't plan for that produce the best results. The tower of Welsh Frankton church emerging from the sea of mist at sunrise (page 80) is a case in point. I had no idea that view was possible, but I just happened to be on Old Oswestry hill fort at the right time.

Time and again I have discovered that you must never let a photo opportunity slip past. A gentle walk up the Wrekin on a beautiful summer's evening turned into a fast jog when I spotted a hot air balloon over the Breidden Hills. I reached the summit just seconds before it landed in the fields below, and I came away with the shot (page 84) of the Stretton Hills.

More exertion was involved when I found a delightful house beneath the Wrekin (page 150). The sun was about to set so I had to jog half a mile across a field in knee-deep snow to get in position before the light disappeared.

I'm always interested to see how views change throughout the year. The old barn at Bromfield (page 158) overlooked by Brown Clee was included in our last book, but that picture was taken in autumn and this latest one is in winter snow, so it looks very different.

Each season offers new perspectives and fresh opportunities, so there is no fear of ever becoming stale or jaded. Roll on the next challenge!

John's equipment: Nikon D850 camera and the following Nikon lenses: 14mm f/2.8, 20mm f/3.5, 24-70mm f/2.8, 70-200mm f/4, 200-500mm f/5.6. Add in a tripod and that means my bag weighs around 28 lb.

Photographer's notes – Mike Hayward

While I love the Shropshire landscape, the many years I spent as a press photographer have made me more than comfortable with capturing images of people.

I'm always on the lookout for the humorous and the offbeat, sometimes without the subjects even knowing they've been 'snapped'.

In particular I like the quirky image of a church service being held among the dodgem cars at Ludlow May Fair (page 7) and the picture of some morris dancers queueing at a bus stop in Shrewsbury (page 48).

I've walked down Grope Lane in Shrewsbury on countless occasions but only recently spotted the street lantern that makes a focal point between the half-timbered buildings crowding in on themselves. A long focal length draws the eye in (page 35).

Village cricket is a delight and always provides some out-of-the-ordinary images. This can be seen on page 52, where a match at Burwarton is framed by a pile of sawn timber, while fielders at Grinshill search for a lost ball.

It's hard to imagine anything more English than a day out at Bishop's Castle Michaelmas Fair (page 106). Here are pictures of a group of morris dancers waiting in the wings while a traction engine passes a vintage car that has broken down and a silver band plays in front of a cavalcade of steam engines.

Very often it's a case of playing the waiting game, as is evidenced by my picture taken on Wyle Cop in Shrewsbury (page 152). I knew what I hoped to see, but I had to wait for over an hour in the pouring rain until a group of people sheltering beneath umbrellas walked past the fibreglass gorilla who appears to be staring straight at them.

Finally, I couldn't pass the bizarre sight of footwear hanging from a tree in Blakeridge Wood (page 154) without stopping. It really is the 'local branch of boots'!

Mike's equipment: Fuji XT2 with 10-24mm, 35mm and 55-200mm lenses. Fuji X100F.

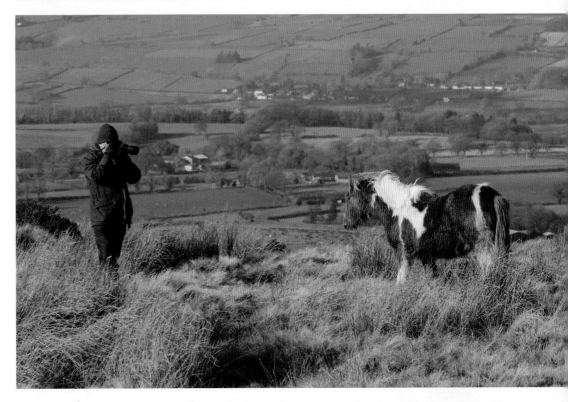

Above: Mike Hayward manages to get close to a wild pony on Brown Clee

Left: An intense blaze of autumn colour at Rectory Wood, which is just a short walk from the centre of Church Stretton

Index of places photographed

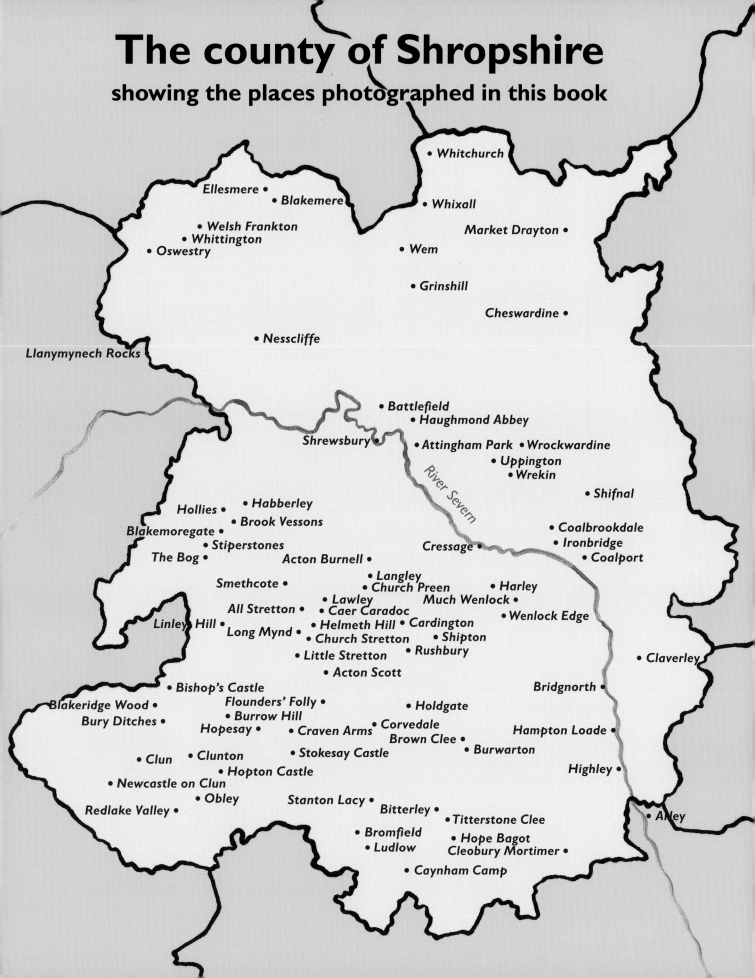

The county of Shropshire
showing the places photographed in this book

• Whitchurch

Ellesmere •
• Blakemere
• Whixall

• Welsh Frankton
Market Drayton •
• Whittington
• Oswestry
• Wem

• Grinshill

Cheswardine •

• Nesscliffe

Llanymynech Rocks

• Battlefield
• Haughmond Abbey
Shrewsbury •
• Attingham Park • Wrockwardine
• Uppington
• Wrekin

River Severn

• Shifnal

• Habberley
Hollies •
• Brook Vessons
Blakemoregate •
• Coalbrookdale
• Stiperstones
• Ironbridge
The Bog •
Acton Burnell •
Cressage •
• Coalport

• Langley
Smethcote •
• Church Preen
• Harley
• Lawley
Much Wenlock •
All Stretton •
• Caer Caradoc
Linley Hill
• Helmeth Hill
Cardington
• Wenlock Edge
Long Mynd •
• Church Stretton
• Shipton
• Little Stretton
• Rushbury
• Claverley
• Acton Scott

Bishop's Castle •
Flounders' Folly •
• Holdgate
Bridgnorth •
Blakeridge Wood •
• Burrow Hill
Bury Ditches •
Corvedale
Hopesay •
• Craven Arms
Hampton Loade •
Brown Clee •
• Clun
• Clunton
• Burwarton
• Stokesay Castle
• Hopton Castle
Highley •
• Newcastle on Clun
• Obley
Stanton Lacy •
Redlake Valley •
Bitterley •
• Arley
• Titterstone Clee
• Bromfield
• Hope Bagot
• Ludlow
Cleobury Mortimer •
• Caynham Camp

Also from Merlin Unwin Books
www.merlinunwin.co.uk

Further Shropshire reading:

A Year in Shropshire Mike & John Hayward

A Shropshire Lad A.E. Housman

Nearest Earthly Place to Paradise *The literary landscape of Shropshire*
 Margaret Wilson & Geoff Taylor

A Most Rare Vision *Shropshire from the Air* Mark Sisson

Ovington's Bank Stanley Weyman

The Temptation & Downfall of the Vicar of Stanton Lacy Peter Klein

Beneath Safer Skies *A child evacuee in Shropshire* Anthea Toft

Myddle *The life & times of a Shropshire farmworker's daughter* Helen Ebrey

It Happened in Shropshire Bob Burrows

How the Other Half Lived *Ludlow's working classes 1850-1960* Derek Beattie

A Farmer's Lot Roger Evans

A View from the Tractor Roger Evans

Fifty Bales of Hay Roger Evans

Pull the Other One Roger Evans

and you may also like...

Much Ado About Mutton Bob Kennard

Extraordinary Villages Tony Francis

The Forest of Bowland Helen Shaw

The Pennines Helen Shaw

For the Haywards' greetings cards, calendars or to buy their images see:
www.shropshireandbeyond.com